# THE LOST ART OF
# Matt Baker

VOL. 1

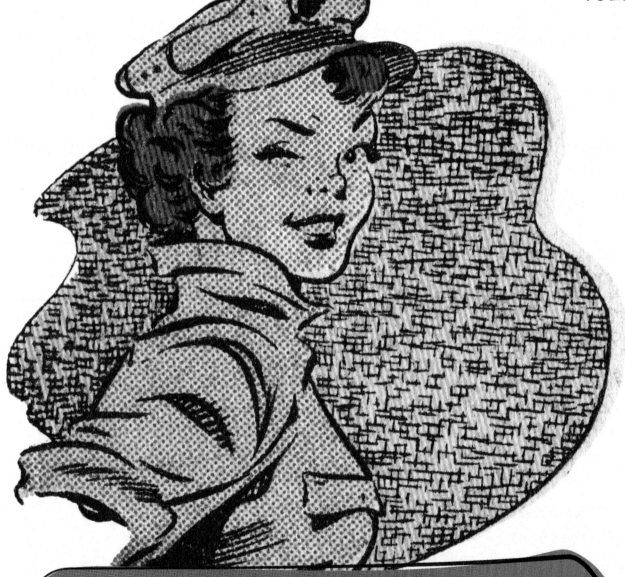

## THE COMPLETE
# Canteen Kate

**LOST ART BOOKS**, the flagship series from Picture This Press, collects and preserves the works of illustrators and cartoonists from the late 19th through the mid-20th centuries. Too many of these artists have gone underappreciated for too long, with much of their work uncollected or unexamined for decades, if at all. The Lost Art Books series aims to preserve this cultural heritage by re-introducing these artists to new generations of working illustrators, historians, and admirers of things beautiful.

**PICTURE THIS PRESS** is dedicated to broadening the appreciation and awareness of the artists who work in the fields of illustration, cartooning, graphic arts, photography, and poster design.

## OTHER LOST ART BOOKS

*The Lost Art of Zim: Cartoons & Caricatures* (2010)

*The Lost Art of E.T. Reed: Prehistoric Peeps* (2010)

*The Lost Art of Frederick Richardson* (2010)

*The Lost Art of Heinrich Kley, Volumes 1 & 2* (2012)

*The Lost Art of the Racy and Risqué, Volumes 1 & 2* (forthcoming)

*The Illustrated Bibliographical Dictionary of Cartoonists* (forthcoming)

*The Lost Art of Ethel Hays* (forthcoming)

# THE LOST ART OF
# Matt Baker
### VOL. 1

## THE COMPLETE
## Canteen Kate

Introduction by Steven Ringgenberg • Edited by Joseph V. Procopio

# ACKNOWLEDGMENTS & EDITOR'S NOTE

"I love to share the things I love with the people I love."

This was something my mother once said to me, and it is a succinct expression of the animating impulse behind Lost Art Books. These books are about legacies, and Lost Art Books is her legacy as well as mine. No expression of gratitude for my mother's guiding spirit will ever feel sufficient, but I think she knew I took what she said to heart.

As always, many hands and hearts went into making this volume. Steven Ringgenberg enthusiastically stepped up to write an erudite introduction and has helped spread the word about this book in ways beyond reasonable expectations. Jim Vadeboncoeur, Jr. once again proved himself to be the patron saint of comics and illustration scholarship, speedily contributing the last needed piece of the puzzle. Kieran Daly, Parisa Damian, and Andrew Adams of Winking Fish elevated the book's design to something worthy of Baker's art. R.C. Harvey's moral support cannot be underestimated, and I'm glad to know he's in my corner. Finally, Ellen Levy's contributions exceed enumeration. Besides carving out the space and time in our lives needed to produce this volume, she brings a formidable set of editorial skills to bear on every Lost Art Book.

Prevalent in material of this nature, there will be cultural and ethnic stereotypes that modern audiences may find problematic. These do not reflect the views of the publisher or any of this book's contributors.

As for the production and editorial choices guiding our first foray into comic book reproduction, we tried to find the most pleasing balance between honoring the artist's intentions and working within the limitations of source material that was considered disposable and thus not worthy of quality printing. Our restoration efforts concentrated on restoring some of the color's lost vibrancy and removing the distracting artifacts of yellowed, foxed paper and a multitude of printing defects. We selectively addressed occasional color registration problems. The philosophical debates around how to best reproduce this material continue unabated. Our ethos is to emphasize the artwork over the decaying physicality of the object on which it was reproduced.

The stories in this volume are sequenced in chronological order according to original publication date. Every page of this volume was scanned and restored from original issues within the publisher's collection, barring one comic borrowed and scanned from another collector. —J.V.P.

Lost Art Books, an imprint of Picture This Press
Silver Spring, Maryland

www.PictureThisPress.com · www.LostArtBooks.com

Lost Art Book No. 6

Library of Congress Cataloging-in-Publication Data
Matt Baker (1921–1959)
the lost art of Matt Baker, volume 1: the complete Canteen Kate / Matt Baker
1. Caricatures and cartoons. 2. Comic books, strips, etc.
I. Baker, Matt. II. Ringgenberg, Steven. III. Procopio, Joseph V.
Library of Congress Control Number: 2013914425

ISBN-13: 978-0-9829276-6-3 (Hardcover)
ISBN-13: 978-0-9829276-8-7 (Paperback)

COMICS & GRAPHIC NOVELS / General
ART / Popular Culture
ART / Individual Artists / General

Publishers—Joseph Procopio & Ellen Levy
Art direction—Joseph Procopio
Interior layout and design—Winking Fish
Cover design—Winking Fish

Printed in the United States of America

# Contents

# Matt Baker

## A Way With Women

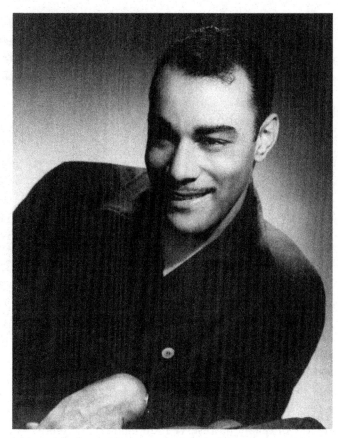

*Clarence Matthew Baker (Dec. 10, 1921–August 11, 1959)*

Dapper, elegant, self-assured, and movie star handsome, Matt Baker was one of the finest draftsmen to ever work in the comics industry, though he had little formal art training. Baker's way with the female form served him well when he segued from his earlier superhero, science fiction, and jungle adventure stories in the late 1940s into the romance genre in the early 1950s. His women were some of the most beautiful ever to grace a comic book page. Unfortunately, his life was cut tragically short when he was felled by a heart attack in 1959 at age 37, just before the Silver Age superhero resurgence got into high gear a few years later. It's a loss to all comics fans that, at the time of Baker's death, the comics business was but an anemic ghost of its former self, thereby limiting his artistic opportunities. It's an intriguing game of "What If" to consider what Baker might have accomplished if he had lived long enough to participate in the superhero revival of the 1960s at Marvel Comics. Imagine Matt Baker drawing the Scarlet Witch, the Wasp, Mary Jane Watson, Pepper Potts, Marvel Girl, or even Millie the Model.

From a historical perspective, Baker's career is notable for a variety of reasons. Primarily, he was one of the first, and indeed, one of the very *few* African American comics artists working in the 1940s and 1950s. Among his other noteworthy accomplishments as a cartoonist, Baker drew covers and interior art for some of the very first 3-D comics during the short-lived fad of the early 1950s. While at St. John Publishing, Baker

also drew one of the very first graphic novels ever published, *It Rhymes with Lust* (1950), a 126-page soap opera intended to appeal to older readers, featuring Baker's patented brand of sexy femme fatales. Working exclusively for the St. John line for several years, Baker was the publisher's definitive cover artist, drawing 219 covers for various titles by the time he stopped working for St. John in 1955. Baker also achieved a kind of comic book infamy when his voluptuously sexy cover for *Phantom Lady #17* was featured in Frederic Wertham's muckraking *Seduction of the Innocent* (1954) book as an example of a "headlights" cover that also featured bondage, something that, according to Wertham at least, would appeal only to sadists.

If Matt Baker is remembered for no other reason than his superb covers and dynamic stories for Fox Features' *Phantom Lady* title, he would still be a legend. The Phantom Lady is one of the sexiest of all costumed heroines (and incidentally had no superpowers), with one of the best costumes (courtesy of frequent Baker collaborator Alex Blum). The Phantom Lady's adventures were published by Fox Feature Syndicate as part of its constant efforts to boost sales by chasing the hot trends. In the post-WWII era, when the sales of superhero comics dried up, comics publishers turned to "good girl" art as one way to pump up sales by appealing to an older readership. Although other good artists like Jack Kamen drew the Phantom Lady, Baker was the definitive artist on the series, contributing seven covers and most of the interior art.

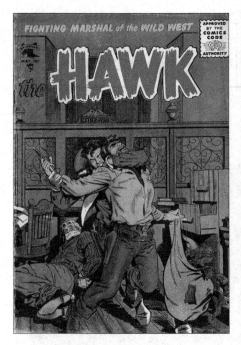

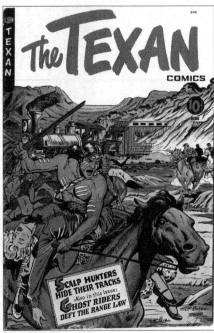

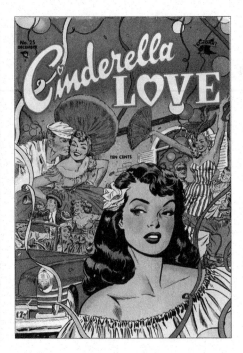

The Hawk #12 (St. John, 1955)    The Texan #8 (St. John, 1950)    Cinderella Love #25 (St. John, 1954)

Colleagues remembered Baker as a polite, nattily dressed gentleman who was either talkative and friendly or quiet and reserved, depending on where he was working. In some work situations, Baker may have kept more to himself due to the pervasive racism of the day, acutely conscious of being the only African American in the room. Yet, he was able to transcend racial considerations because of his talent; he earned respect everywhere he worked due to his speed and the uniformly high quality of his work. Another factor that may have contributed to Baker's personal reserve is the possibility that he was bisexual or gay, something that was asserted by his close friend, Frank Giusto. Although we live in more enlightened times, consider what it must have been like to be a gay black man in the 1940s and '50s, when racism and homophobia were the societal norms.

Despite the brevity of his comics career (only 15 years), he was incredibly prolific and had a reputation as a hard worker. Knowing that his weak heart might end his life prematurely, Baker may have been driven to make the most of every day. Friends and family members remember that he would stay up late, working through the night, smoking cigarettes and listening to jazz while he drew.

For years, Baker was best known to old-time comics fans as a "good girl" artist for his luscious depictions of the female form in comics like Canteen Kate, The Phantom Lady, Teenage Romances, and a whole bevy of different romance titles for St. John, Atlas/Marvel, Charlton, and others. However, it deserves emphasizing that Baker wasn't just a top "good girl" artist—he was versatile enough to tackle genres like superheroes (albeit usually featuring sexy female sidekicks or

damsels in distress), jungle adventures, war stories, westerns, and humor (again, usually featuring sexy teenage girls or women). Among the more interesting aspects of Baker's style is that he forged his own artistic path, unlike many of his contemporaries, who were either inspired by or just slavishly copied the styles of Alex Raymond, Hal Foster, and Milton Caniff. Not only did Baker's characters look different than anyone else's (barring the legion of inferior imitators who subsequently copied his style and "swiped" his luscious female figures), but he also wasn't afraid to experiment with his page layouts and odd panel shapes if it served his dynamic storytelling.

All of Baker's 22 "Canteen Kate" stories featured in this volume were originally done for St. John Publishing, where Baker worked exclusively from 1952 until 1954. The company ran into financial trouble due to the crash of the 3-D craze, in which publisher Archer St. John had invested heavily. After 1954, Baker was no longer exclusive to St. John but continued to freelance there until 1955. The last Baker cover for St. John appeared on Secrets of True Love #1, cover-dated February 1958, but it was obviously an inventory job from the 1954–55 period that had remained unpublished. Baker's "Sky Girl" (aka Ginger Maguire), which Baker had done for Fiction House's Jumbo Comics anthology, can be seen as a prototype for Canteen Kate. One of the notable things about Canteen Kate is her costume. She was invariably shown in olive drab uniform shorts with her blouse unbuttoned halfway down the front to display her cleavage. Her nickname derives from the fact that she runs the canteen for the Marines, a sort of diner and enlisted men's club where they hung out when off duty.

In these stories, the Cold War atmosphere is minimal, even though they were published and set during the Korean War. The stories are all light-hearted, humorous romps, even though the Chinese Army makes occasional appearances. Really, they're just typical service comedies, though focused on the eponymous, beautiful heroine, whose sidekicks are her enlisted Marine pals, a bad-tempered sergeant, and an infrequently used Korean boy nicknamed Small Change, who is the Marines' mascot. The stories always focus on the humorous scrapes Kate and her pals get into on base and not on the horrors of war. If you took away the uniforms and the Korean War setting, the hijinks in the "Canteen Kate" plots could easily be transposed into an Archie Comic. It's too bad Baker never worked on any of the Archie titles—Betty and Veronica could've been even sexier than Bob Montana or Dan DeCarlo ever drew them.

The "Canteen Kate" stories first appeared in *Fightin' Marines* #15 then continued to appear in subsequent issues of that series and three issues of her own title, with a final "Canteen Kate" story appearing in the one-off *Anchors Andrews* in 1953. After St. John sold the rights to *Fightin' Marines* to Charlton, "Canteen Kate" reprint stories appeared in the Charlton issues #14–16. The book that you are holding in your hand represents the first time that all of these stories have been collected in a single volume.

By the mid-1950s, as comic book companies were folding up their tents due to slumping sales and censorship pressure from the newly established Comics Code Authority, Baker had fewer and fewer outlets for his comic book work, and finally realized his early dream of becoming a magazine illustrator, though more out of financial necessity than anything else. While breaking into the field of magazine illustration on titles like *Nugget*, Baker took on shorter-length, lower-paying western and romance comics stories for the publishers Atlas, Charlton, and Harvey. In the 1954–56 period, he also managed to get work from Quality Comics before that company, too, gave up the ghost, thereafter selling off many of their characters and titles to DC Comics.

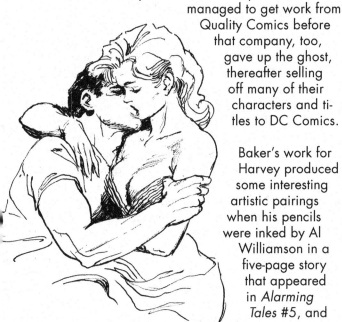

Baker's work for Harvey produced some interesting artistic pairings when his pencils were inked by Al Williamson in a five-page story that appeared in *Alarming Tales* #5, and

Williamson's fellow "Fleagle Gang" member Angelo Torres did some very nice inking over Baker's pencils for three romance stories drawn in 1958. Interestingly, only two of the jobs inked by Torres were published during that period; the final one did not see print until 1962, several years after Baker's death. Because so little was known about Baker for many years, there was a fair amount of misinformation circulating about him, which wasn't helped by inker Vince Colletta's incorrect assertion to comics historian Ron Goulart that Baker died in 1962. Baker's family has since confirmed that he passed away in 1959, at the age of 37, done in by a heart weakened by a childhood bout of rheumatic fever (Baker probably didn't help his heart problems by smoking cigarettes, either).

In spite of an abbreviated career, Baker managed to be very prolific. What makes it difficult for comics historians like Jim Vadeboncoeur and others to nail down a definitive list of Baker's work is that he was rarely allowed to sign his art, though his signature can be seen on some of his later cover work, especially those done for St. John (about half of which are signed). It wasn't racial discrimination that kept Baker from signing his work; unlike newspaper cartoonists, it simply was not common practice for comic book artists to sign their work until the early 1960s. By contrast, some of the newspaper cartoonists, such as Alex Raymond, Milton Caniff, and E.C. Segar, were heavily promoted by their syndicates and became wealthy, pop culture superstars. In terms of giving credit where it was due, EC Comics was one of the period's few exceptions, allowing the artists to sign their covers and stories, even going as far as to promote their stable of artists by running biographies of them in all of its titles. In another case of a missed opportunity that left comics fans poorer, it's really too bad Baker never worked for EC alongside his old colleagues Jack Kamen and Al Feldstein. It's tantalizing to consider what Baker would have done with EC Comics' more adult scripts, which routinely featured murderous beauties and exotic alien women.

Nugget *magazine #1 (Flying Eagle, 1955)*

A further factor that makes it hard to definitively identify Baker's work is just how good he was. Everywhere Baker worked—Fox Features, the Jerry Iger shop, St. John Publishing—he was the star artist, which meant that other artists looked at his work and copied his figures, especially his gorgeous women. At the Iger shop especially, owner Jerry Iger actively encouraged other artists to copy Baker's style. Some artists obviously swiped Baker's graceful figures, and Iger added to the confusion by sometimes repackaging old Baker stories with altered art and rewritten scripts. Furthermore, the way comics were produced in the Iger shop, often assembly-line style, confounds efforts to positively identify Baker's comics. Sometimes multiple artists would pencil different pages in a story, with a single inker imposing a unified "house" style on the finished art.

Identifying Baker's work becomes less problematic for comics scholars after 1948, when he left the Iger shop to work for Fiction House. While at Fiction House, he drew the "Camilla" strip in *Jungle Comics* and "Mysta of the Moon" in *Planet Comics*. Baker did the "Camilla" strip through 1949, and may have contributed layouts to some of the later stories. He did "Mysta of the Moon" in issues #53–59 (1948–49), with inks provided by friend and frequent Baker collaborator Roy Osrin. Fiction House colleague Bob Lubbers remembered Baker as a friendly man with a good sense of humor.

Approved Comics #12 (St. John, 1954)

In the hectic, anything-goes period following World War II, the numerous comic book companies of the day kept the talented Baker as busy as he wanted to be, allowing Baker to live far better than most African Americans of the day. He used this money to support his family and purchase all the fine clothes he wanted (he was known for his sartorial flair). Baker eventually bought a canary yellow Oldsmobile 88 with a red leather interior, becoming one of the first members of his family to own a car, or learn to drive, for that matter. Family members like his half-brother Fred Robinson and Matt's nephew Matt D. Baker (the son of Matt's brother, Robert) recalled in *Matt Baker: The Art of Glamour* (TwoMorrows, 2013) that Matt adored his mother and doted on her, providing her with whatever his considerable cartooning income could afford, eventually buying a house for her. He was generous with other family members as well, allowing his nephew to live in his New York apartment, rent-free for over a year, even though much of his cartooning income had unfortunately dried up by that time.

Authentic Police Cases #3 (St. John, 1954)

His half-brother and his nephew both noted that Matt was generous to a fault. Fred Robinson, who was younger than Matt and his older brother John, idolized his older siblings and sought to be like them. As Robinson recalled in a 2004 interview conducted by comics historian Jim Amash, "Both (Matt) and John were born more or less with pencils in their hands. They always drew, from the time that they were little boys right up to their deaths." Friends like Frank Giusto confirm that Matt Baker was in love with drawing. Even though he spent hours at the drawing board, churning out bevies of well-endowed beauties for comic book covers and interior pages, in his rare free time, he would draw for his own amusement, even sending his friend Giusto heavily illustrated envelopes and letters while he was away in the Navy during World War II. In the same interview, Robinson went on to tell Amash, "Matt and John inspired me. I wanted to be like my big brothers." Robinson did, indeed, emulate his older brothers' drawing talent, going on to a long career as a commercial artist and art director (though he never drew comics). Nephew Matt D. Baker also told Amash, "I can remember that even during the year that I lived with him, comics were on the decline, but he would still get three or four stories at a time to draw. I'm sure that he got even more comics work back in the '40s, probably as much as he had time to do. He was able to turn things out so fast that he was in big demand."

Although his time on Earth was far too brief, Matt Baker left behind an amazing legacy of beautiful and influential artwork that is only now starting to be acknowledged properly. His artistic success is all the more remarkable when you consider that Baker was working in an industry that was dominated by white men, with relatively few women or minorities working in it. But as Fred Robinson noted, "The reason that Matt got so much work wasn't because he was black or white; he got it because he was good. It's as simple as that. If you're good, and you have what people want, they're going to use you…Other artists' women were like mannequins: they were all perfect and smooth, but they had no soul to them. But the women that Matt did created a fire within you, within your imagination…I think the 'Matt Baker woman' struck such a responsive chord because she was beautiful and strong." Baker's small army of fans is fortunate that he was around to share his vision with us. There will be more to come in future Picture This Press volumes of *The Lost Art of Matt Baker*. Stay tuned, Baker fans…the best is yet to come!

—*Steven Ringgenberg*

*Steven Ringgenberg thanks Jon B. Cooke, John Morrow, and his publisher Joe Procopio for their gracious assistance with his research for this article. His primary source was TwoMorrows' Matt Baker: The Art of Glamour, which is the most definitive book on this talented artist to date, and as such, is highly recommended to our readers.*

*S.C. "Steve" Ringgenberg has been a freelance writer for more than 30 years, interviewing over 200 people in comics, film, and other areas of interest. He has written comics scripts and articles for DC, Marvel, Bongo Comics, Heavy Metal, and Dark Horse, authored six young adult mystery novels for Simon & Schuster, and co-wrote the book Al Williamson: Hidden Lands. For more than a dozen years he wrote the "Dossier" column for Heavy Metal magazine. Currently, he is writing biographies of the EC Comics artists for Fantagraphics, and his first short story collection, Zombie Gundown and Other Tales, will be published in the fall of 2013. When not writing, he likes to read comics, listen to the blues, attend the Burning Man festival, travel the world, and plot global domination.*

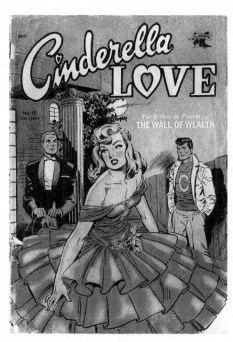

Cinderella Love #15 (St. John, 1954)

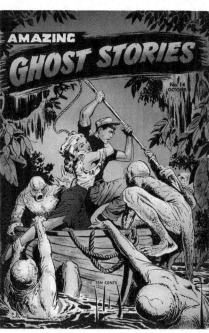

Amazing Ghost Stories #14 (St. John, 1954)

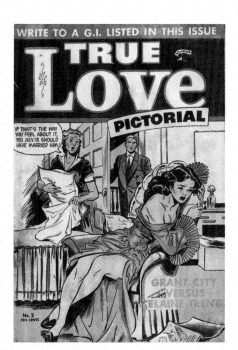

True Love Pictorial #2 (St. John, 1953)

# The Complete
# "Canteen Kate"

When the 'BOMBSHELL FROM BROOKLYN' LANDED IN JAPAN THE FUR STARTED FLYING! G.I.'S AND C.O.'S ALIKE AGREED THAT AN ENEMY BARRAGE COULDN'T STIR UP AS MUCH FIRE AS CANTEEN KATE, BUT HER INGENUITY WITH A GREEN APPLE PIE WON THEIR HEARTS AND FORGIVENESS UNTIL ONE HOT DAY...

# Canteen Kate
## in "The BIG FREEZE"

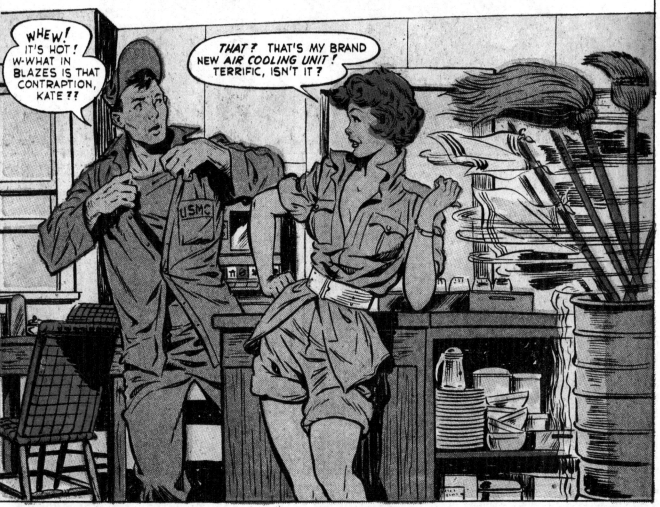

WHEW! IT'S HOT! W-WHAT IN BLAZES IS THAT CONTRAPTION, KATE??

THAT? THAT'S MY BRAND NEW AIR COOLING UNIT! TERRIFIC, ISN'T IT?

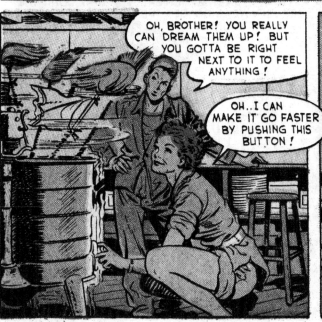

OH, BROTHER! YOU REALLY CAN DREAM THEM UP! BUT YOU GOTTA BE RIGHT NEXT TO IT TO FEEL ANYTHING!

OH.. I CAN MAKE IT GO FASTER BY PUSHING THIS BUTTON!

WOW! THAT'S WHAT I CALL A BREEZE!

THERE! SEE? AND IT WAS JUST AN OLD-FASHIONED WASHING MACHINE BEFORE I GOT MY HANDS ON IT!

THAT NIGHT...

WE SHOULDN'T BE DOIN' THIS!

STOP TALKING AND START DRIVING! IT'S TOO HOT TO ARGUE!

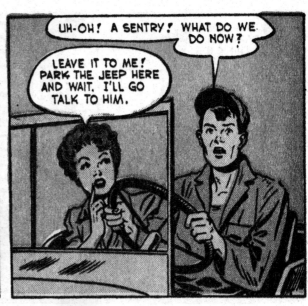

UH-OH! A SENTRY! WHAT DO WE DO NOW?

LEAVE IT TO ME! PARK THE JEEP HERE AND WAIT. I'LL GO TALK TO HIM.

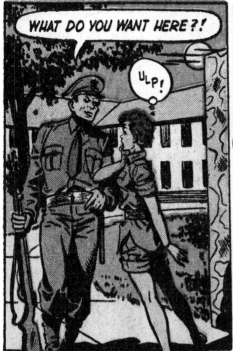

WHAT DO YOU WANT HERE?!

ULP!

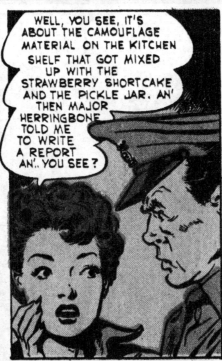

WELL, YOU SEE, IT'S ABOUT THE CAMOUFLAGE MATERIAL ON THE KITCHEN SHELF THAT GOT MIXED UP WITH THE STRAWBERRY SHORTCAKE AND THE PICKLE JAR. AN' THEN MAJOR HERRINGBONE TOLD ME TO WRITE A REPORT AN'.. YOU SEE?

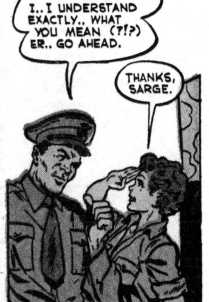

OH, YEAH.. YEAH! I.. I UNDERSTAND EXACTLY.. WHAT YOU MEAN (?!?) ER.. GO AHEAD.

THANKS, SARGE.

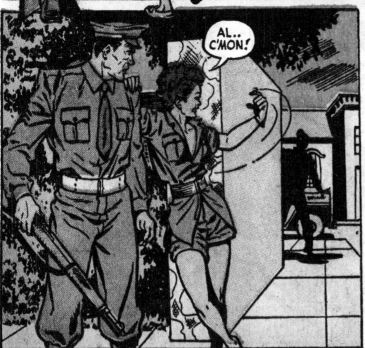

AL.. C'MON!

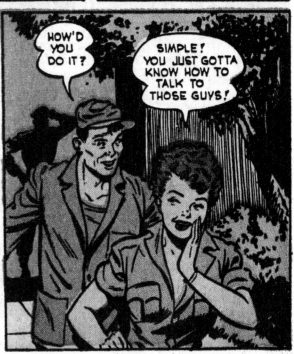

HOW'D YOU DO IT?

SIMPLE! YOU JUST GOTTA KNOW HOW TO TALK TO THOSE GUYS!

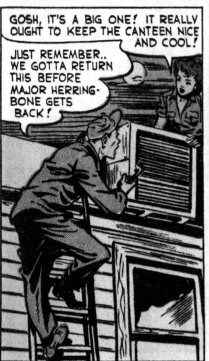

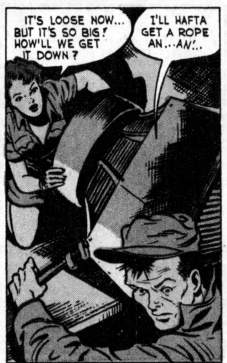

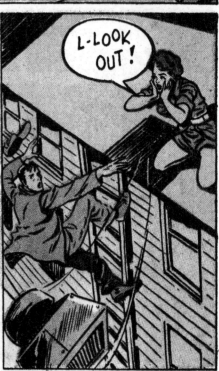

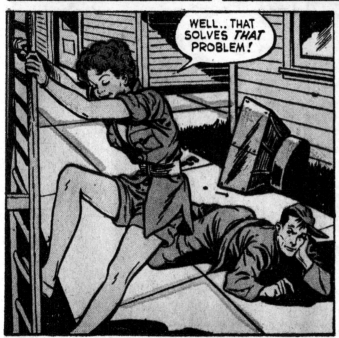

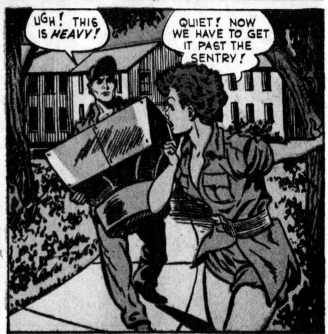

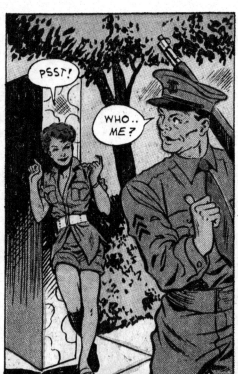

HOW'LL WE DO IT?

I'LL DISTRACT HIM.. AND YOU TAKE IT OUT TO THE JEEP! I'LL MEET YOU THERE.

PSST!

WHO.. ME?

A SHORT WHILE LATER...

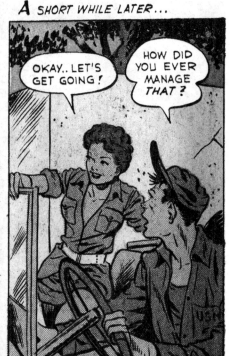

OKAY.. LET'S GET GOING!

HOW DID YOU EVER MANAGE THAT?

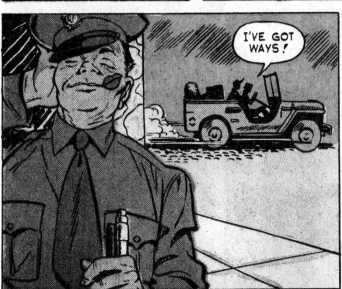

I'VE GOT WAYS!

LATER...

THERE.. IT'S IN! I HOPE IT'S A NICE, BREEZY, QUIET ONE!

YEAH.. IF NOISE OF THIS EVER GOT AROUND WE'D BE IN A PACK OF TROUBLE! WELL, YA MAY AS WELL PUSH THE BUTTON AN' START IT!

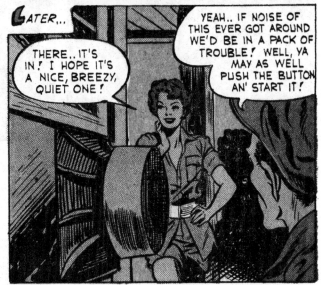

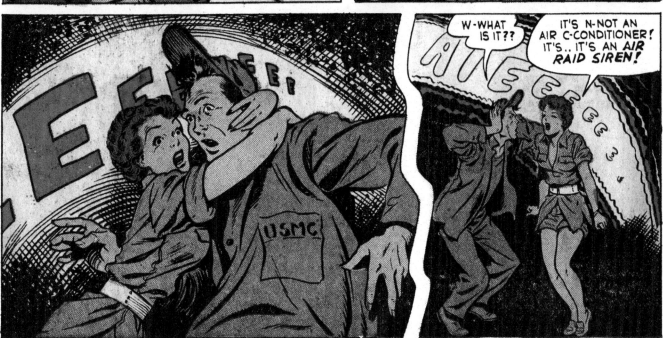

EEEE!

W-WHAT IS IT??

IT'S N-NOT AN AIR C-CONDITIONER! IT'S.. IT'S AN AIR RAID SIREN!

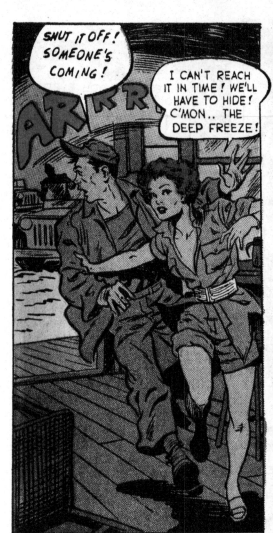

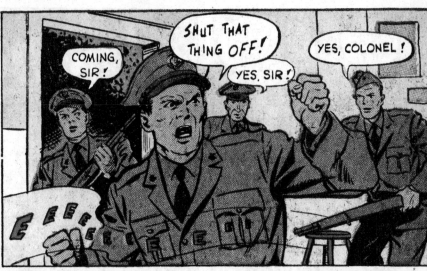

Matt Baker

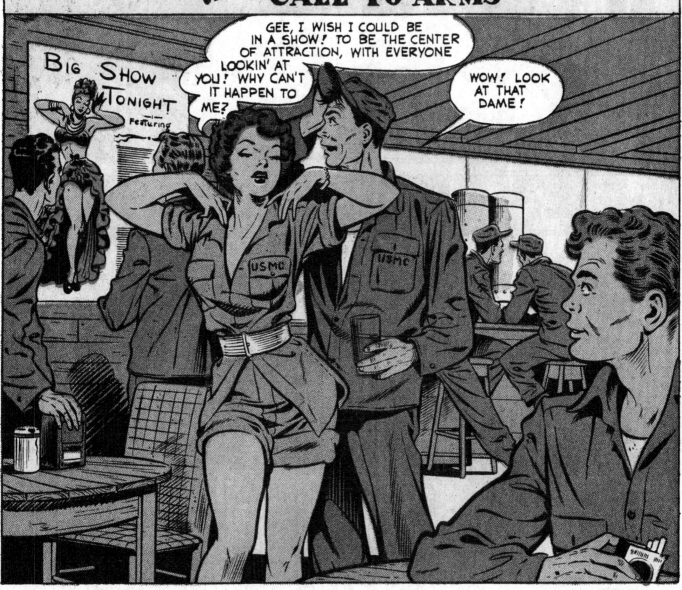

# Canteen Kate
## in "CALL TO ARMS"

BIG SHOW TONIGHT — featuring...

GEE, I WISH I COULD BE IN A SHOW! TO BE THE CENTER OF ATTRACTION, WITH EVERYONE LOOKIN' AT YOU! WHY CAN'T IT HAPPEN TO ME?

WOW! LOOK AT THAT DAME!

SAY, AL.. YOU HAVE A JEEP OUTSIDE, HAVEN'T YOU? I'VE GOT AN IDEA!

OH, NO! EVERY TIME YOU GET AN IDEA, I GET INTO TROUBLE!

I KNEW YOU'D HELP! I JUST WANT YOU TO DRIVE ME TO TH THEATRE. I'M GOING TO GET A PART IN THE SHOW!

A MAN'S ARMY.. HMPH!

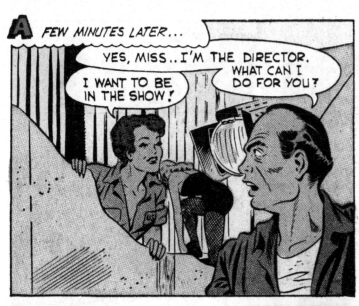

A FEW MINUTES LATER...

YES, MISS..I'M THE DIRECTOR. WHAT CAN I DO FOR YOU?

I WANT TO BE IN THE SHOW!

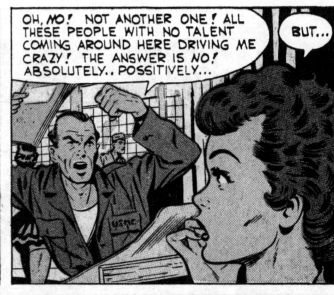

OH, NO! NOT ANOTHER ONE! ALL THESE PEOPLE WITH NO TALENT COMING AROUND HERE DRIVING ME CRAZY! THE ANSWER IS NO! ABSOLUTELY.. POSSITIVELY...

BUT...

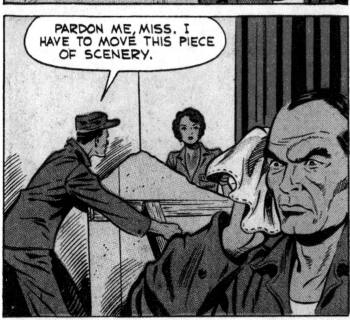

PARDON ME, MISS. I HAVE TO MOVE THIS PIECE OF SCENERY.

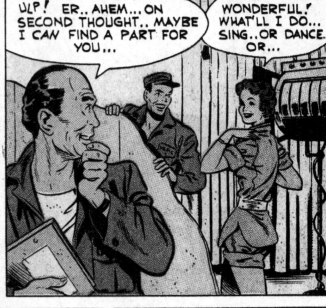

ULP! ER.. AHEM...ON SECOND THOUGHT.. MAYBE I CAN FIND A PART FOR YOU...

WONDERFUL! WHAT'LL I DO... SING..OR DANCE.. OR...

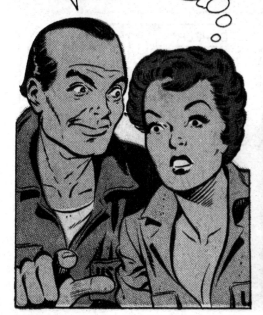

YOU'LL BE AN UNDERSTUDY TO DORIS REVERE. SHE'S OVER THERE.

GEE! SHE MUST BE THE STAR!

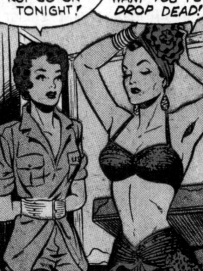

HELLO, MISS REVERE. I'M YOUR UNDER-STUDY...UH.. YOU DON'T LOOK VERY WELL. MAYBE YOU'D RATHER NOT GO ON TONIGHT!

I NEVER FELT BETTER IN MY LIFE! UNDER-STUDIES ARE ALL ALIKE! THEY'RE VERY NICE..BUT THEY ALWAYS WANT YOU TO DROP DEAD!

I CAN'T MISS MY PERFORM-ANCE. I MUSTN'T DISAPPOINT MY PUBLIC, YOU KNOW! THERE MIGHT EVEN BE A GENERAL IN THE AUDIENCE! I'VE NEVER HAD A DATE WITH A GENERAL!

A DATE WITH A GENERAL? OH, I CAN GET A GENERAL FOR YOU ANY TIME.

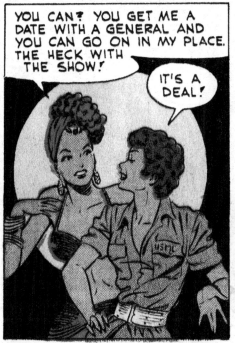

YOU CAN? YOU GET ME A DATE WITH A GENERAL AND YOU CAN GO ON IN MY PLACE. THE HECK WITH THE SHOW!

IT'S A DEAL!

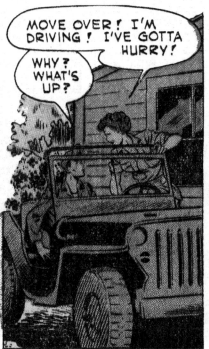

MOVE OVER! I'M DRIVING! I'VE GOTTA HURRY!

WHY? WHAT'S UP?

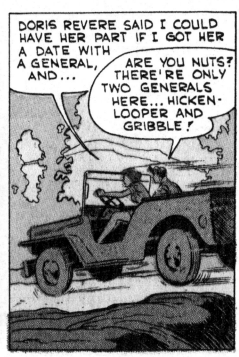

DORIS REVERE SAID I COULD HAVE HER PART IF I GOT HER A DATE WITH A GENERAL, AND...

ARE YOU NUTS? THERE'RE ONLY TWO GENERALS HERE... HICKEN-LOOPER AND GRIBBLE!

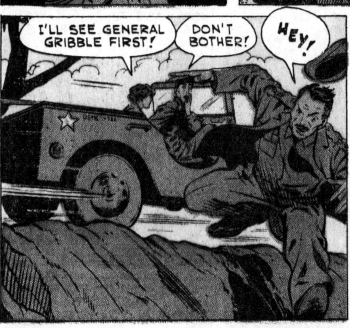

I'LL SEE GENERAL GRIBBLE FIRST!

DON'T BOTHER!

HEY!

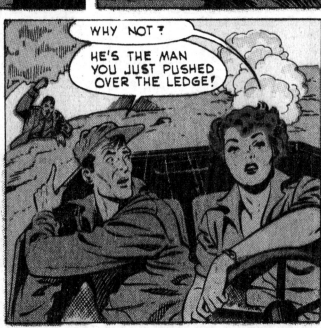

WHY NOT?

HE'S THE MAN YOU JUST PUSHED OVER THE LEDGE!

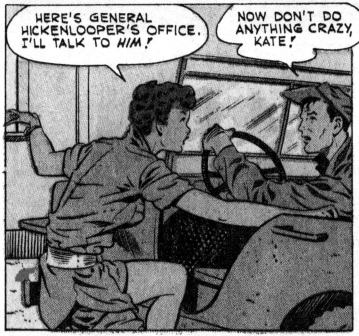

HERE'S GENERAL HICKENLOOPER'S OFFICE. I'LL TALK TO HIM!

NOW DON'T DO ANYTHING CRAZY, KATE!

UMMM... THAT MUST BE HIS SEC-RETARY!

AND WHY DO YOU WANT TO SEE GENERAL HICKENLOOPER?

WELL.. I GUESS I CAN TELL *YOU!* I CAN ARRANGE A DATE FOR HIM TONIGHT WITH A BEAUTIFUL BRUNETTE FROM THE SHOW!

YOUNG LADY! HOW DARE YOU! DO YOU KNOW WHO I AM?

NO.. I DON'T...

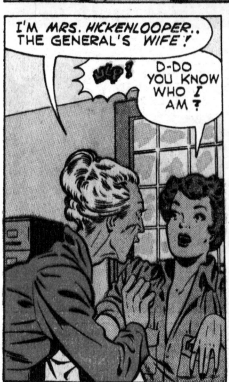

I'M *MRS. HICKENLOOPER..* THE GENERAL'S *WIFE!*

ULP!

D-DO YOU KNOW WHO *I* AM?

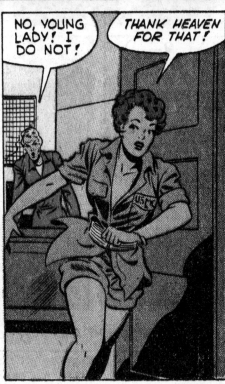

NO, YOUNG LADY! I DO NOT!

THANK HEAVEN FOR THAT!

*LATER THAT EVENING...*

HOW WAS I TO KNOW THE GENERAL'S WIFE WAS WAITING FOR HIM! NOW I'M ALL OUT OF GENERALS AND THE SHOW WILL BE ON SOON!

I WISH THAT GUY WOULD KEEP QUIET

WAITRESS!

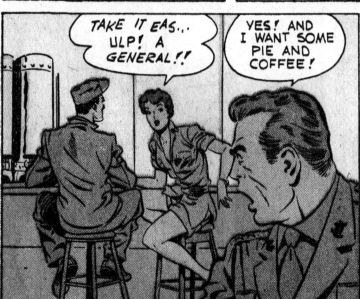

TAKE IT EAS.. ULP! A GENERAL!!

YES! AND I WANT SOME PIE AND COFFEE!

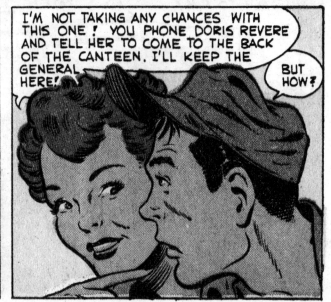

I'M NOT TAKING ANY CHANCES WITH THIS ONE! YOU PHONE DORIS REVERE AND TELL HER TO COME TO THE BACK OF THE CANTEEN. I'LL KEEP THE GENERAL HERE!

BUT HOW?

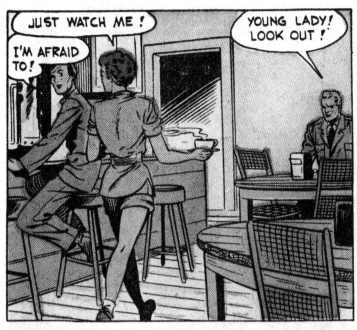

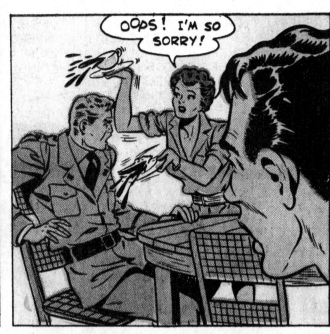

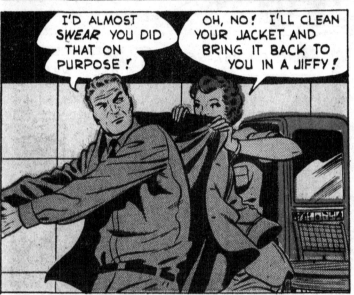

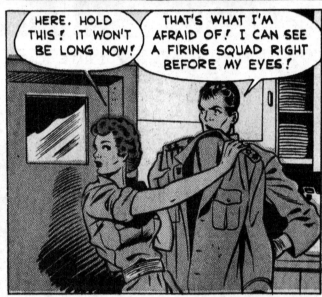

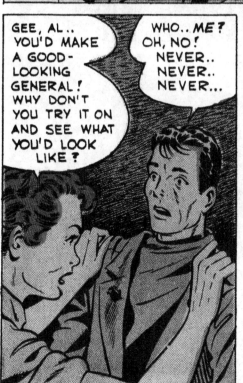

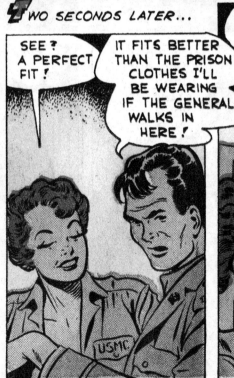

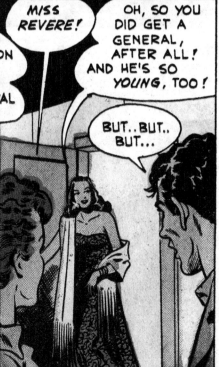

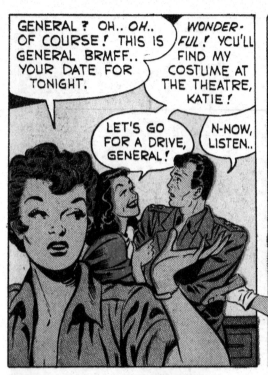

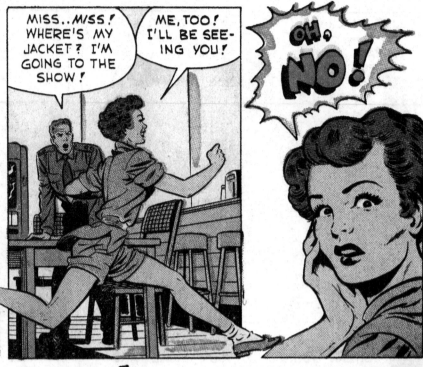

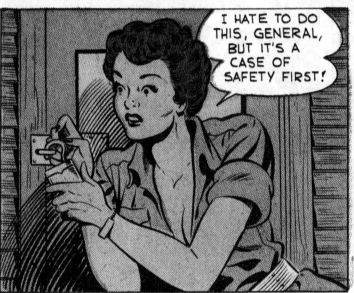

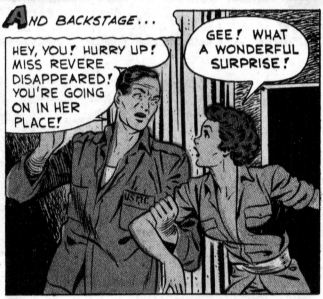

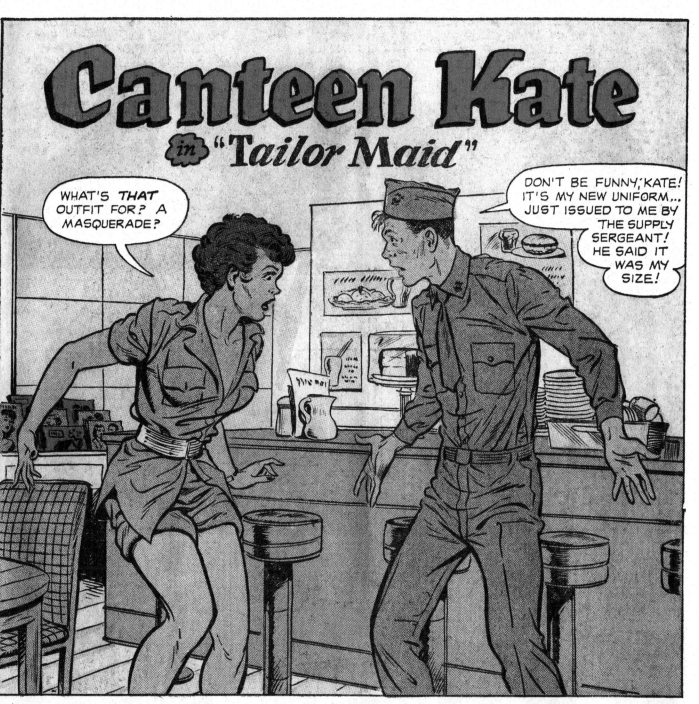

# Canteen Kate
## in "Tailor Maid"

WHAT'S *THAT* OUTFIT FOR? A MASQUERADE?

DON'T BE FUNNY, KATE! IT'S MY NEW UNIFORM... JUST ISSUED TO ME BY THE SUPPLY SERGEANT! HE SAID IT WAS MY SIZE!

THEY ONLY SEEM TO HAVE *TWO* SIZES AROUND HERE... *TOO BIG* AND *TOO SMALL!* YOU TAKE THAT RIGHT BACK AND EXCHANGE IT!

NUTHIN' DOIN'! YOU DON'T KNOW THE SUPPLY SERGEANT!

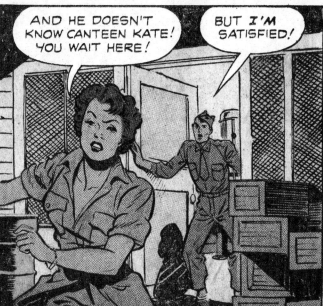

AND HE DOESN'T KNOW CANTEEN KATE! YOU WAIT HERE!

BUT *I'M* SATISFIED!

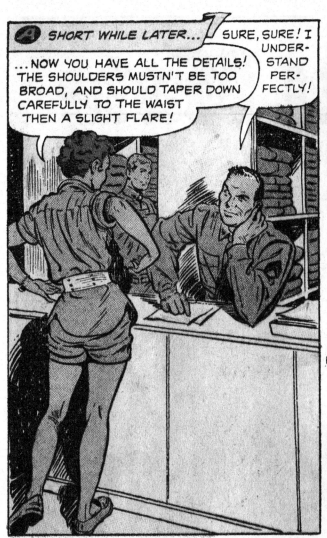

...NOW YOU HAVE ALL THE DETAILS! THE SHOULDERS MUSTN'T BE TOO BROAD, AND SHOULD TAPER DOWN CAREFULLY TO THE WAIST THEN A SLIGHT FLARE!

SURE, SURE! I UNDERSTAND PERFECTLY!

HEY, MAC! A *BIG* ONE FOR THE LADY!

WISE GUY!

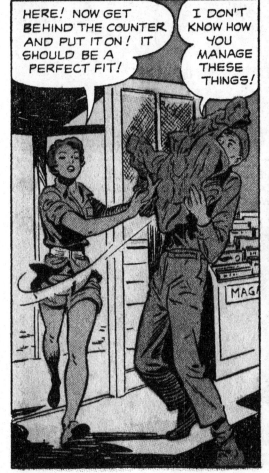

HERE! NOW GET BEHIND THE COUNTER AND PUT IT ON! IT SHOULD BE A PERFECT FIT!

I DON'T KNOW HOW YOU MANAGE THESE THINGS!

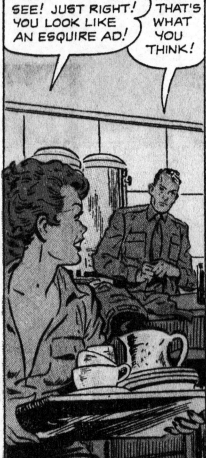

SEE! JUST RIGHT! YOU LOOK LIKE AN ESQUIRE AD!

THAT'S WHAT YOU THINK!

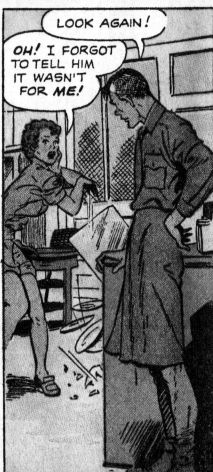

LOOK AGAIN!

*OH!* I FORGOT TO TELL HIM IT WASN'T FOR *ME!*

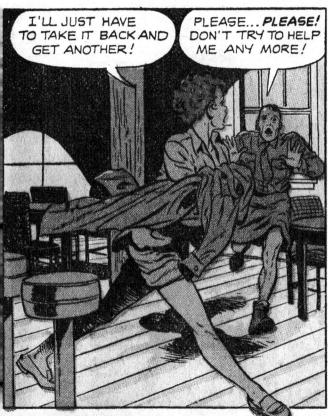

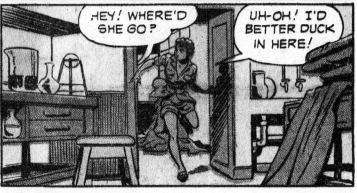

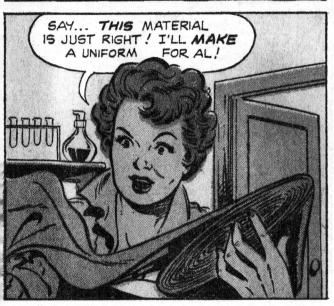

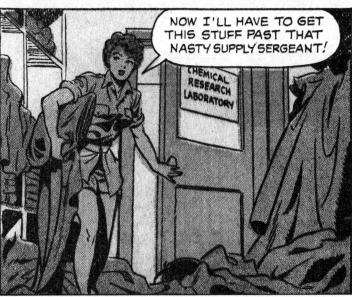

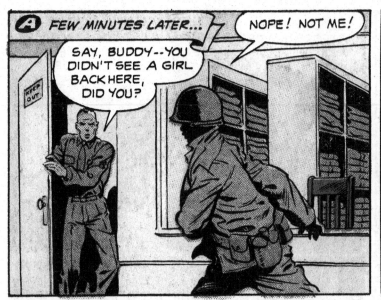

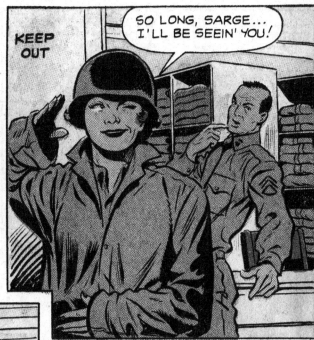

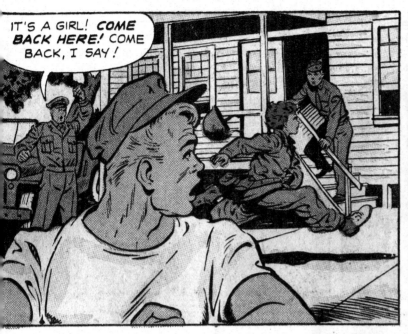

IT'S A GIRL! *COME BACK HERE!* COME BACK, I SAY!

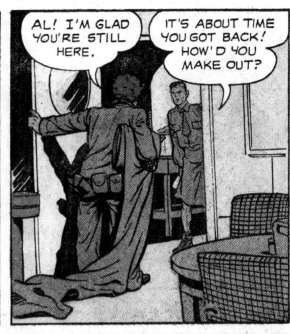

AL! I'M GLAD YOU'RE STILL HERE.

IT'S ABOUT TIME YOU GOT BACK! HOW'D YOU MAKE OUT?

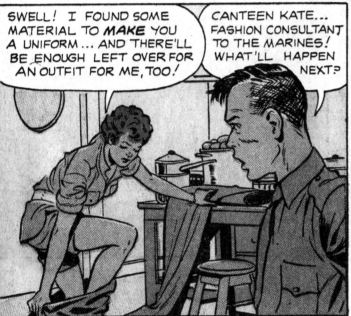

SWELL! I FOUND SOME MATERIAL TO *MAKE* YOU A UNIFORM... AND THERE'LL BE ENOUGH LEFT OVER FOR AN OUTFIT FOR ME, TOO!

CANTEEN KATE... FASHION CONSULTANT TO THE MARINES! WHAT'LL HAPPEN NEXT?

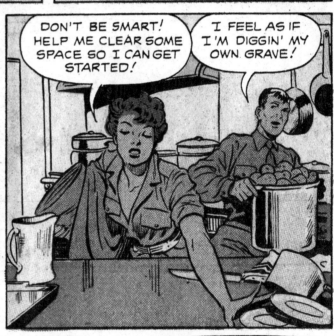

DON'T BE SMART! HELP ME CLEAR SOME SPACE SO I CAN GET STARTED!

I FEEL AS IF I'M DIGGIN' MY OWN GRAVE!

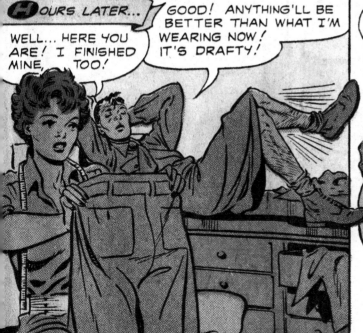

*H*OURS LATER...

WELL... HERE YOU ARE! I FINISHED MINE, TOO!

GOOD! ANYTHING'LL BE BETTER THAN WHAT I'M WEARING NOW! IT'S DRAFTY!

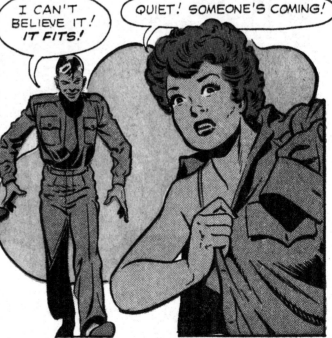

I CAN'T BELIEVE IT! *IT FITS!*

QUIET! SOMEONE'S COMING!

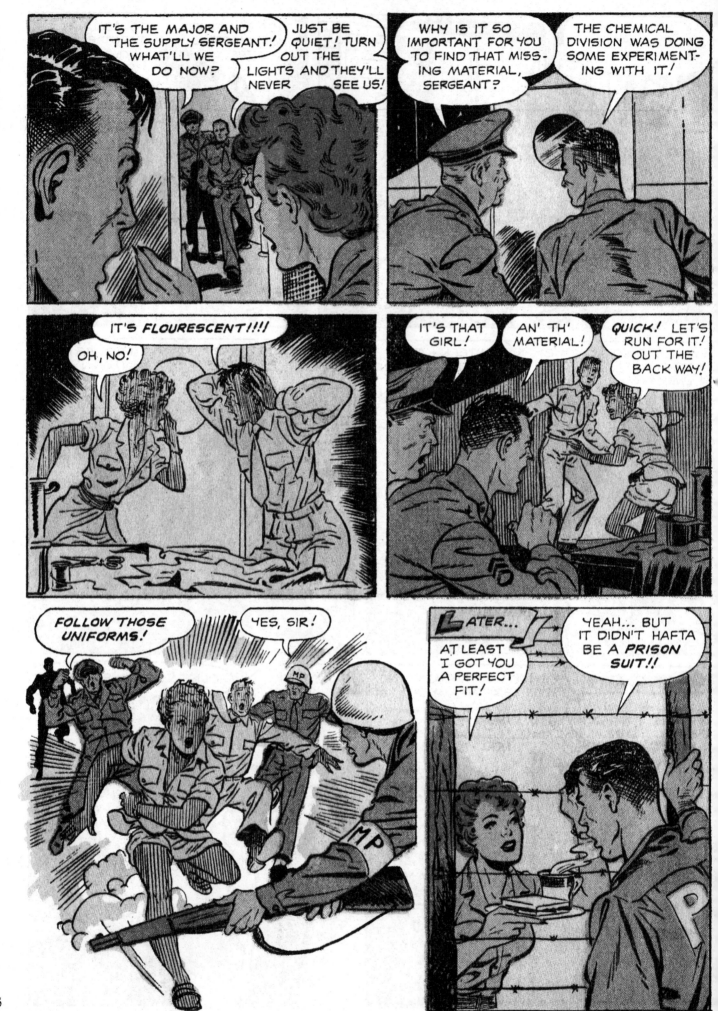

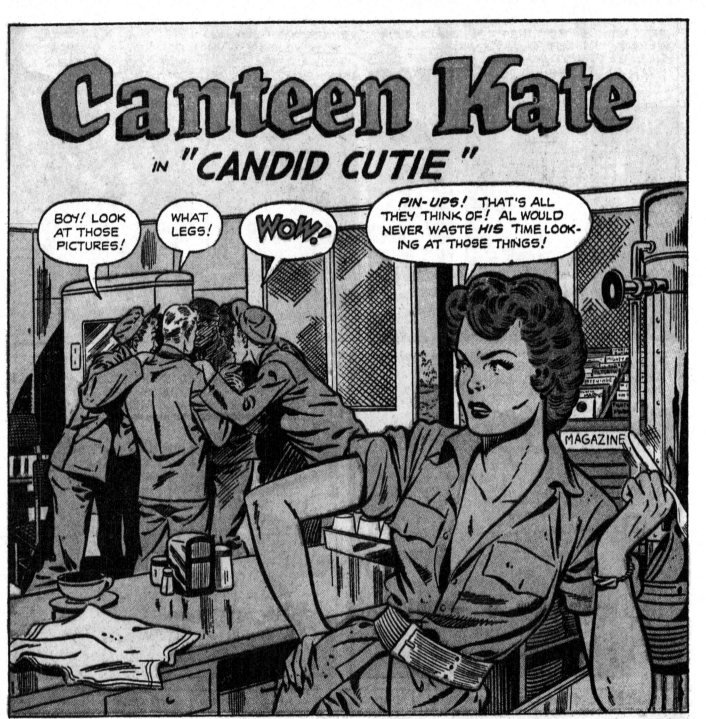

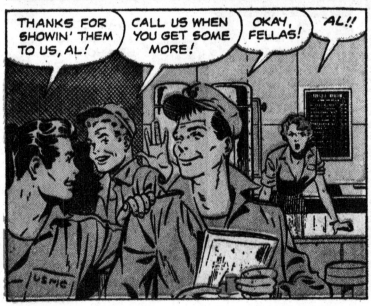

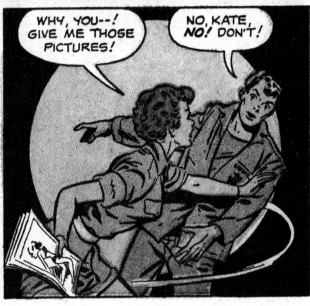

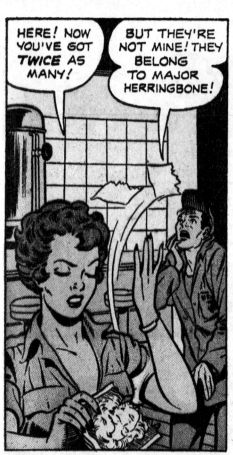

HERE! NOW YOU'VE GOT *TWICE* AS MANY!

BUT THEY'RE NOT MINE! THEY BELONG TO MAJOR HERRINGBONE!

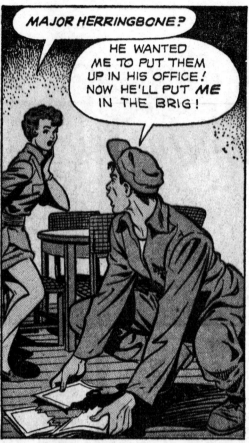

MAJOR HERRINGBONE?

HE WANTED ME TO PUT THEM UP IN HIS OFFICE! NOW HE'LL PUT *ME* IN THE BRIG!

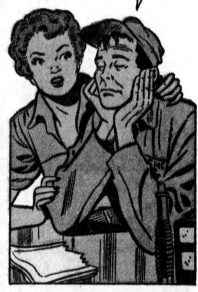

DON'T YOU WORRY ABOUT A THING! I HAVE AN IDEA!

IN THAT CASE...I MIGHT AS WELL SAVE TIME AN' GO TO THE BRIG RIGHT NOW!

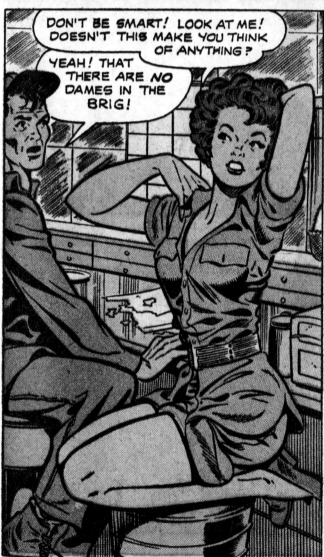

DON'T BE SMART! LOOK AT ME! DOESN'T THIS MAKE YOU THINK OF ANYTHING?

YEAH! THAT THERE ARE *NO* DAMES IN THE BRIG!

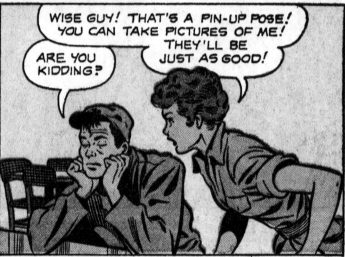

WISE GUY! THAT'S A PIN-UP POSE! YOU CAN TAKE PICTURES OF ME! THEY'LL BE JUST AS GOOD!

ARE YOU KIDDING?

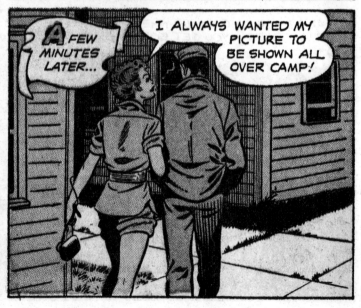

A FEW MINUTES LATER...

I ALWAYS WANTED MY PICTURE TO BE SHOWN ALL OVER CAMP!

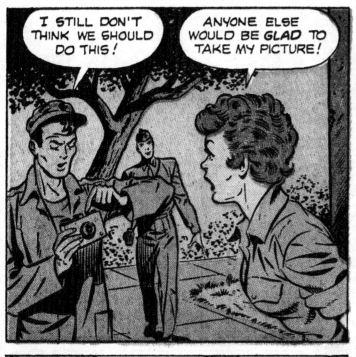

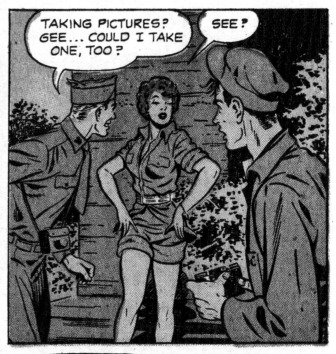

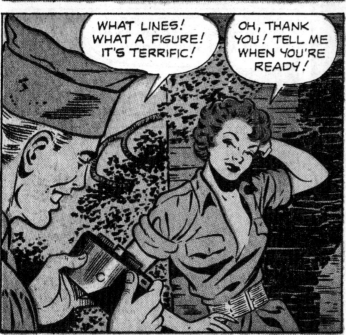

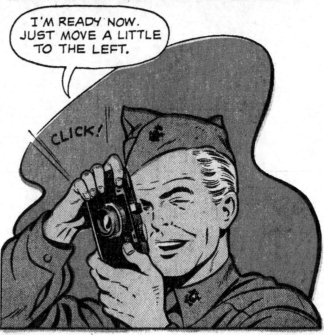

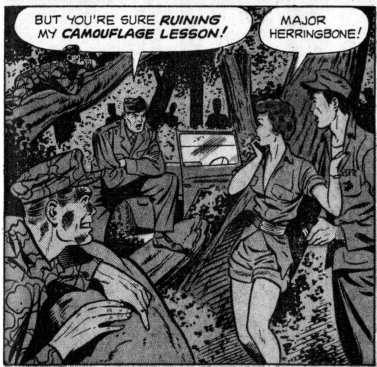

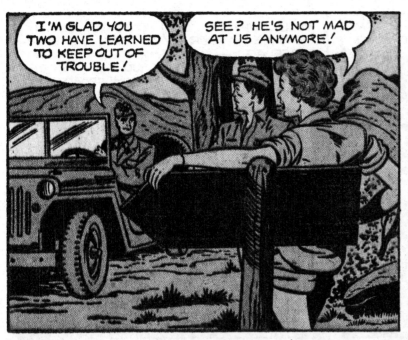

I'M GLAD YOU TWO HAVE LEARNED TO KEEP OUT OF TROUBLE!

SEE? HE'S NOT MAD AT US ANYMORE!

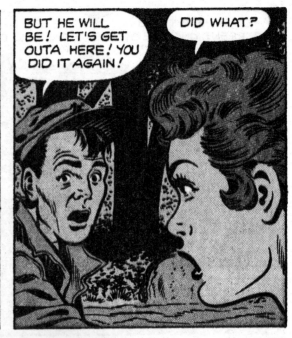

BUT HE WILL BE! LET'S GET OUTA HERE! YOU DID IT AGAIN!

DID WHAT?

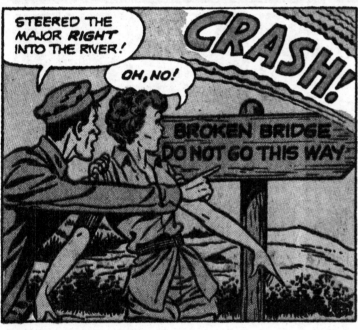

STEERED THE MAJOR *RIGHT* INTO THE RIVER!

OH, NO!

CRASH!

BROKEN BRIDGE DO NOT GO THIS WAY

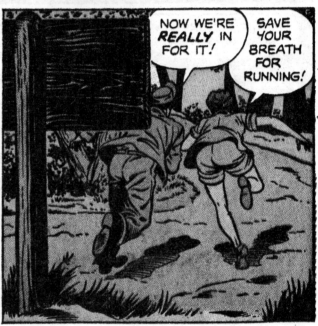

NOW WE'RE *REALLY* IN FOR IT!

SAVE YOUR BREATH FOR RUNNING!

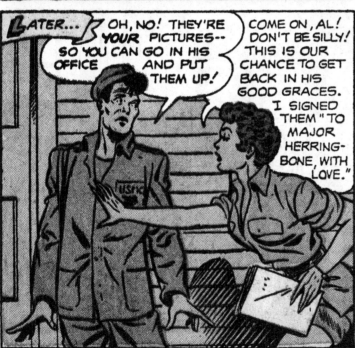

LATER... OH, NO! THEY'RE *YOUR* PICTURES-- SO YOU CAN GO IN HIS OFFICE AND PUT THEM UP!

COME ON, AL! DON'T BE SILLY! THIS IS OUR CHANCE TO GET BACK IN HIS GOOD GRACES. I SIGNED THEM "TO MAJOR HERRING-BONE, WITH LOVE."

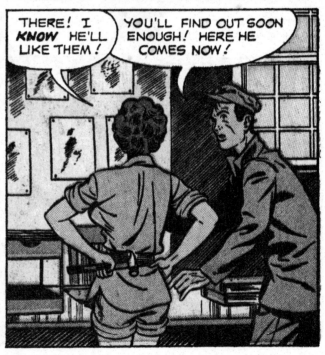

THERE! I *KNOW* HE'LL LIKE THEM!

YOU'LL FIND OUT SOON ENOUGH! HERE HE COMES NOW!

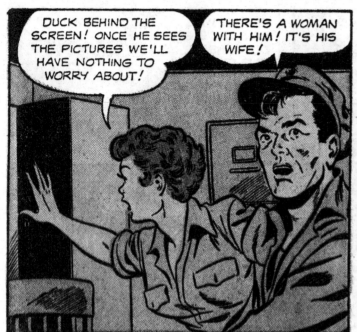

DUCK BEHIND THE SCREEN! ONCE HE SEES THE PICTURES WE'LL HAVE NOTHING TO WORRY ABOUT!

THERE'S A WOMAN WITH HIM! IT'S HIS WIFE!

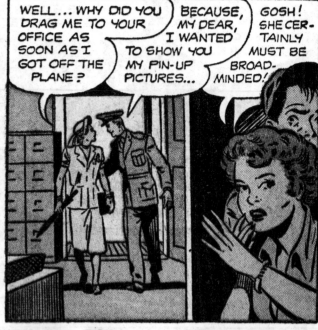

WELL... WHY DID YOU DRAG ME TO YOUR OFFICE AS SOON AS I GOT OFF THE PLANE?

BECAUSE, MY DEAR, I WANTED TO SHOW YOU MY PIN-UP PICTURES...

GOSH! SHE CERTAINLY MUST BE BROADMINDED!

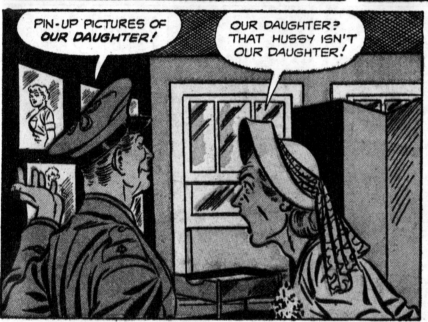

PIN-UP PICTURES OF OUR DAUGHTER!

OUR DAUGHTER? THAT HUSSY ISN'T OUR DAUGHTER!

OH, NO!

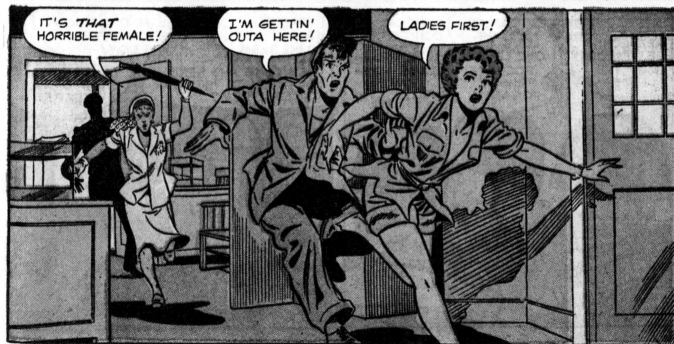

IT'S THAT HORRIBLE FEMALE!

I'M GETTIN' OUTA HERE!

LADIES FIRST!

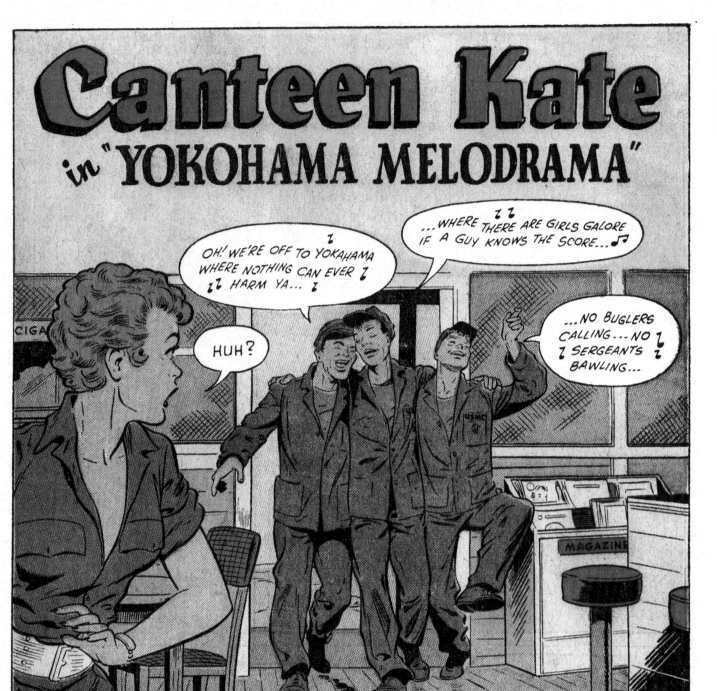

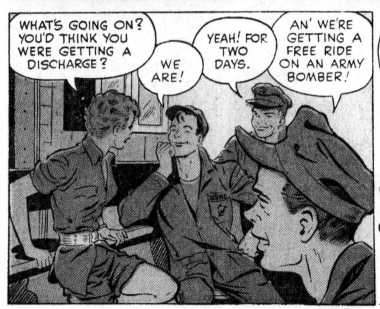

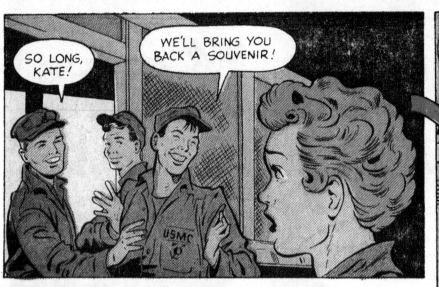

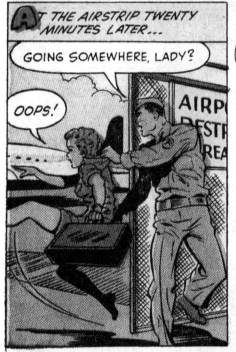

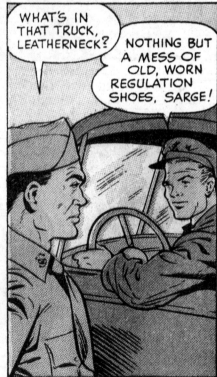

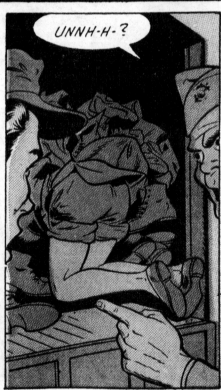

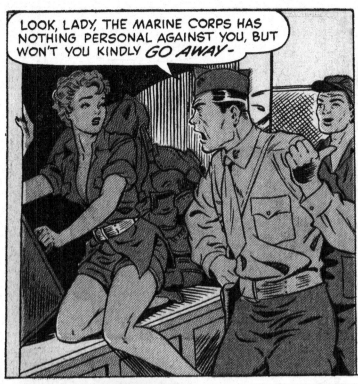

LOOK, LADY, THE MARINE CORPS HAS NOTHING PERSONAL AGAINST YOU, BUT WON'T YOU KINDLY *GO AWAY*-

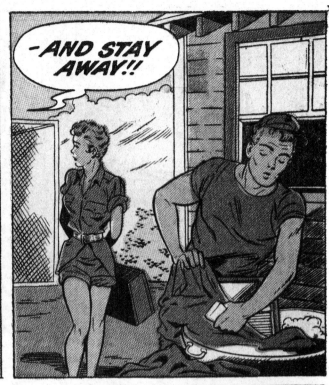

-AND STAY AWAY!!

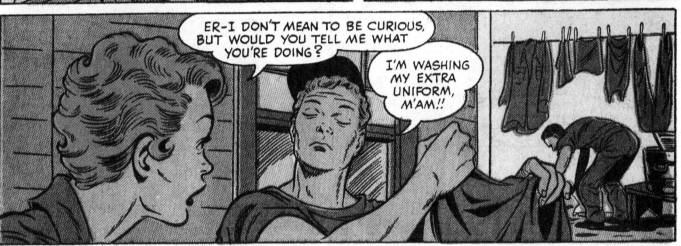

ER-I DON'T MEAN TO BE CURIOUS, BUT WOULD YOU TELL ME WHAT YOU'RE DOING?

I'M WASHING MY EXTRA UNIFORM, M'AM!!

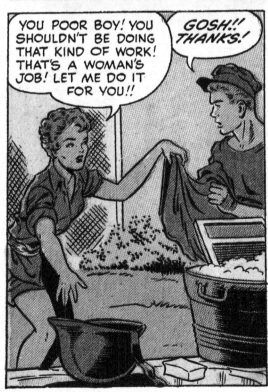

YOU POOR BOY! YOU SHOULDN'T BE DOING THAT KIND OF WORK! THAT'S A WOMAN'S JOB! LET ME DO IT FOR YOU!!

GOSH!! THANKS!

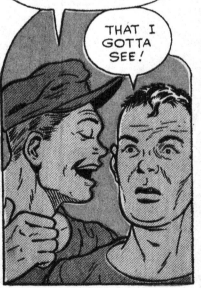

BOY!! WHAT A BREAK!! THIS BEAUTIFUL DOLL WALKS UP TO ME AN' SAYS, MISTER, MAY I WASH YOUR UNIFORM!!

THAT I GOTTA SEE!

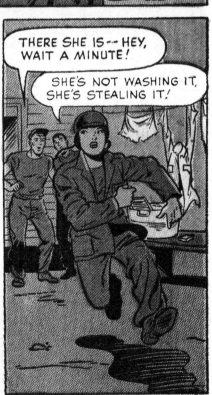

THERE SHE IS-- HEY, WAIT A MINUTE!

SHE'S NOT WASHING IT, SHE'S STEALING IT!

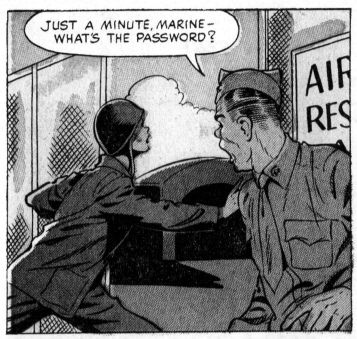

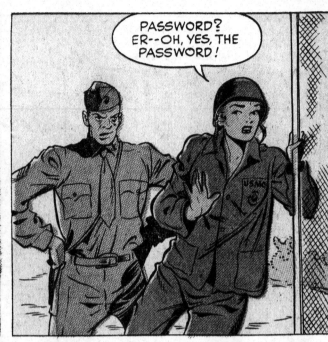

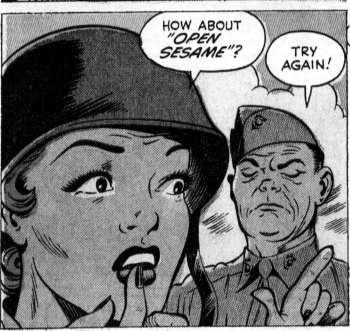

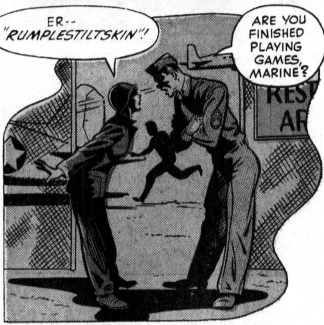

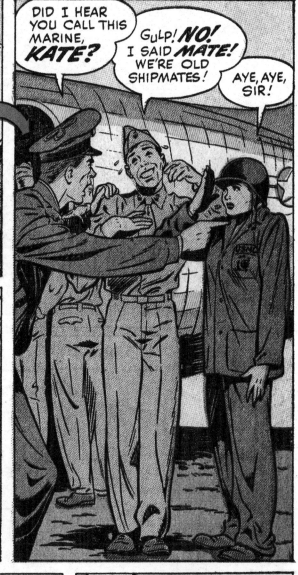

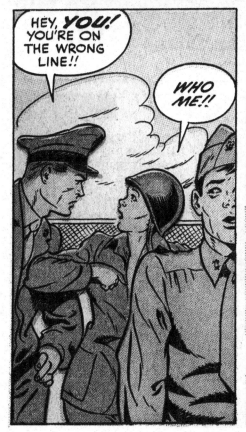

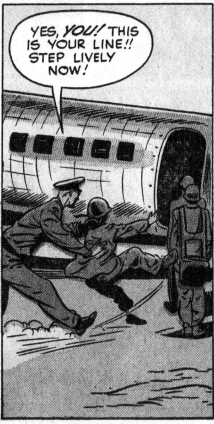

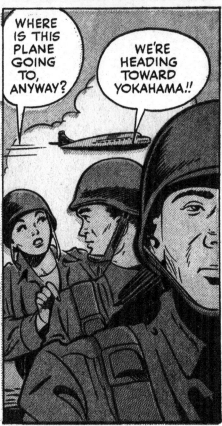

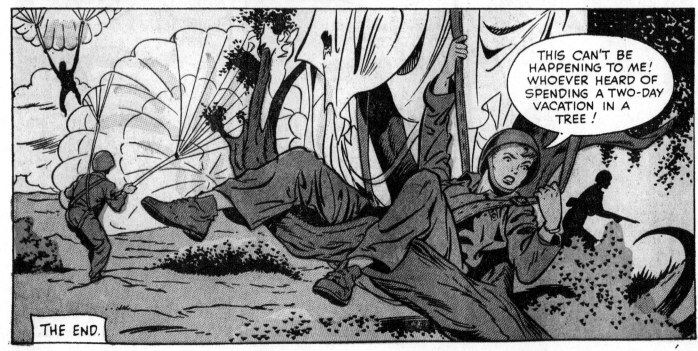

# Canteen Kate in "Sleepy-Time Girl"

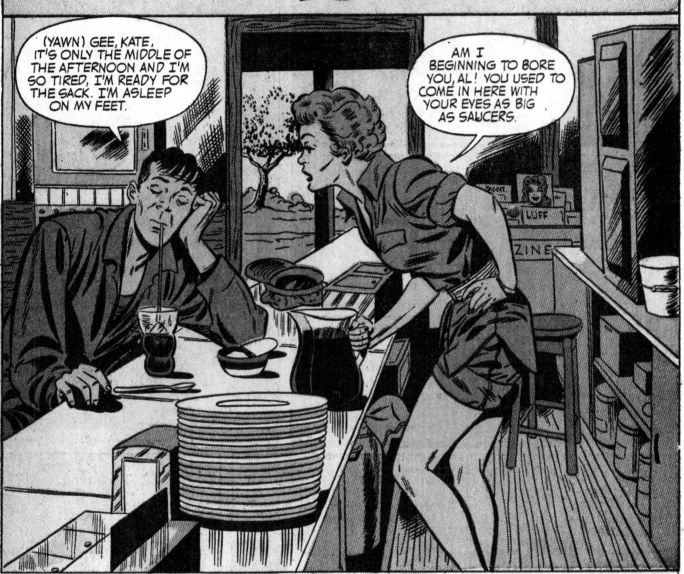

(YAWN) GEE, KATE, IT'S ONLY THE MIDDLE OF THE AFTERNOON AND I'M SO TIRED, I'M READY FOR THE SACK. I'M ASLEEP ON MY FEET.

AM I BEGINNING TO BORE YOU, AL! YOU USED TO COME IN HERE WITH YOUR EYES AS BIG AS SAUCERS.

YOU KNOW YOU DON'T, KATE. IT'S JUST THAT BUGLER . . . HE GETS UP TOO EARLY.

WHAT AL NEEDS IS A GOOD SHOCK! MAYBE THIS'LL DO IT!

HEY! WHEW! HALP!

IT DID!

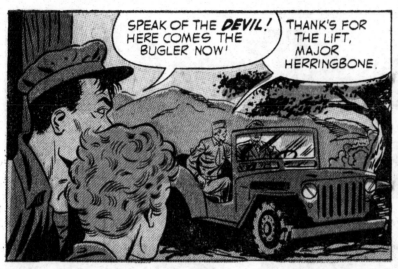

SPEAK OF THE *DEVIL!* HERE COMES THE BUGLER NOW!

THANK'S FOR THE LIFT, MAJOR HERRINGBONE.

HE SEEMS LIKE SUCH A NICE BOY PERHAPS IF YOU SPOKE TO HIM AND TOLD HIM HE WAS DISTURBING YOUR SLEEP--

COME ON, KATE, YOU DON'T UNDERSTAND THIS MAN'S ARMY!

WELL, I UNDERSTAND ONE THING - EITHER YOU GET MORE SLEEP OR YOU GET YOURSELF A NEW GIRL-FRIEND! I'LL HELP YOU FIGURE OUT A WAY.

EVERYTIME YOU START FIGURING I START WORRYING.

BUT I'VE GOT A SUREFIRE SCHEME, AL! WHICH IS THE BUGLER'S BARRACKS?

THAT ONE, WHY?

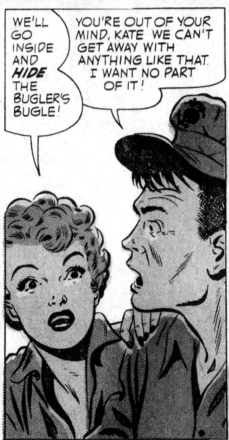

WE'LL GO INSIDE AND *HIDE* THE BUGLER'S BUGLE!

YOU'RE OUT OF YOUR MIND, KATE. WE CAN'T GET AWAY WITH ANYTHING LIKE THAT. I WANT NO PART OF IT!

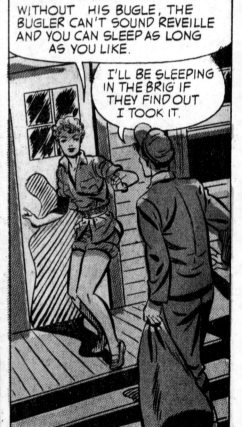

WITHOUT HIS BUGLE, THE BUGLER CAN'T SOUND REVEILLE AND YOU CAN SLEEP AS LONG AS YOU LIKE.

I'LL BE SLEEPING IN THE BRIG IF THEY FIND OUT I TOOK IT.

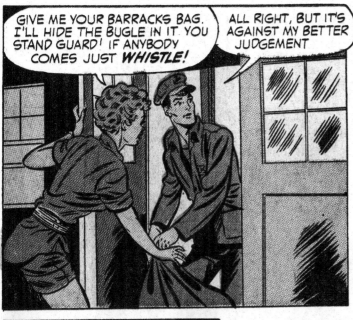

GIVE ME YOUR BARRACKS BAG. I'LL HIDE THE BUGLE IN IT. YOU STAND GUARD! IF ANYBODY COMES JUST *WHISTLE!*

ALL RIGHT, BUT IT'S AGAINST MY BETTER JUDGEMENT

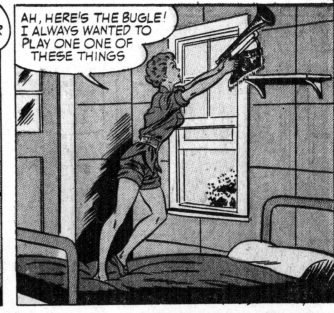

AH, HERE'S THE BUGLE! I ALWAYS WANTED TO PLAY ONE ONE OF THESE THINGS

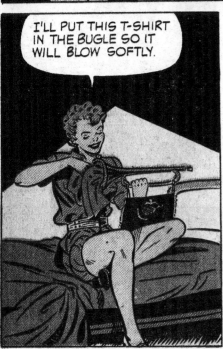

I'LL PUT THIS T-SHIRT IN THE BUGLE SO IT WILL BLOW SOFTLY.

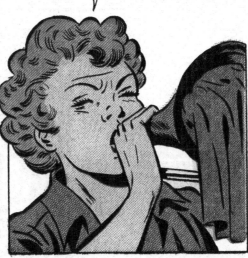

PUFF! PUFF! WHEW! IT TAKES MORE WIND THAN I THOUGHT!

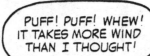
TA-TA-TA

...OH, MY GOSH! OF ALL THE FOOL TRICKS! KATE'S BLOWING THE BUGLE! I HOPE NOBODY HEARS HER!

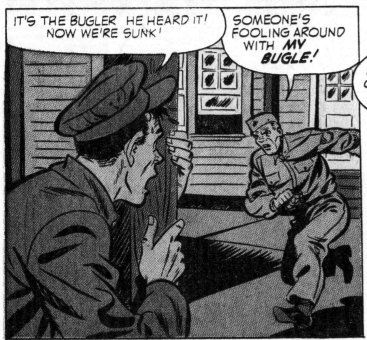

IT'S THE BUGLER HE HEARD IT! NOW WE'RE SUNK!

SOMEONE'S FOOLING AROUND WITH *MY BUGLE!*

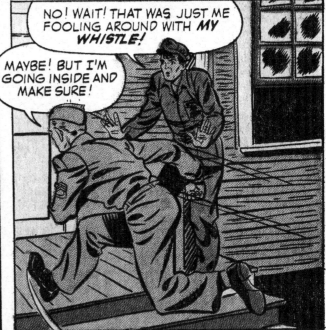

NO! WAIT! THAT WAS JUST ME FOOLING AROUND WITH *MY WHISTLE!*

MAYBE! BUT I'M GOING INSIDE AND MAKE SURE!

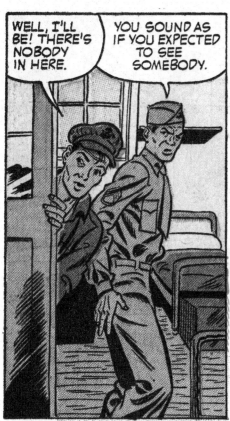

WELL, I'LL BE! THERE'S NOBODY IN HERE.

YOU SOUND AS IF YOU EXPECTED TO SEE SOMEBODY.

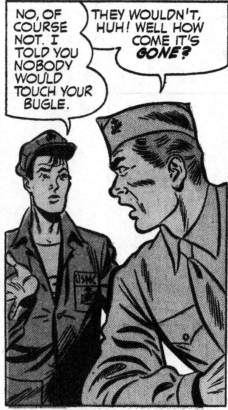

NO, OF COURSE NOT. I TOLD YOU NOBODY WOULD TOUCH YOUR BUGLE.

THEY WOULDN'T, HUH! WELL HOW COME IT'S *GONE*?

I'LL REPORT IT TO MAJOR HERRINGBONE! HE'LL GET TO THE *BOTTOM* OF THIS! THEN SOMEBODY'S NAME WILL BE *MUD*!

KATE! KATE! COME OUT! WHERE ARE YOU?

IN YOUR BARRACKS BAG AND I'VE GOT THE *BUGLE*, TOO!

WE HAVE TO GET OUT OF HERE BEFORE MAJOR HERRINGBONE COMES. DUCK DOWN IN THAT BAG AGAIN!

OH, YOU'RE GOING TO SMUGGLE ME OUT! WELL, DON'T BE ROUGH!

THE TREATMENT YOU GET WILL BE A LOT ROUGHER IF HERRINGBONE GETS HOLD OF YOU, BABE!

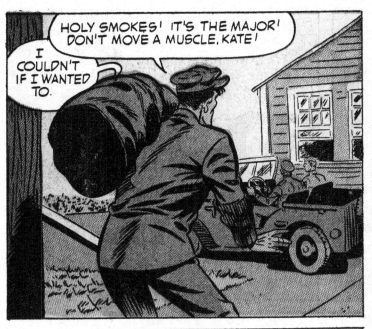

HOLY SMOKES! IT'S THE MAJOR! DON'T MOVE A MUSCLE, KATE!

I COULDN'T IF I WANTED TO.

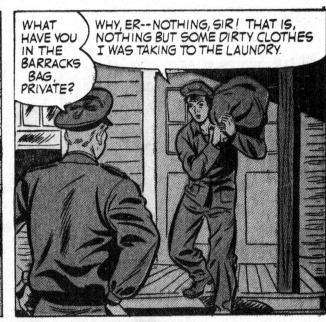

WHAT HAVE YOU IN THE BARRACKS BAG, PRIVATE?

WHY, ER--NOTHING, SIR! THAT IS, NOTHING BUT SOME DIRTY CLOTHES I WAS TAKING TO THE LAUNDRY.

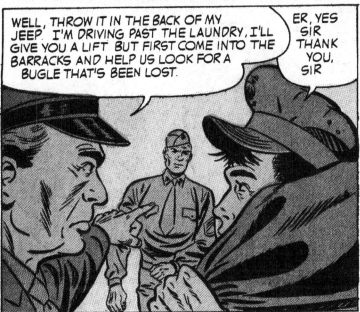

WELL, THROW IT IN THE BACK OF MY JEEP. I'M DRIVING PAST THE LAUNDRY, I'LL GIVE YOU A LIFT BUT FIRST COME INTO THE BARRACKS AND HELP US LOOK FOR A BUGLE THAT'S BEEN LOST.

ER, YES SIR THANK YOU, SIR

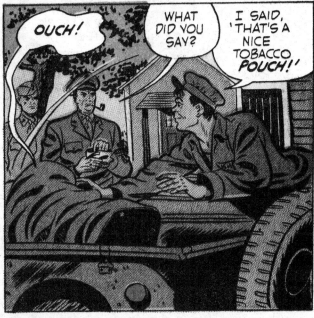

OUCH!

WHAT DID YOU SAY?

I SAID, 'THAT'S A NICE TOBACCO POUCH!'

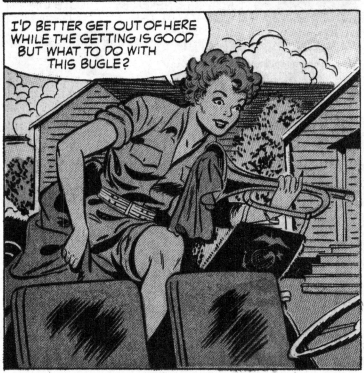

I'D BETTER GET OUT OF HERE WHILE THE GETTING IS GOOD BUT WHAT TO DO WITH THIS BUGLE?

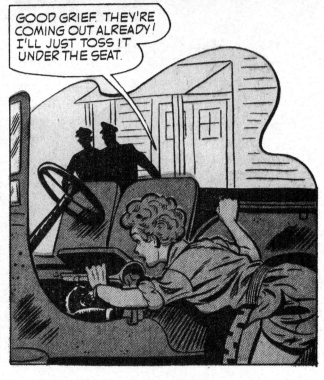

GOOD GRIEF. THEY'RE COMING OUT ALREADY! I'LL JUST TOSS IT UNDER THE SEAT.

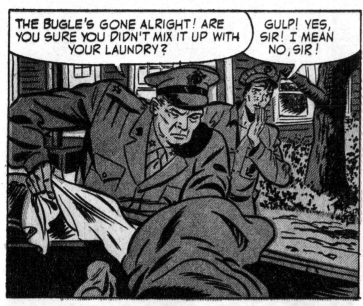

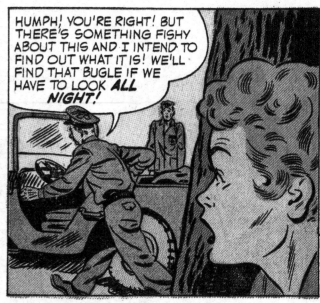

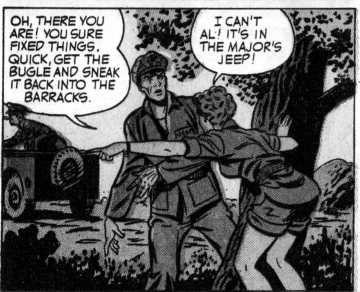

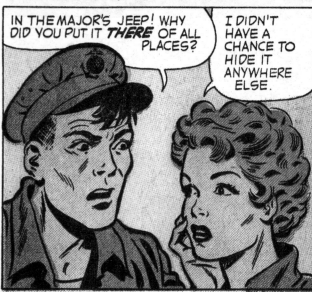

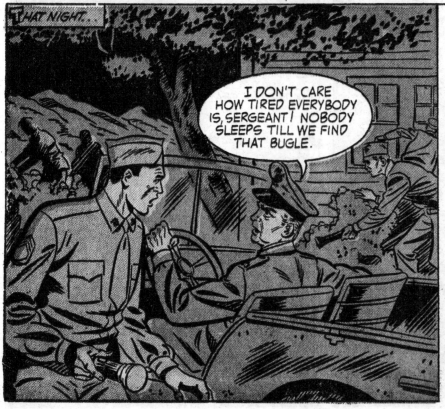

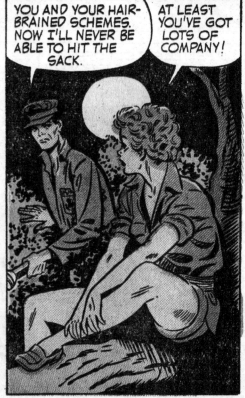

REPORT TO ME AS SOON AS YOU LAY YOUR HANDS ON THAT CONFOUNDED INSTRUMENT!

YES, SIR!

AL! THE BUGLE! IT POPPED OUT OF THE MAJOR'S JEEP!

OH, MIGOSH! NOW WE'RE *REALLY* IN FOR IT!

WHOSE T-SHIRT IS THIS STUFFED IN THE HORN?

I DON'T KNOW, SIR! IT'S NOT MINE!

PRIVATE AL BROWN! YOUR NAME'S STENCILLED ON THIS! WHAT HAVE YOU GOT TO SAY FOR YOURSELF?

W-WHY, SOME-HOW, SIR, I'M SORTA LOST FOR WORDS!

IT WASN'T REALLY AL'S FAULT, MAJOR! YOU'RE NOT GOING TO BE TOO HARD ON HIM, ARE YOU?

I'M AN HONEST AND JUST MAN, YOUNG LADY! THE PUNISHMENT WILL FIT THE CRIME!

THE NEXT DAY...

GEE, AL, YOU LOOK MORE TIRED THAN EVER! WHAT DID THE MAJOR DO?

JUST WHAT HE SAID HE'D DO... AND THE PAYOFF IS THAT NOW I'M THE GUY WHO GETS THE BUGLER UP!

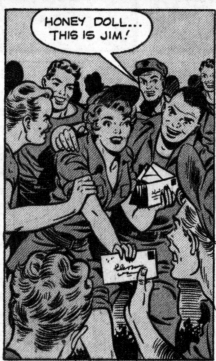

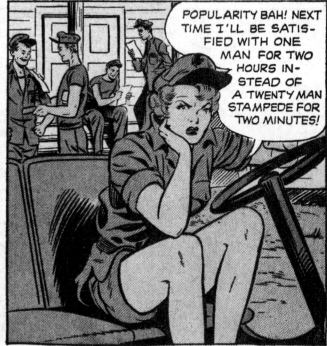

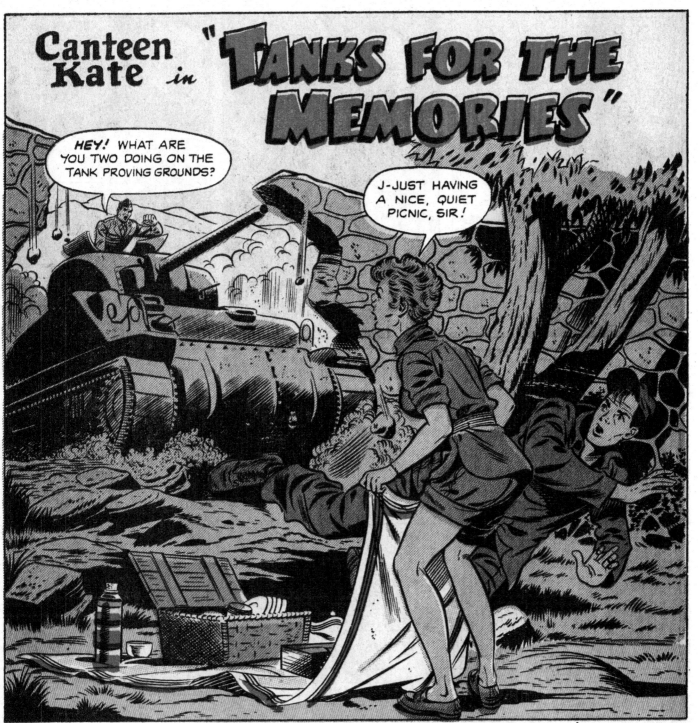

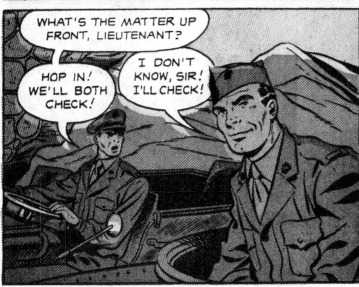

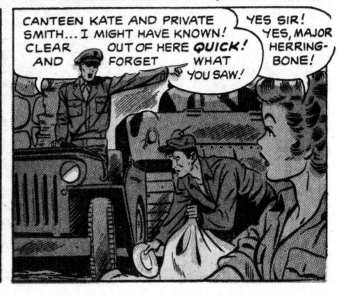

Canteen Kate — "Tanks for the Memories"

47

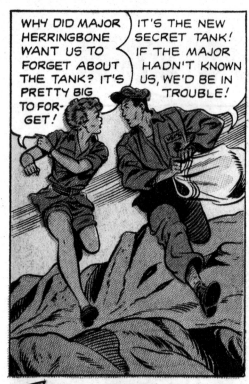

WHY DID MAJOR HERRINGBONE WANT US TO FORGET ABOUT THE TANK? IT'S PRETTY BIG TO FORGET!

IT'S THE NEW SECRET TANK! IF THE MAJOR HADN'T KNOWN US, WE'D BE IN TROUBLE!

OOPS!!

OH-OH! I SPOKE TOO SOON!

AL! HELP ME!

YOU MAKE THE CRAZIEST REQUESTS AT THE MOST IMPOSSIBLE TIMES!

THAT EVENING...

WELL, KATE! DID THIS DINNER SORTA MAKE UP FOR OUR PICNIC?

SURE, AL... NOW QUIET, WHILE I MAKE A WISH!

OKAY, PULL!

HEY, KATE! COME BACK HERE!

THAT DAME! WHOEVER HEARD OF FALLING HEAD OVER HEELS FOR A WISHBONE!

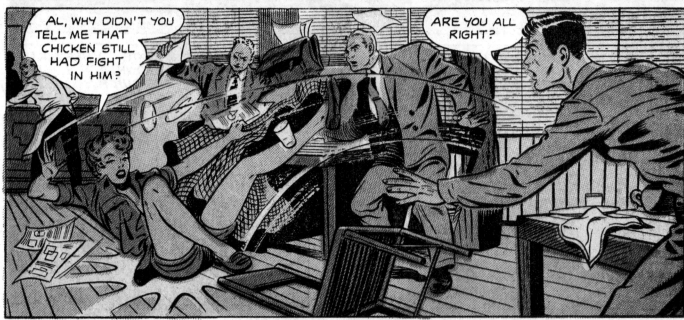

AL, WHY DIDN'T YOU TELL ME THAT CHICKEN STILL HAD FIGHT IN HIM?

ARE YOU ALL RIGHT?

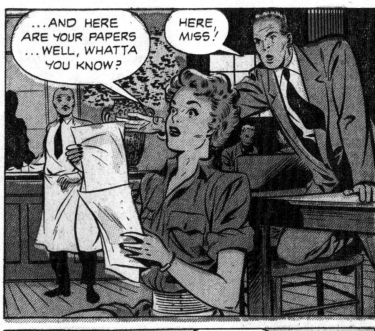

I'M SORRY I PULLED EVERYTHING OFF YOUR TABLE, MISTER! I'LL PICK IT UP!

...AND HERE ARE YOUR PAPERS ...WELL, WHATTA YOU KNOW?

HERE, MISS!

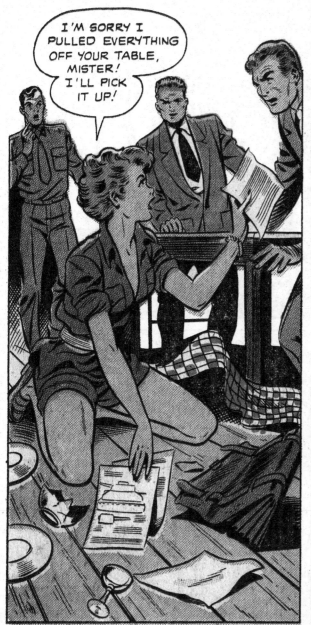

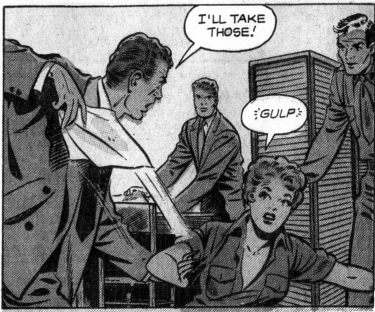

I'LL TAKE THOSE!

GULP

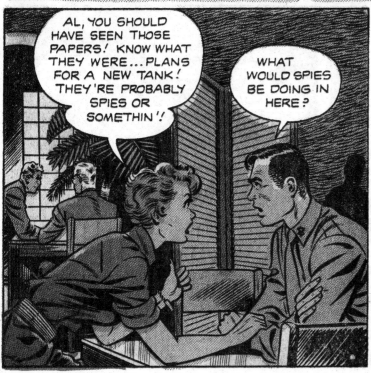

AL, YOU SHOULD HAVE SEEN THOSE PAPERS! KNOW WHAT THEY WERE...PLANS FOR A NEW TANK! THEY'RE PROBABLY SPIES OR SOMETHIN'!

WHAT WOULD SPIES BE DOING IN HERE?

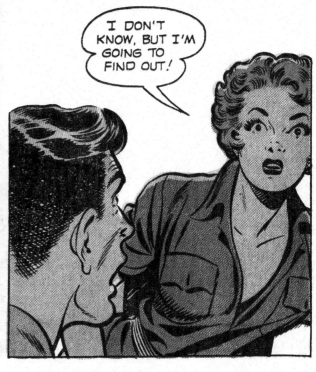

I DON'T KNOW, BUT I'M GOING TO FIND OUT!

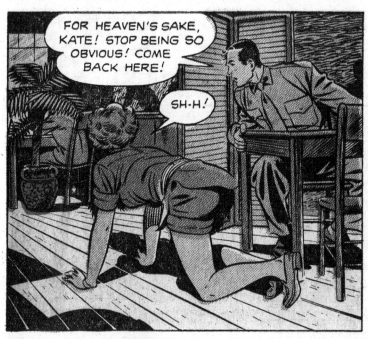

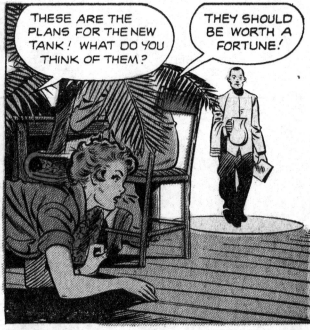

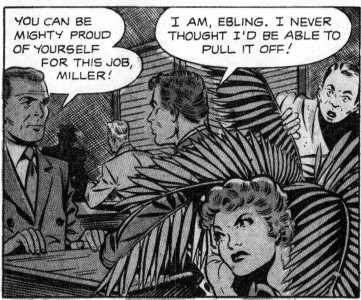

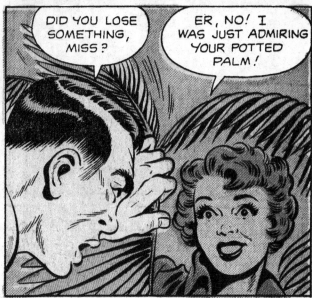

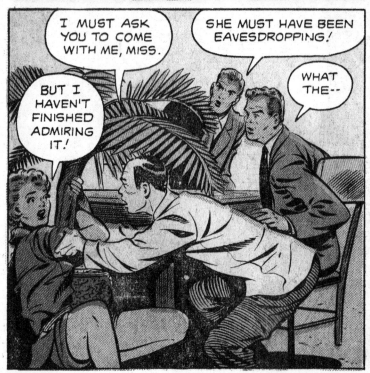

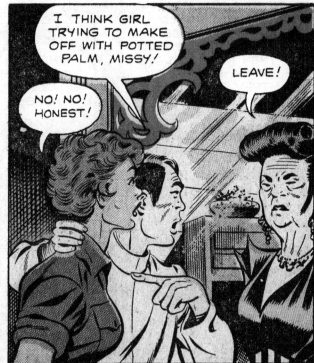

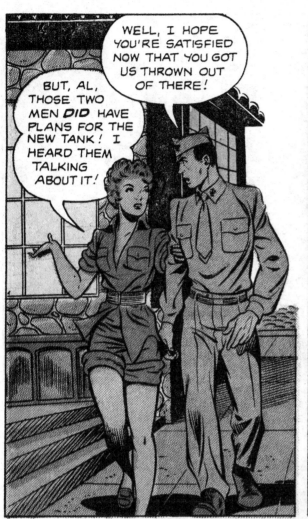

BUT, AL, THOSE TWO MEN *DID* HAVE PLANS FOR THE NEW TANK! I HEARD THEM TALKING ABOUT IT!

WELL, I HOPE YOU'RE SATISFIED NOW THAT YOU GOT US THROWN OUT OF THERE!

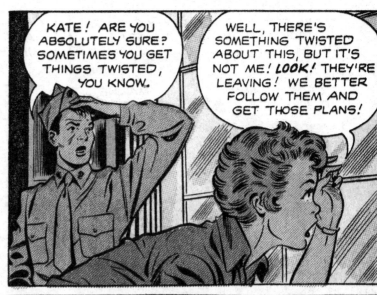

KATE! ARE YOU ABSOLUTELY SURE? SOMETIMES YOU GET THINGS TWISTED, YOU KNOW.

WELL, THERE'S SOMETHING TWISTED ABOUT THIS, BUT IT'S NOT ME! *LOOK!* THEY'RE LEAVING! WE BETTER FOLLOW THEM AND GET THOSE PLANS!

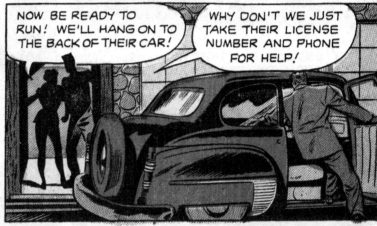

NOW BE READY TO RUN! WE'LL HANG ON TO THE BACK OF THEIR CAR!

WHY DON'T WE JUST TAKE THEIR LICENSE NUMBER AND PHONE FOR HELP!

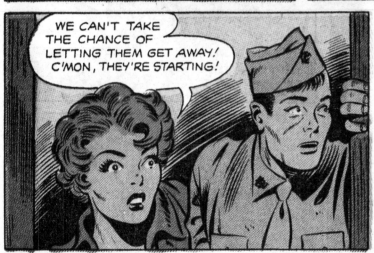

WE CAN'T TAKE THE CHANCE OF LETTING THEM GET AWAY! C'MON, THEY'RE STARTING!

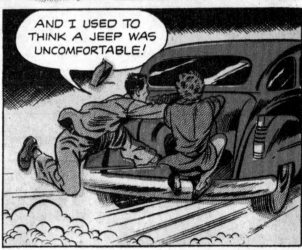

AND I USED TO THINK A JEEP WAS UNCOMFORTABLE!

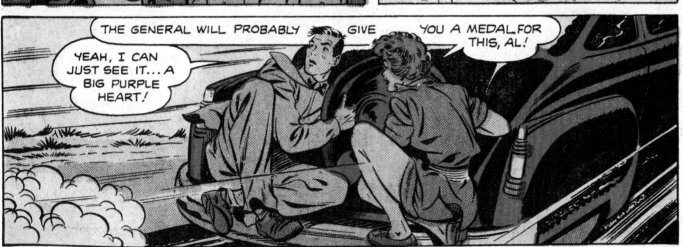

THE GENERAL WILL PROBABLY GIVE YOU A MEDAL FOR THIS, AL!

YEAH, I CAN JUST SEE IT... A BIG PURPLE HEART!

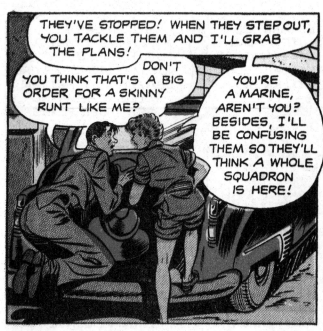

THEY'VE STOPPED! WHEN THEY STEP OUT, YOU TACKLE THEM AND I'LL GRAB THE PLANS!

DON'T YOU THINK THAT'S A BIG ORDER FOR A SKINNY RUNT LIKE ME?

YOU'RE A MARINE, AREN'T YOU? BESIDES, I'LL BE CONFUSING THEM SO THEY'LL THINK A WHOLE SQUADRON IS HERE!

READY, MEN! ATTACK! BRING UP THE RESERVES! MOW 'EM DOWN!

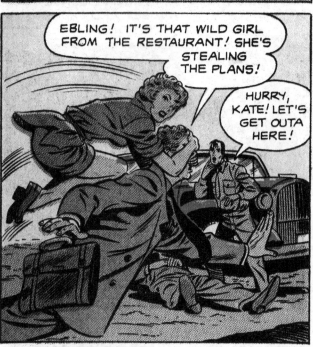

EBLING! IT'S THAT WILD GIRL FROM THE RESTAURANT! SHE'S STEALING THE PLANS!

HURRY, KATE! LET'S GET OUTA HERE!

HURRY, KATE! I'VE GOT IT STARTED! JUMP ON THE RUNNING BOARD!

WE'VE GOT TO STOP THEM, MILLER! LET'S GRAB THAT STATION WAGON OVER THERE!

FIFTEEN MINUTES LATER, AL AND KATE ROAR INTO THE MARINE BASE WITH EBLING AND MILLER IN CLOSE PURSUIT...

BE CAREFUL, AL! THAT JEEP!

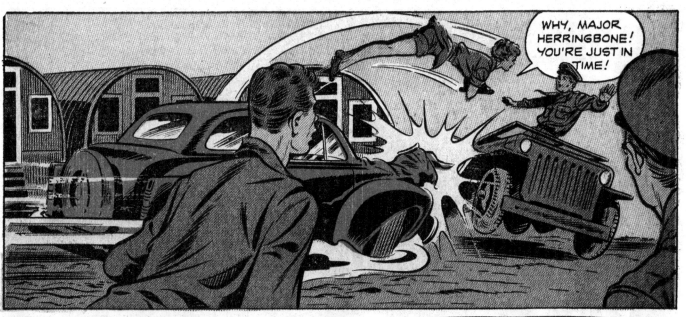

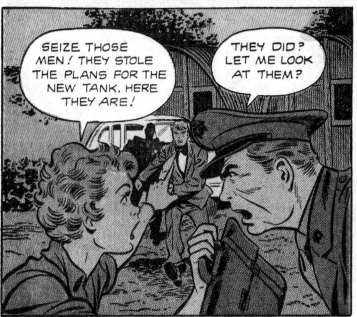

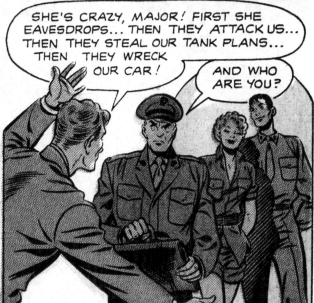

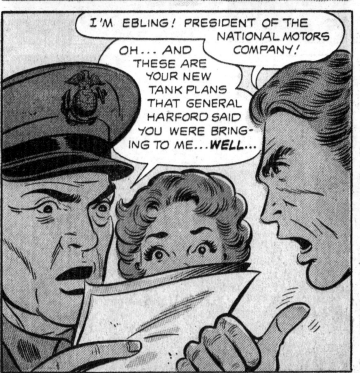

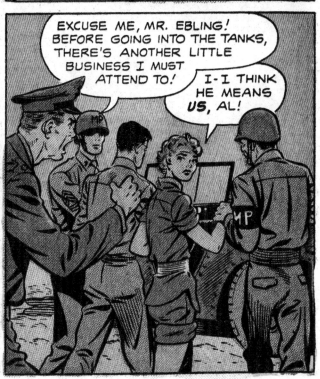

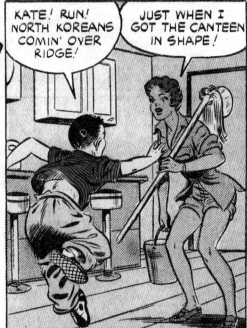

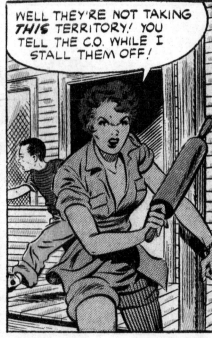

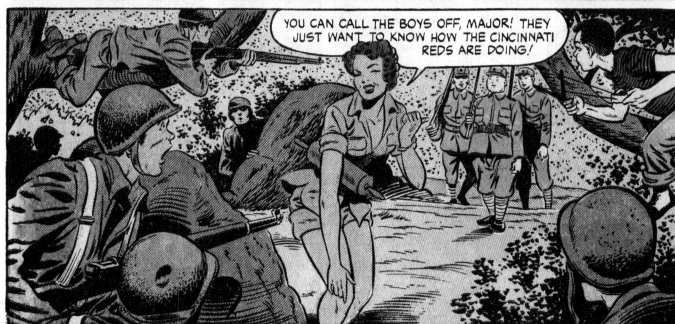

Lost Art of Matt Baker Vol. 1

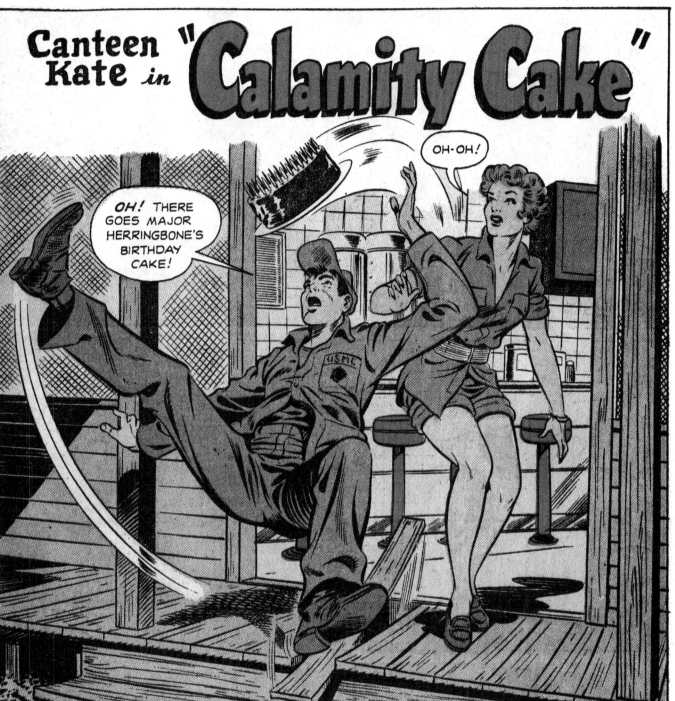

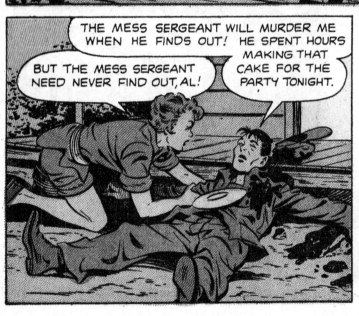

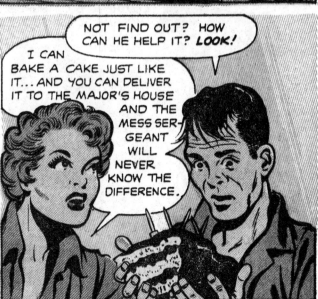

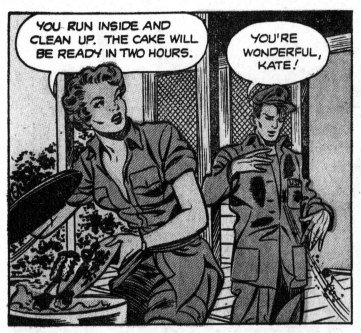

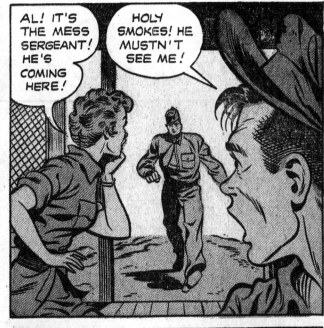

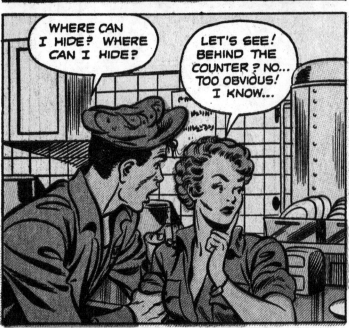

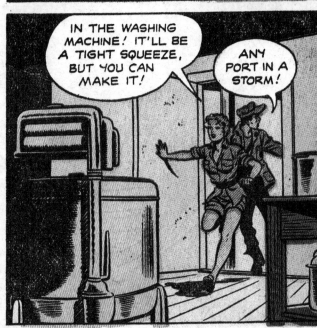

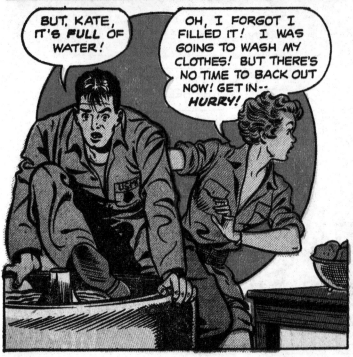

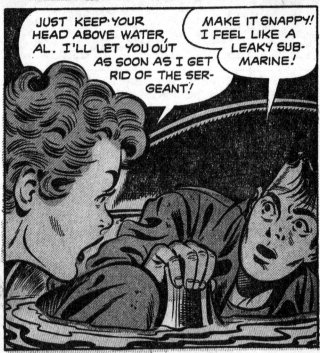

HELLO, KATE. THINGS ARE A LITTLE SLACK OVER AT THE MESS HALL. I THOUGHT I'D PAY YOU A VISIT.

W-WHY, HELLO, SERGEANT.

WHATCHA DOING WITH THE WASHER?

I WAS JUST ABOUT TO WASH MY CLOTHES WHEN YOU CAME IN.

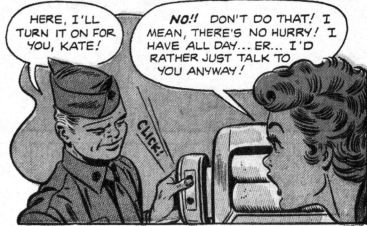

HERE, I'LL TURN IT ON FOR YOU, KATE!

NO!! DON'T DO THAT! I MEAN, THERE'S NO HURRY! I HAVE ALL DAY... ER... I'D RATHER JUST TALK TO YOU ANYWAY!

CLICK!

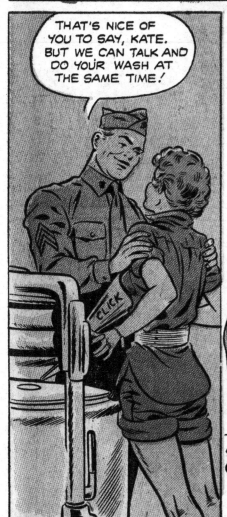

THAT'S NICE OF YOU TO SAY, KATE. BUT WE CAN TALK AND DO YOUR WASH AT THE SAME TIME!

CLICK

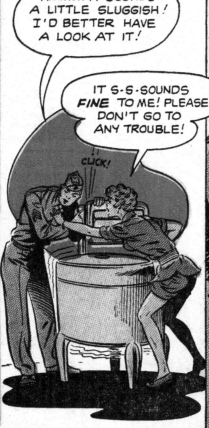

HMM... IT SOUNDS A LITTLE SLUGGISH! I'D BETTER HAVE A LOOK AT IT!

IT S-S-SOUNDS FINE TO ME! PLEASE DON'T GO TO ANY TROUBLE!

CLICK!

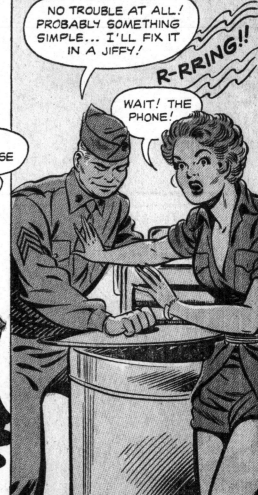

NO TROUBLE AT ALL! PROBABLY SOMETHING SIMPLE... I'LL FIX IT IN A JIFFY!

R-RRING!!

WAIT! THE PHONE!

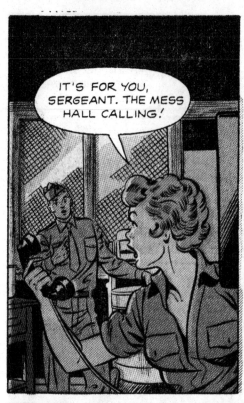

IT'S FOR YOU, SERGEANT. THE MESS HALL CALLING!

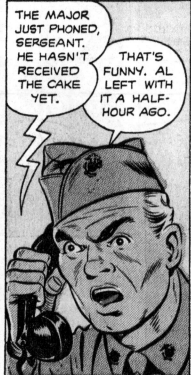

THE MAJOR JUST PHONED, SERGEANT. HE HASN'T RECEIVED THE CAKE YET.

THAT'S FUNNY. AL LEFT WITH IT A HALF-HOUR AGO.

WE'LL HAVE TO POSTPONE OUR TALK, KATE. I HAVE TO FIND THAT LAME-BRAIN AL. HE'S PROBABLY LOITERING AROUND SOMEWHERE!

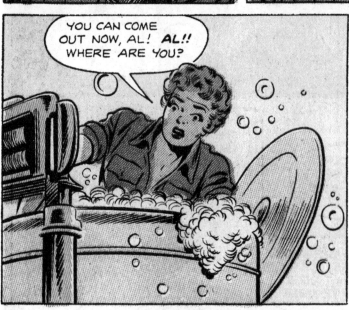

YOU CAN COME OUT NOW, AL! AL!! WHERE ARE YOU?

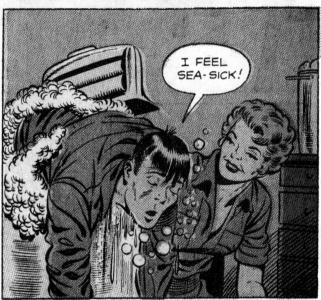

I FEEL SEA-SICK!

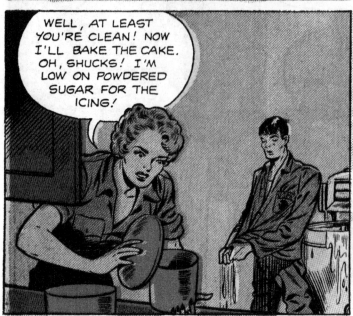

WELL, AT LEAST YOU'RE CLEAN! NOW I'LL BAKE THE CAKE. OH, SHUCKS! I'M LOW ON POWDERED SUGAR FOR THE ICING!

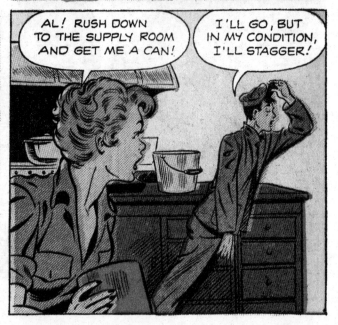

AL! RUSH DOWN TO THE SUPPLY ROOM AND GET ME A CAN!

I'LL GO, BUT IN MY CONDITION, I'LL STAGGER!

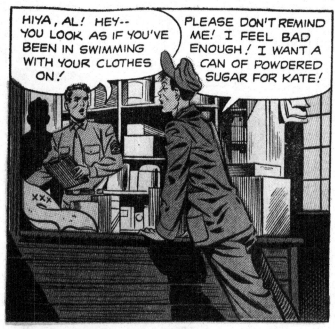

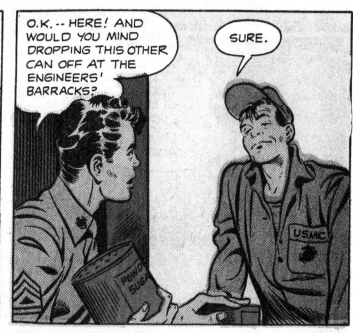

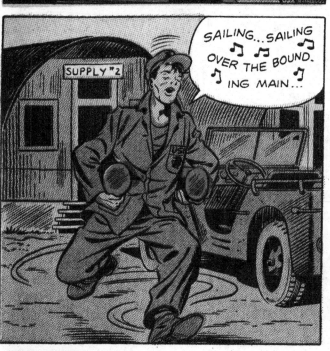

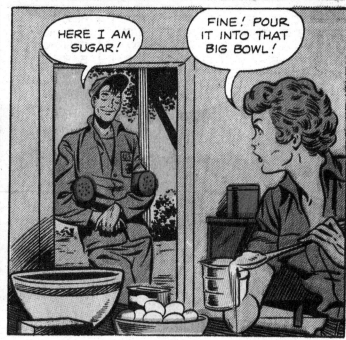

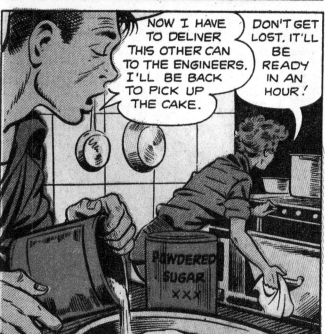

AND AN HOUR LATER...

KATE, I'M PROUD OF YOU! IT'S THE EXACT IMAGE OF THE MESS SERGEANT'S CAKE!

IT SHOULD BE GOOD, TOO!

SO THERE YOU ARE! I'VE BEEN LOOKING ALL OVER FOR YOU! GIVE ME THAT CAKE-- I'LL DELIVER IT MYSELF!

GOSH, HE SURE WAS SORE! BUT THINK HOW SORE HE'D BE IF HE KNEW I'D RUINED HIS CAKE!

WHAT HE DOESN'T KNOW CAN'T HURT YOU!

HEY, AL-- YOU TURNING INTO A PRACTICAL JOKER? THAT CAN YOU LEFT AT OUR BARRACKS WAS POWDERED SUGAR. WE CAN'T BLAST STUMPS WITH THAT!

POWDERED SUGAR!

BACK IN KATE'S KITCHEN...

AL! YOU MUST HAVE POURED GUNPOWDER IN-TO THE MIXING BOWL! AND I ICED THE CAKE WITH IT!

QUICK! WE HAVE TO GET TO THE MAJOR'S HOUSE...

...BEFORE HE LIGHTS THOSE CANDLES!

HE MUST HAVE LIT THE CANDLES!

BOOM!

BOOM!

DO YOU THINK HE'D FORGIVE US IF WE SANG HAPPY BIRTHDAY VERY LOUD!

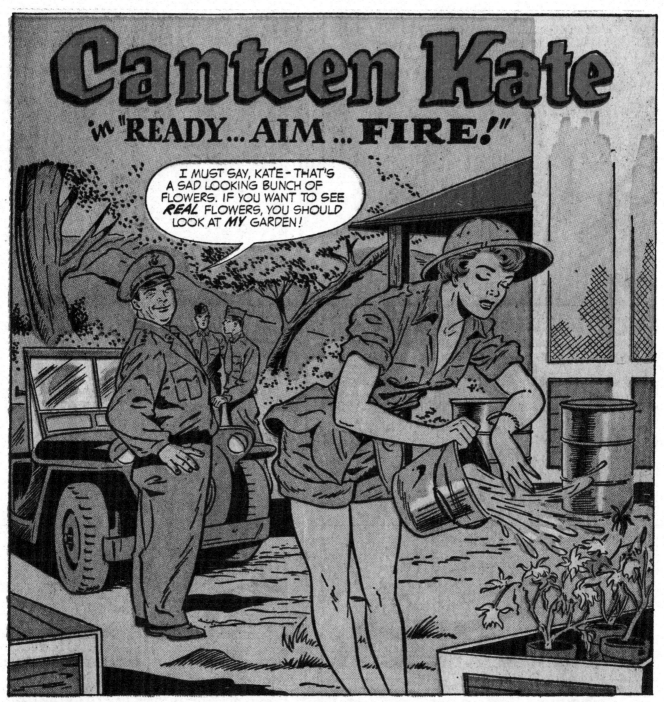

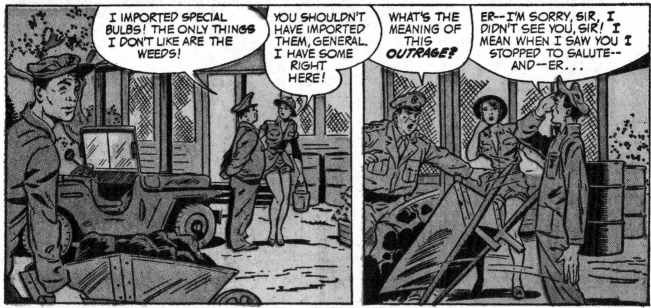

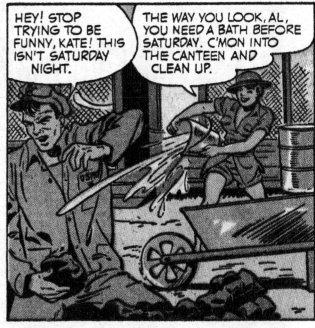

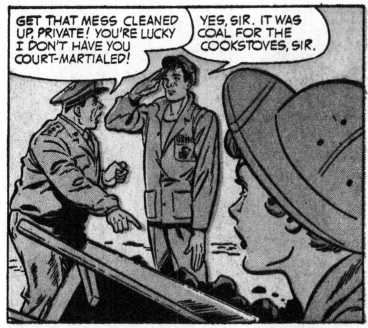

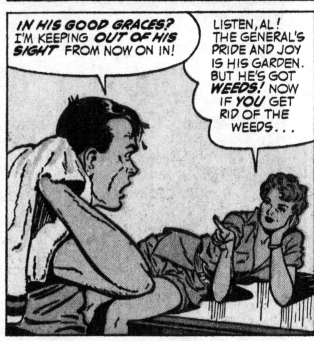

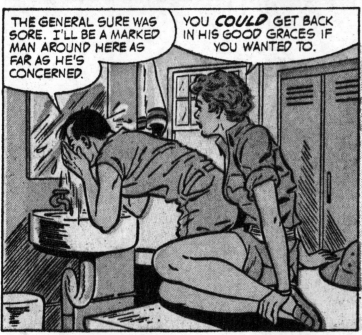

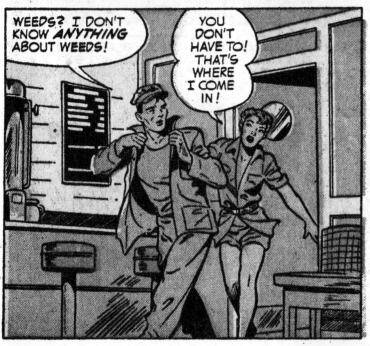

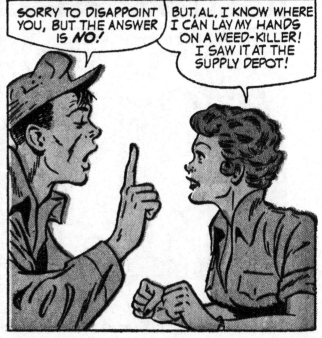

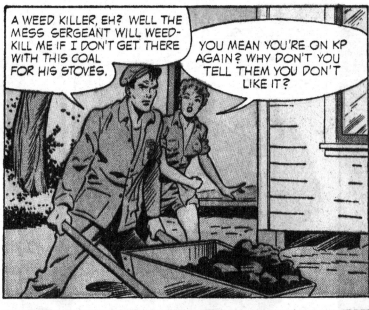

A WEED KILLER, EH? WELL THE MESS SERGEANT WILL WEED-KILL ME IF I DON'T GET THERE WITH THIS COAL FOR HIS STOVES.

YOU MEAN YOU'RE ON KP AGAIN? WHY DON'T YOU TELL THEM YOU DON'T LIKE IT?

THAT'S JUST WHAT I'LL DO, KATE... THE NEXT TIME I HAVE TEA WITH THE GENERAL.

I'LL BET IF YOU GOT RID OF THE GENERAL'S WEEDS YOU WOULDN'T HAVE ANY MORE KP DUTY.

HMM. MAYBE YOU'RE RIGHT, KATE. LET'S GO AND FIND OUT IF THE WEED-KILLER REALLY KILLS WEEDS.

I NEED A JEEP, LIEUTENANT, TO PICK UP THE NEW REFRIGERATOR AT THE SUPPLY DEPOT FOR MY NEW CANTEEN.

HMM—ALL RIGHT, THIS REQUISITION IS IN ORDER. I'LL GET THE KEYS!

I THOUGHT WE WERE GOING TO PICK UP A WEED-KILLER.

WE ARE, SILLY. BUT YOU KNOW NAVY RED TAPE. IF WE PUT IN A REQUISITION FOR WEED-KILLER IT WOULD TAKE WEEKS...

I REQUESTED THE REFRIGERATOR TWO MONTHS AGO AND THEY JUST TOLD ME TODAY THAT I COULD PICK IT UP.

WELL, THEN HOW DO WE GET THE WEED-KILLER?

YOU'LL SEE!

YIPE! A BLACK CAT! I HAVE A FEELING THIS ISN'T GOING TO BE MY LUCKY NIGHT!

HERE'S THE REFRIGERATOR, KATE. JUST SIGN THIS RECEIPT.

BEFORE I SIGN, I WANT TO MAKE SURE IT'S PERFECT. THE LIGHT IN THE LAST ONE DIDN'T TURN OFF WHEN THE DOOR CLOSED.

YOU GET INSIDE, AND I'LL CLOSE THE DOOR. THEN YOU CAN TELL ME IF THE LIGHT GOES OUT.

W-WELL. I WOULDN'T DO THIS FOR ANYBODY ELSE. BUT OK.

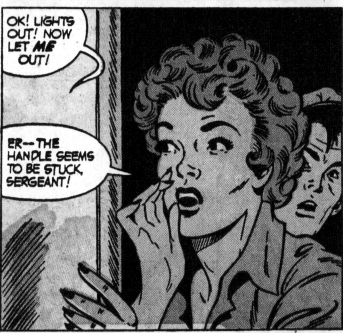

OK! LIGHTS OUT! NOW LET ME OUT!

ER--THE HANDLE SEEMS TO BE STUCK, SERGEANT!

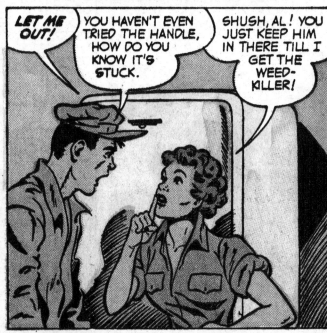

LET ME OUT!

YOU HAVEN'T EVEN TRIED THE HANDLE, HOW DO YOU KNOW IT'S STUCK.

SHUSH, AL! YOU JUST KEEP HIM IN THERE TILL I GET THE WEED-KILLER!

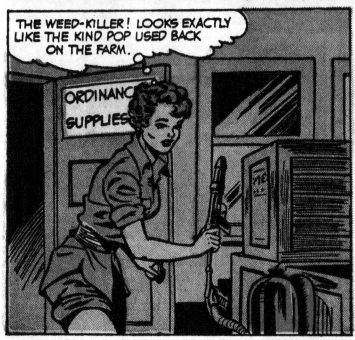

THE WEED-KILLER! LOOKS EXACTLY LIKE THE KIND POP USED BACK ON THE FARM.

ORDINANCE SUPPLIES

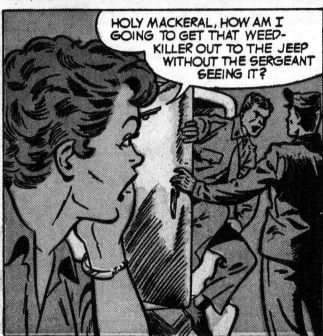

HOLY MACKERAL, HOW AM I GOING TO GET THAT WEED-KILLER OUT TO THE JEEP WITHOUT THE SERGEANT SEEING IT?

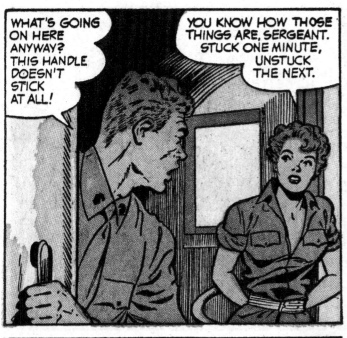

WHAT'S GOING ON HERE ANYWAY? THIS HANDLE DOESN'T STICK AT ALL!

YOU KNOW HOW THOSE THINGS ARE, SERGEANT. STUCK ONE MINUTE, UNSTUCK THE NEXT.

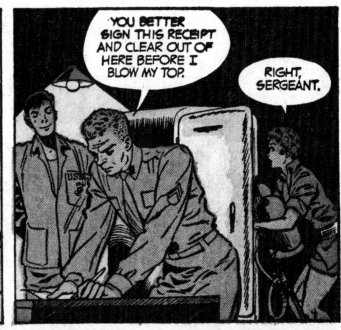

YOU BETTER SIGN THIS RECEIPT AND CLEAR OUT OF HERE BEFORE I BLOW MY TOP.

RIGHT, SERGEANT.

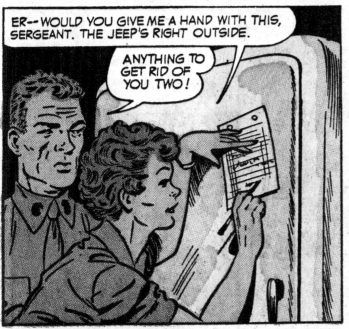

ER-- WOULD YOU GIVE ME A HAND WITH THIS, SERGEANT. THE JEEP'S RIGHT OUTSIDE.

ANYTHING TO GET RID OF YOU TWO!

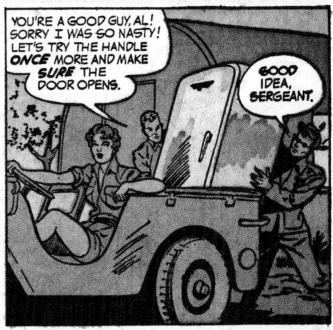

YOU'RE A GOOD GUY, AL! SORRY I WAS SO NASTY! LET'S TRY THE HANDLE *ONCE* MORE AND MAKE *SURE* THE DOOR OPENS.

GOOD IDEA, SERGEANT.

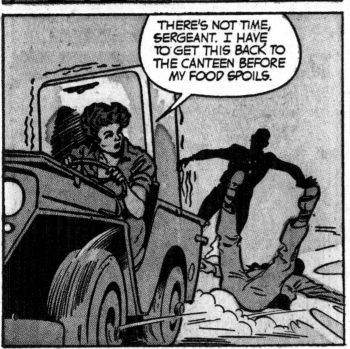

THERE'S NOT TIME, SERGEANT. I HAVE TO GET THIS BACK TO THE CANTEEN BEFORE MY FOOD SPOILS.

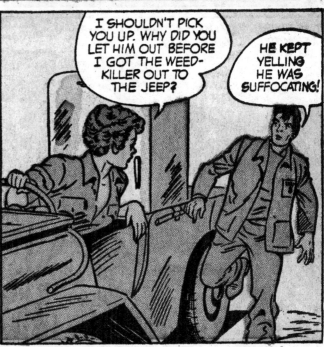

I SHOULDN'T PICK YOU UP. WHY DID YOU LET HIM OUT BEFORE I GOT THE WEED-KILLER OUT TO THE JEEP?

HE KEPT YELLING HE WAS SUFFOCATING!

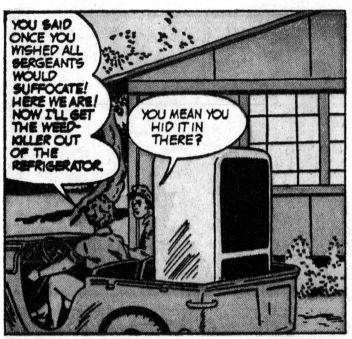

YOU SAID ONCE YOU WISHED ALL SERGEANTS WOULD SUFFOCATE! HERE WE ARE! NOW I'LL GET THE WEED-KILLER OUT OF THE REFRIGERATOR.

YOU MEAN YOU HID IT IN THERE?

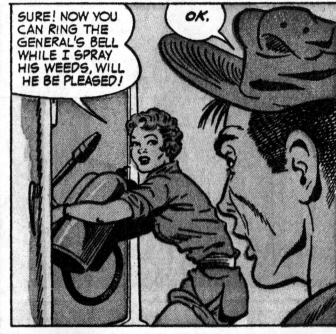

SURE! NOW YOU CAN RING THE GENERAL'S BELL WHILE I SPRAY HIS WEEDS, WILL HE BE PLEASED!

OK.

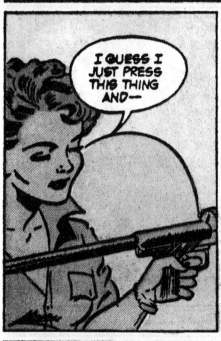

I GUESS I JUST PRESS THIS THING AND--

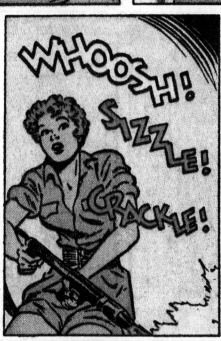

WHOOSH! SIZZLE! CRACKLE!

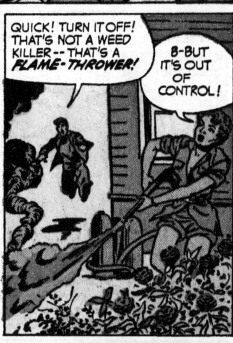

QUICK! TURN IT OFF! THAT'S NOT A WEED KILLER -- THAT'S A *FLAME-THROWER!*

B-BUT IT'S OUT OF CONTROL!

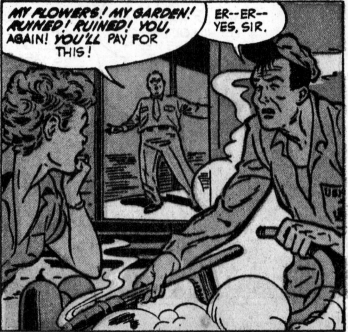

MY FLOWERS! MY GARDEN! RUINED! RUINED! YOU, AGAIN! *YOU'LL* PAY FOR THIS!

ER--ER-- YES, SIR.

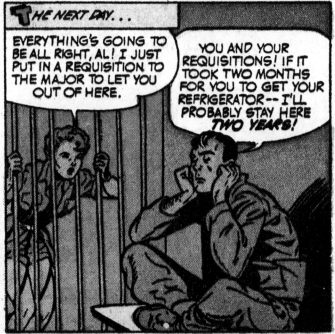

*THE NEXT DAY...*

EVERYTHING'S GOING TO BE ALL RIGHT, AL! I JUST PUT IN A REQUISITION TO THE MAJOR TO LET YOU OUT OF HERE.

YOU AND YOUR REQUISITIONS! IF IT TOOK TWO MONTHS FOR YOU TO GET YOUR REFRIGERATOR -- I'LL PROBABLY STAY HERE *TWO YEARS!*

# Canteen Kate in Rugged Rug-Cutters

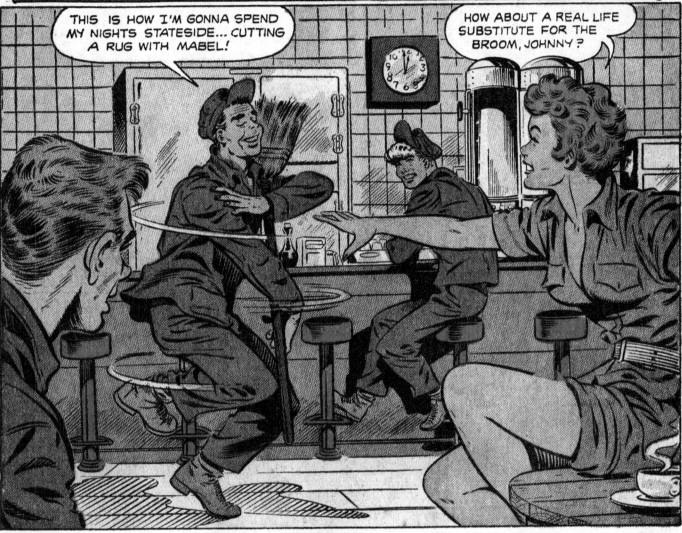

THIS IS HOW I'M GONNA SPEND MY NIGHTS STATESIDE... CUTTING A RUG WITH MABEL!

HOW ABOUT A REAL LIFE SUBSTITUTE FOR THE BROOM, JOHNNY?

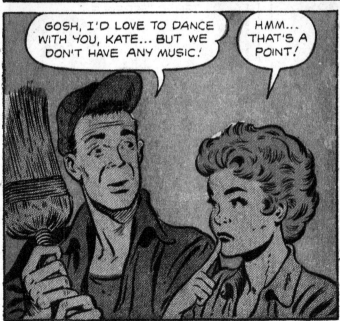

GOSH, I'D LOVE TO DANCE WITH YOU, KATE... BUT WE DON'T HAVE ANY MUSIC!

HMM... THAT'S A POINT!

I'LL GLADLY WARBLE FOR YOU ALL! AN' ARKANSAS HAS A MOUTH ORGAN! HOW 'BOUT IT?

I'LL TRY ANYTHING ONCE... AS LONG AS I DON'T HAVE TO GET OFF MY FEET!

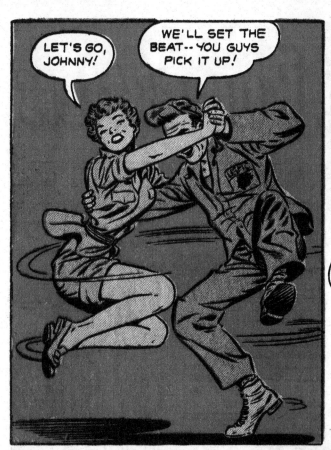

LET'S GO, JOHNNY!

WE'LL SET THE BEAT-- YOU GUYS PICK IT UP!

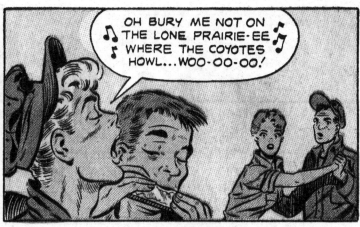

OH BURY ME NOT ON THE LONE PRAIRIE-EE WHERE THE COYOTES HOWL...WOO-OO-OO!

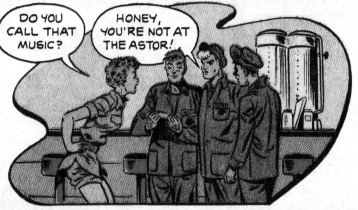

DO YOU CALL THAT MUSIC?

HONEY, YOU'RE NOT AT THE ASTOR!

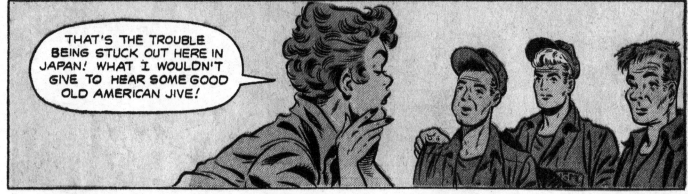

THAT'S THE TROUBLE BEING STUCK OUT HERE IN JAPAN! WHAT I WOULDN'T GIVE TO HEAR SOME GOOD OLD AMERICAN JIVE!

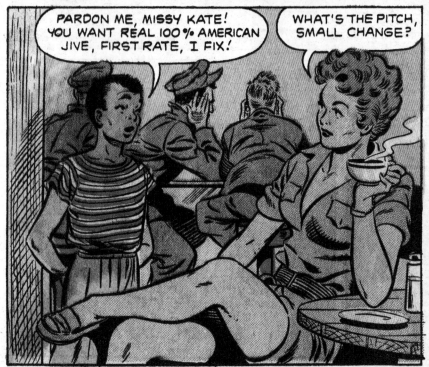

PARDON ME, MISSY KATE! YOU WANT REAL 100% AMERICAN JIVE, FIRST RATE, I FIX!

WHAT'S THE PITCH, SMALL CHANGE?

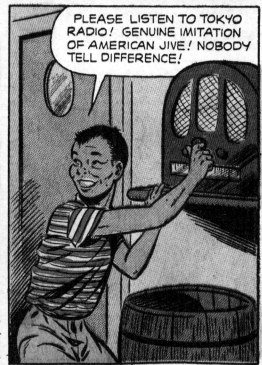

PLEASE LISTEN TO TOKYO RADIO! GENUINE IMITATION OF AMERICAN JIVE! NOBODY TELL DIFFERENCE!

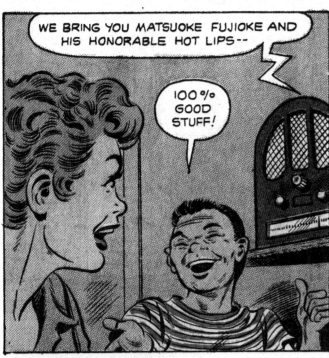

WE BRING YOU MATSUOKE FUJIOKE AND HIS HONORABLE HOT LIPS--

100% GOOD STUFF!

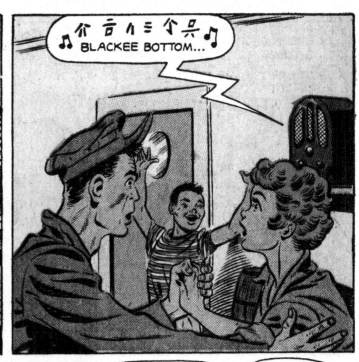

♪ 介言ハ三个兵 ♪ BLACKEE BOTTOM...

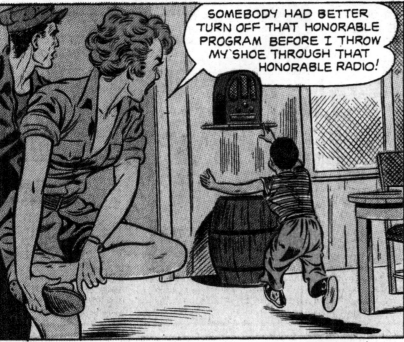

SOMEBODY HAD BETTER TURN OFF THAT HONORABLE PROGRAM BEFORE I THROW MY SHOE THROUGH THAT HONORABLE RADIO!

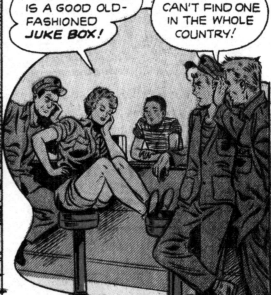

WHAT WE NEED IS A GOOD OLD-FASHIONED JUKE BOX!

I BET YOU CAN'T FIND ONE IN THE WHOLE COUNTRY!

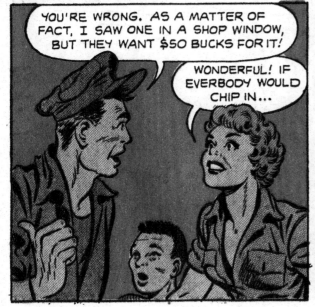

YOU'RE WRONG. AS A MATTER OF FACT, I SAW ONE IN A SHOP WINDOW, BUT THEY WANT $50 BUCKS FOR IT!

WONDERFUL! IF EVERBODY WOULD CHIP IN...

HEY-- WAIT!

ER...

'BYE NOW...

KATE...

9

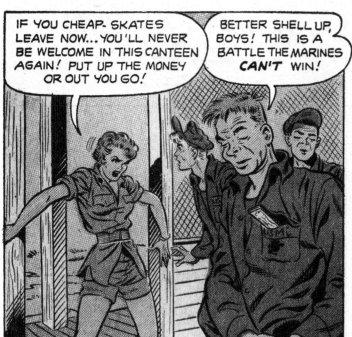

IF YOU CHEAP-SKATES LEAVE NOW...YOU'LL NEVER BE WELCOME IN THIS CANTEEN AGAIN! PUT UP THE MONEY OR OUT YOU GO!

BETTER SHELL UP, BOYS! THIS IS A BATTLE THE MARINES CAN'T WIN!

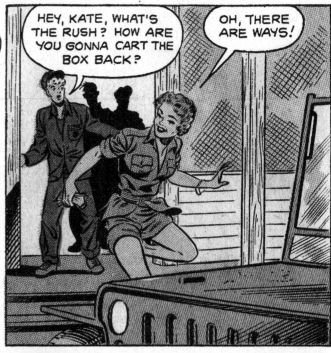

HEY, KATE, WHAT'S THE RUSH? HOW ARE YOU GONNA CART THE BOX BACK?

OH, THERE ARE WAYS!

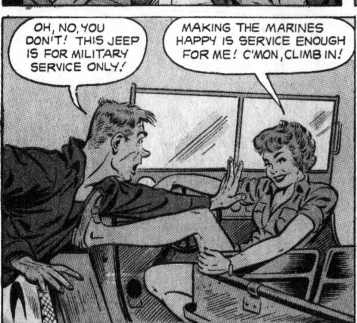

OH, NO, YOU DON'T! THIS JEEP IS FOR MILITARY SERVICE ONLY!

MAKING THE MARINES HAPPY IS SERVICE ENOUGH FOR ME! C'MON, CLIMB IN!

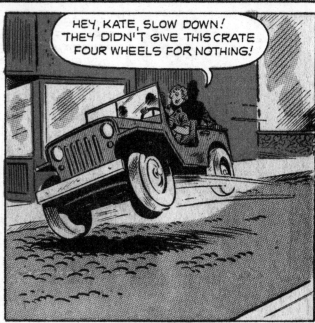

HEY, KATE, SLOW DOWN! THEY DIDN'T GIVE THIS CRATE FOUR WHEELS FOR NOTHING!

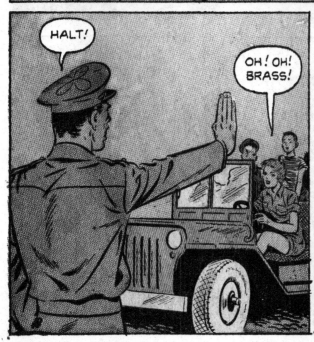

HALT!

OH! OH! BRASS!

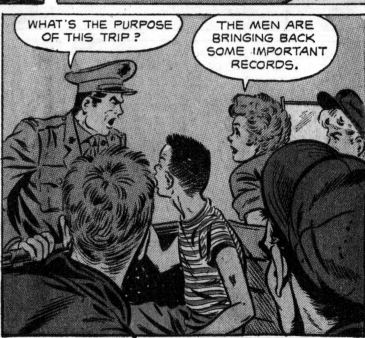

WHAT'S THE PURPOSE OF THIS TRIP?

THE MEN ARE BRINGING BACK SOME IMPORTANT RECORDS.

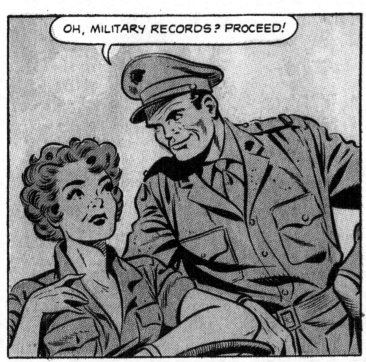

OH, MILITARY RECORDS? PROCEED!

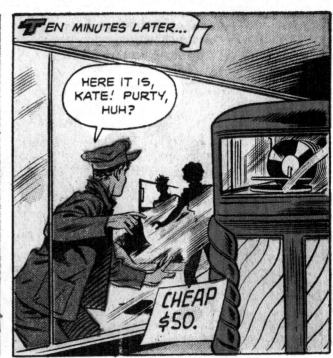

TEN MINUTES LATER...

HERE IT IS, KATE! PURTY, HUH?

CHEAP $50.

VERY FORTUNATE YOUNG LADY! THIS IS VERY FINE MACHINE! IT LIGHTS UP IN FOUR COLORS!

WE'LL TAKE IT! HOW DOES IT PLAY?

HONORABLE MOTOR IS BROKEN, BUT IT LIGHTS UP A1! GOODBYE! MUST CATCH BUS! SO SORRY!

HUH?

WELL, THERE GOES OUR MONEY AND OUR MUSIC!

RELAX, ROCKY! WE CAN PICK UP SOME SPARE PARTS AT THE BASE!

THE GUARDHOUSE IS FULL OF GUYS WHO HAD THAT IDEA!

NO EXCUSE! WE'LL MEET AT THE CANTEEN IN HALF AN HOUR... AFTER YOU PICK UP THE PARTS!

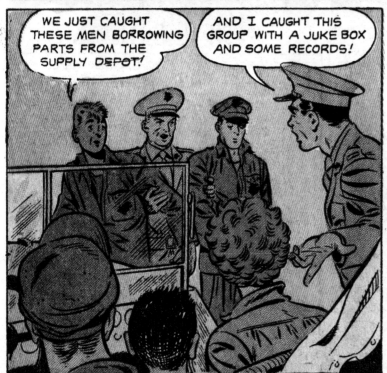

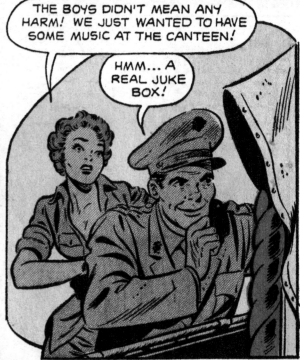

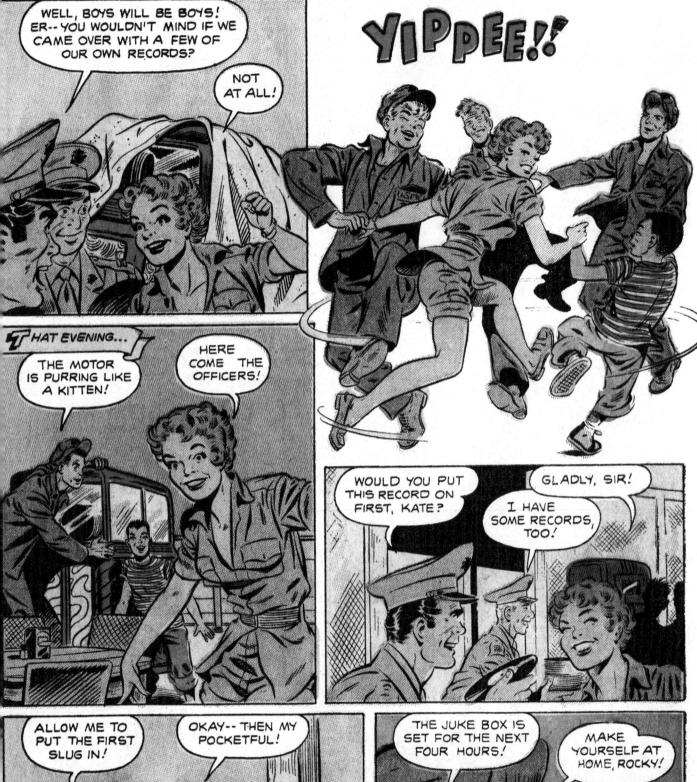

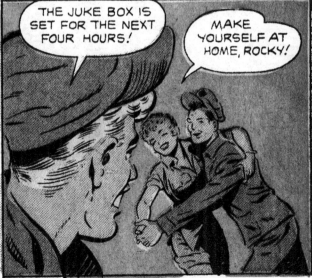

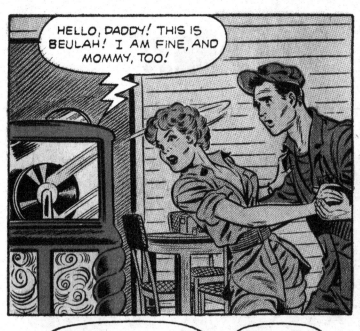

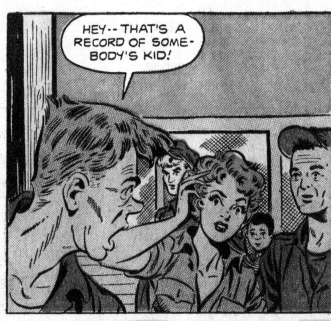

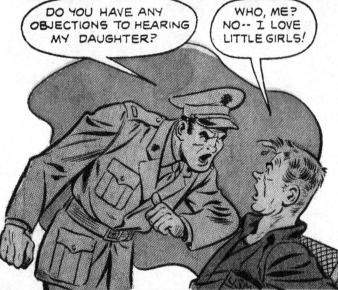

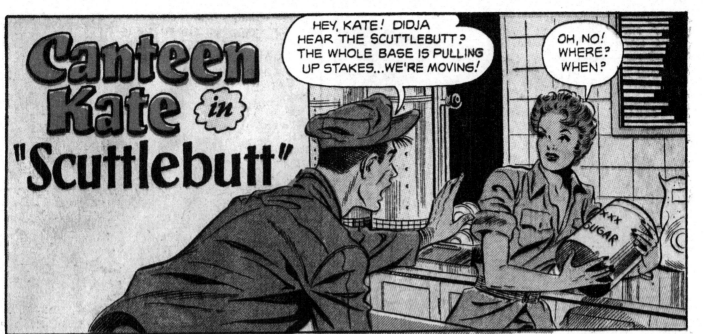

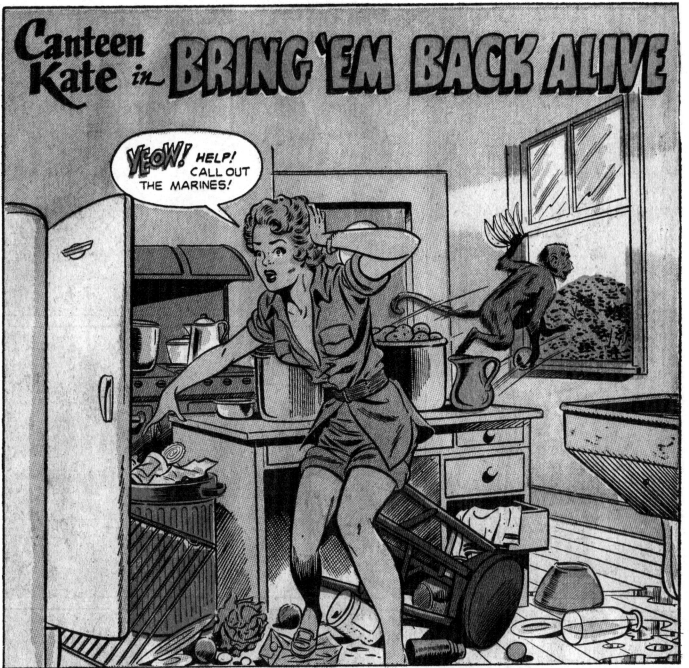

# Canteen Kate in BRING 'EM BACK ALIVE

YEOW! HELP! CALL OUT THE MARINES!

I WAS ON GUARD DUTY AND HEARD YOU SCREAM! WHAT'S THE MATTER?

AL, A MONSTER! IT RAIDED THE ICEBOX, AND THEN JUMPED OUT THE WINDOW!

HEY, KATE, GIVE ME BACK THAT RIFLE!

I'VE GOT TO BAG THAT MONSTER BEFORE HE GETS AWAY! HE WAS AT LEAST SEVEN FEET TALL!

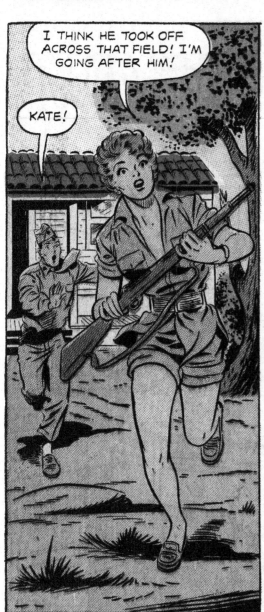

I THINK HE TOOK OFF ACROSS THAT FIELD! I'M GOING AFTER HIM!

KATE!

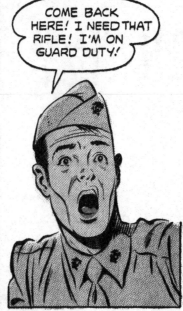

COME BACK HERE! I NEED THAT RIFLE! I'M ON GUARD DUTY!

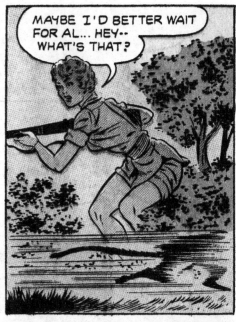

MAYBE I'D BETTER WAIT FOR AL... HEY-- WHAT'S THAT?

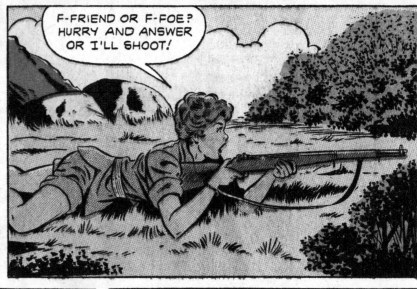

F-FRIEND OR F-FOE? HURRY AND ANSWER OR I'LL SHOOT!

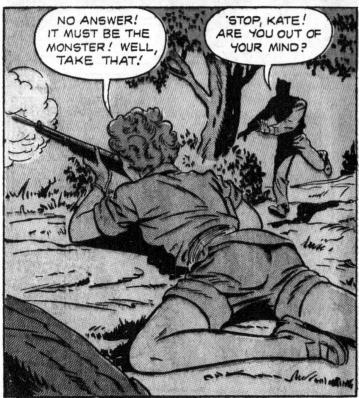

NO ANSWER! IT MUST BE THE MONSTER! WELL, TAKE THAT!

'STOP, KATE! ARE YOU OUT OF YOUR MIND?

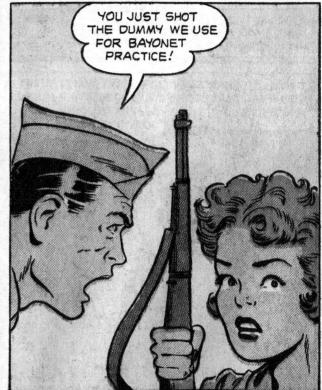

YOU JUST SHOT THE DUMMY WE USE FOR BAYONET PRACTICE!

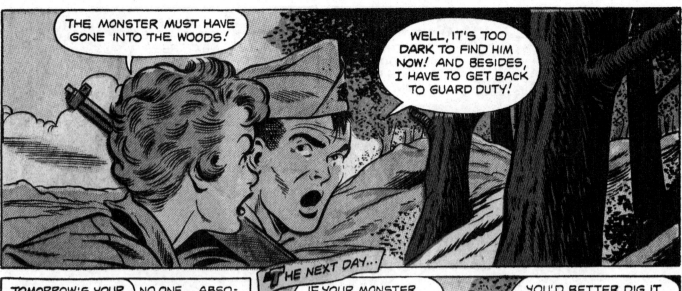

THE MONSTER MUST HAVE GONE INTO THE WOODS!

WELL, IT'S TOO DARK TO FIND HIM NOW! AND BESIDES, I HAVE TO GET BACK TO GUARD DUTY!

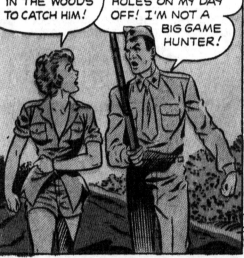

TOMORROW'S YOUR DAY OFF, ISN'T IT, AL? LET'S BUILD A TRAP IN THE WOODS TO CATCH HIM!

NO ONE... ABSOLUTELY NO ONE IS GOING TO TALK ME INTO DIGGING HOLES ON MY DAY OFF! I'M NOT A BIG GAME HUNTER!

THE NEXT DAY...

IF YOUR MONSTER DOESN'T FALL INTO THIS PIT, OUR FRIENDSHIP IS ON THE ROCKS!

YOU'D BETTER DIG IT GOOD AND DEEP THEN! I DON'T WANT A LITTLE THING LIKE A MONSTER TO COME BETWEEN US, AL!

THERE! NOW WE'LL COVER IT WITH BRANCHES AND IT'LL BE ALL SET!

AND IT ONLY TOOK YOU TWO HOURS!

HONEY, TWO HOURS ON YOUR DAY OFF IN THE MARINES IS WORTH TWO YEARS OF SUNDAYS STATESIDE! THERE ARE SOME PRETTY GIRLS IN TOWN!

IT'S MORE FUN TRAPPING A MONSTER THAN A GIRL!

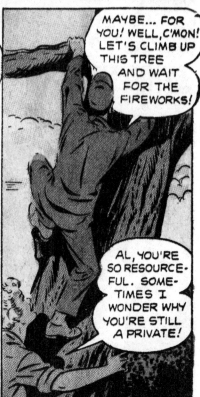

MAYBE... FOR YOU! WELL, C'MON! LET'S CLIMB UP THIS TREE AND WAIT FOR THE FIREWORKS!

AL, YOU'RE SO RESOURCEFUL. SOMETIMES I WONDER WHY YOU'RE STILL A PRIVATE!

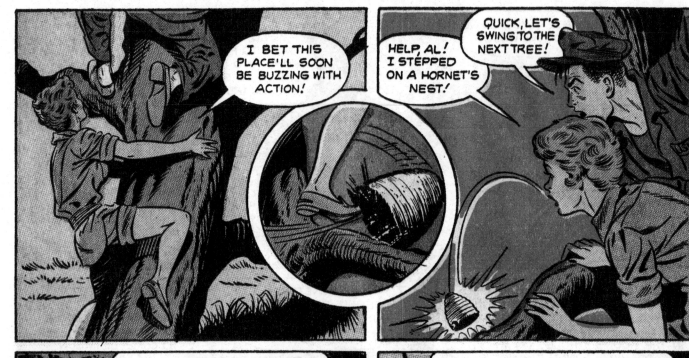

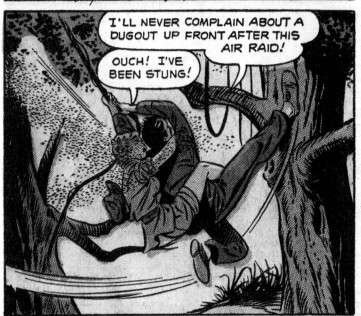

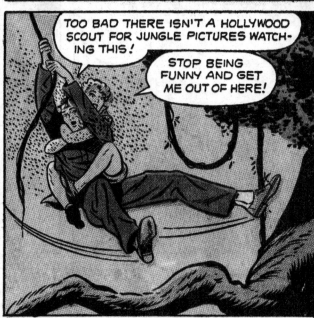

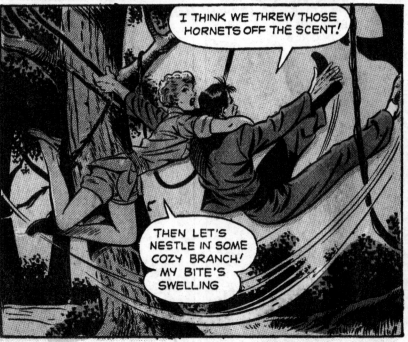

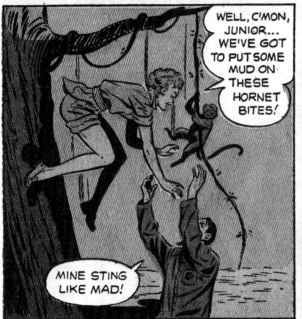

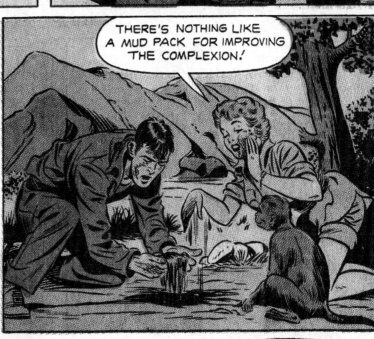

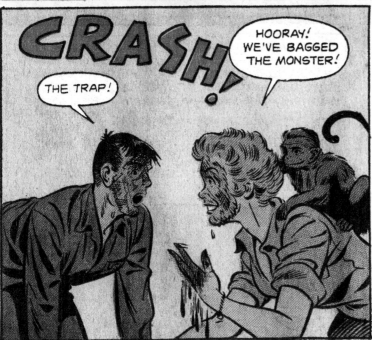

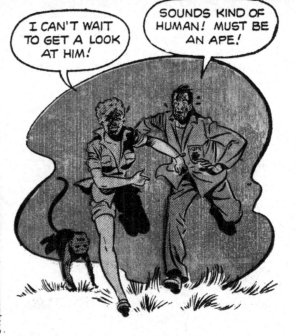

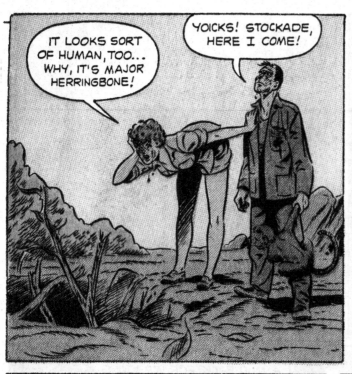

IT LOOKS SORT OF HUMAN, TOO... WHY, IT'S MAJOR HERRINGBONE!

YOICKS! STOCKADE, HERE I COME!

GET ME OUT OF HERE! QUICK! WHO ARE YOU TWO ANYWAY?

UH-- I'M PRIVATE--

SHH! AL, HE DOESN'T RECOGNIZE US WITH THESE MUD PACKS! LET'S CLEAR OUT OF HERE!

WELL, ANSWER ME!

HEY! DON'T DO THAT! YOU'R RUINING MY CAMOUFLAGE!

THE LITTLE TRAITOR!

NOW I RECOGNIZE YOU! PRIVATE AL BROWN AND CANTEEN KATE--PFFT!!

AND THEN, THAT NIGHT...

AL! I JUST FIGURED SOMETHING OUT! MY MONSTER WAS ONLY THE MONKEY'S SHADOW!

YOUR FIGURE MIGHT BE OKAY, HONEY, BUT YOUR FIGURING IS STRICTLY BEHIND THE TIMES!

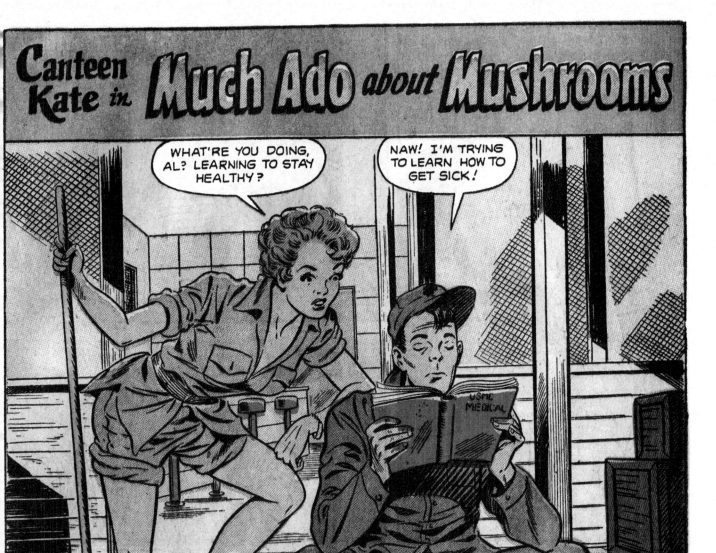

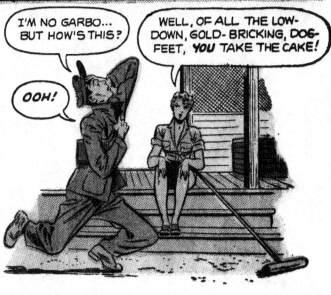

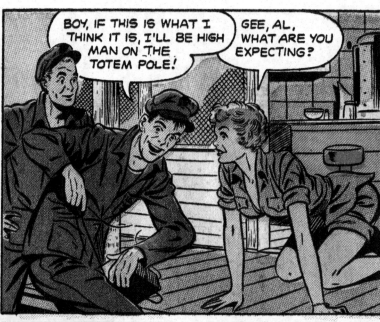

HEY, AL! MAIL JUST CAME IN! THERE'S A PACKAGE FOR YOU!

WELL, IT'S ABOUT TIME SANTA CLAUS REMEMBERED KOREA!

BOY, IF THIS IS WHAT I THINK IT IS, I'LL BE HIGH MAN ON THE TOTEM POLE!

GEE, AL, WHAT ARE YOU EXPECTING?

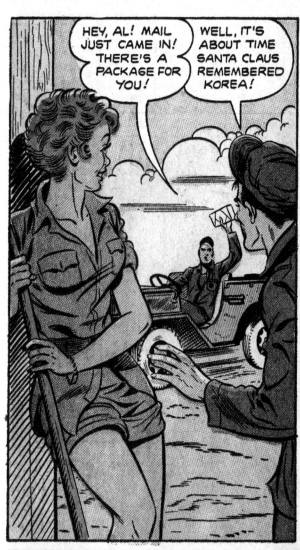

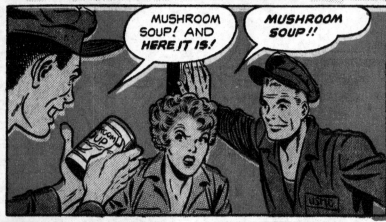

MUSHROOM SOUP! AND *HERE IT IS!*

*MUSHROOM SOUP!!*

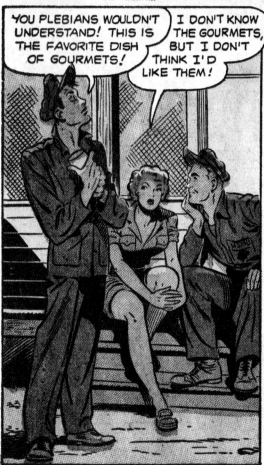

YOU PLEBIANS WOULDN'T UNDERSTAND! THIS IS THE FAVORITE DISH OF GOURMETS!

I DON'T KNOW THE GOURMETS, BUT I DON'T THINK I'D LIKE THEM!

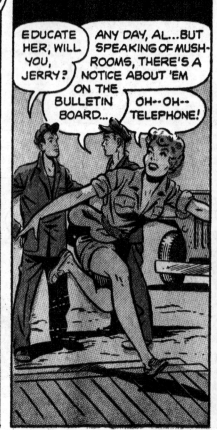

EDUCATE HER, WILL YOU, JERRY?

ANY DAY, AL...BUT SPEAKING OF MUSHROOMS, THERE'S A NOTICE ABOUT 'EM ON THE BULLETIN BOARD...

OH--OH-- TELEPHONE!

KATE...THIS IS MAJOR HERRINGBONE! I'VE GOT A YOUNG MAN IN MY OFFICE. THOUGHT HE MIGHT BE ABLE TO HELP OUT AT THE CANTEEN... INTERESTED?

INTERESTED? YESSIR! I'LL BE RIGHT OVER!

HEY, KATE! WHERE ARE YOU GOIN'? AREN'T YOU GONNA FIX THIS SOUP FOR ME?

CAN'T RIGHT NOW! LEAVE IT ON THE SHELF! I'LL FIX IT FOR YOU TONIGHT!

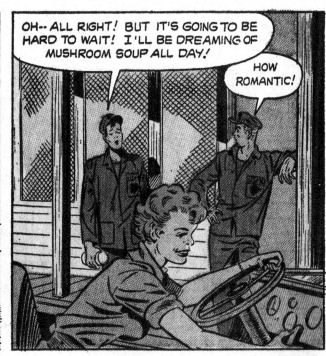

OH-- ALL RIGHT! BUT IT'S GOING TO BE HARD TO WAIT! I'LL BE DREAMING OF MUSHROOM SOUP ALL DAY!

HOW ROMANTIC!

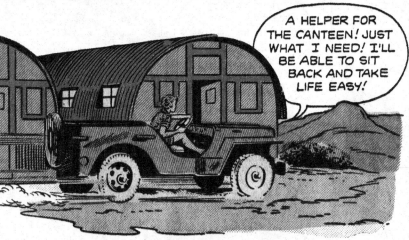

A HELPER FOR THE CANTEEN! JUST WHAT I NEED! I'LL BE ABLE TO SIT BACK AND TAKE LIFE EASY!

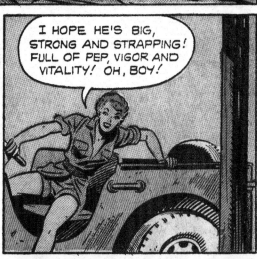

I HOPE HE'S BIG, STRONG AND STRAPPING! FULL OF PEP, VIGOR AND VITALITY! OH, BOY!

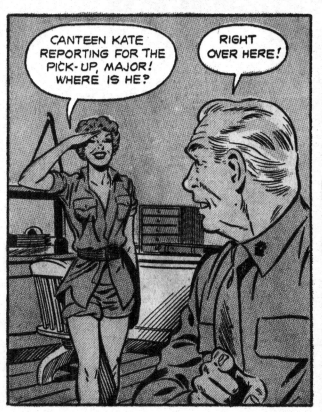

CANTEEN KATE REPORTING FOR THE PICK-UP, MAJOR! WHERE IS HE?

RIGHT OVER HERE!

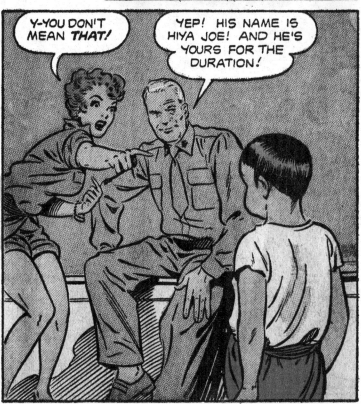

Y-YOU DON'T MEAN THAT!

YEP! HIS NAME IS HIYA JOE! AND HE'S YOURS FOR THE DURATION!

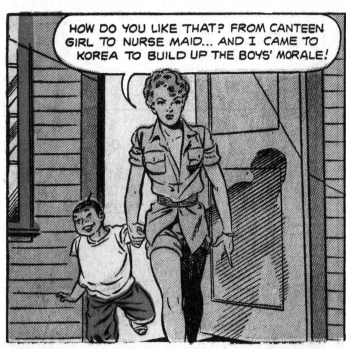

HOW DO YOU LIKE THAT? FROM CANTEEN GIRL TO NURSE MAID... AND I CAME TO KOREA TO BUILD UP THE BOYS' MORALE!

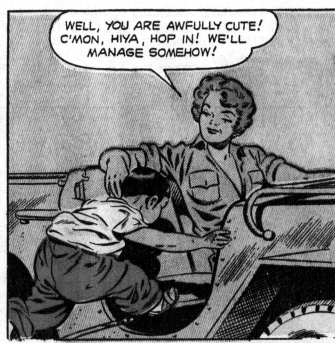

WELL, YOU ARE AWFULLY CUTE! C'MON, HIYA, HOP IN! WE'LL MANAGE SOMEHOW!

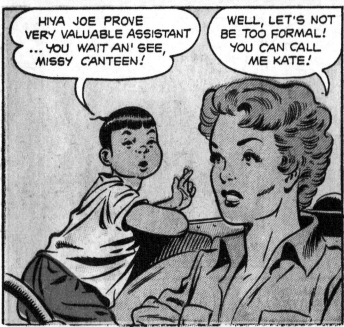

HIYA JOE PROVE VERY VALUABLE ASSISTANT ... YOU WAIT AN' SEE, MISSY CANTEEN!

WELL, LET'S NOT BE TOO FORMAL! YOU CAN CALL ME KATE!

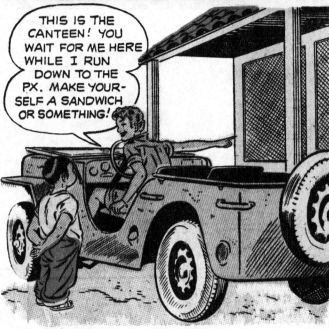

THIS IS THE CANTEEN! YOU WAIT FOR ME HERE WHILE I RUN DOWN TO THE PX. MAKE YOUR-SELF A SANDWICH OR SOMETHING!

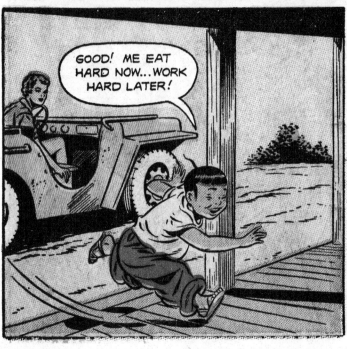

GOOD! ME EAT HARD NOW...WORK HARD LATER!

SMART KID! MAYBE HE'LL TURN OUT TO BE A PRIZE PACKAGE, AFTER ALL! AND THE BOYS WILL LOVE HIM ...PARTICULARLY AL!

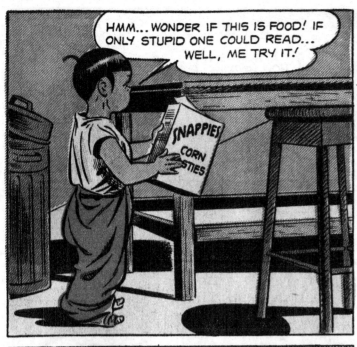

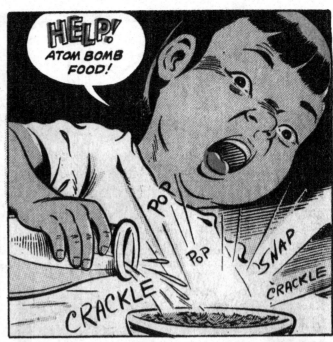

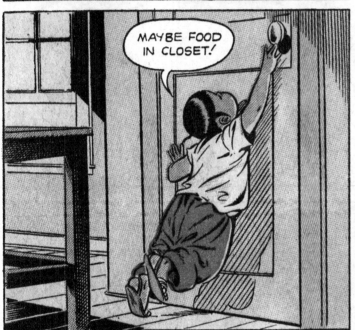

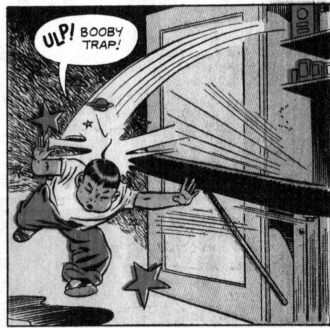

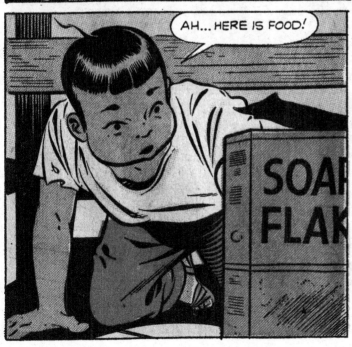

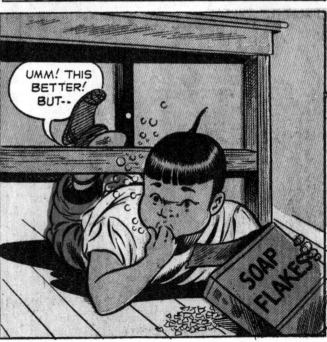

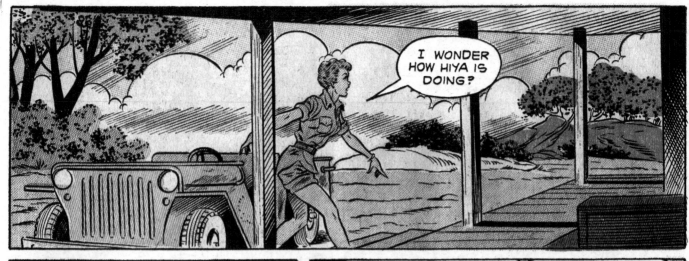

I WONDER HOW HIYA IS DOING?

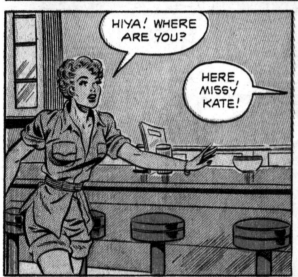

HIYA! WHERE ARE YOU?

HERE, MISSY KATE!

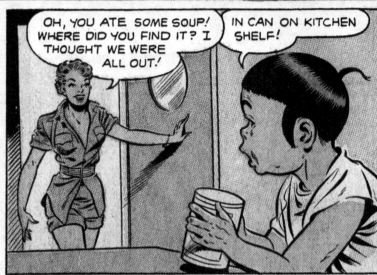

OH, YOU ATE SOME SOUP! WHERE DID YOU FIND IT? I THOUGHT WE WERE ALL OUT!

IN CAN ON KITCHEN SHELF!

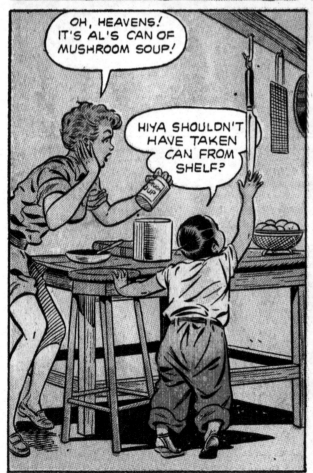

OH, HEAVENS! IT'S AL'S CAN OF MUSHROOM SOUP!

HIYA SHOULDN'T HAVE TAKEN CAN FROM SHELF?

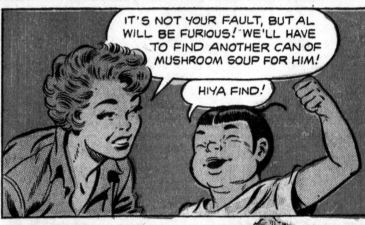

IT'S NOT YOUR FAULT, BUT AL WILL BE FURIOUS! WE'LL HAVE TO FIND ANOTHER CAN OF MUSHROOM SOUP FOR HIM!

HIYA FIND!

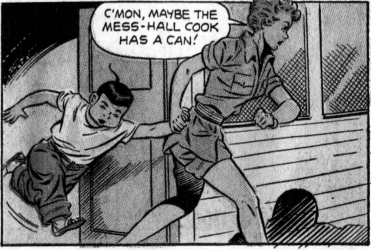

C'MON, MAYBE THE MESS-HALL COOK HAS A CAN!

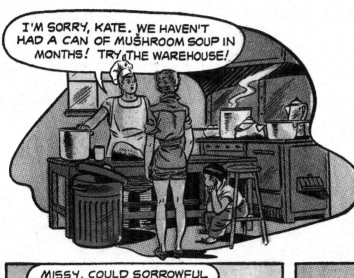

I'M SORRY, KATE. WE HAVEN'T HAD A CAN OF MUSHROOM SOUP IN MONTHS! TRY THE WAREHOUSE!

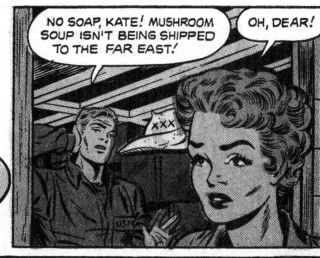

NO SOAP, KATE! MUSHROOM SOUP ISN'T BEING SHIPPED TO THE FAR EAST!

OH, DEAR!

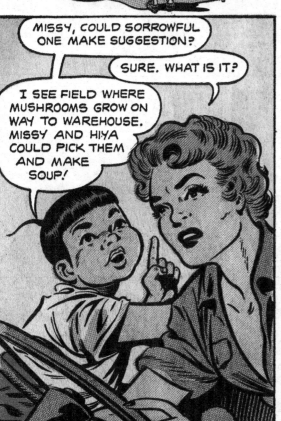

MISSY, COULD SORROWFUL ONE MAKE SUGGESTION?

SURE. WHAT IS IT?

I SEE FIELD WHERE MUSHROOMS GROW ON WAY TO WAREHOUSE. MISSY AND HIYA COULD PICK THEM AND MAKE SOUP!

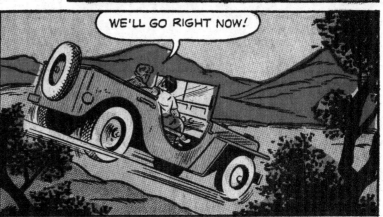

WE'LL GO RIGHT NOW!

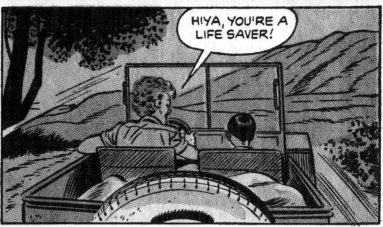

HIYA, YOU'RE A LIFE SAVER!

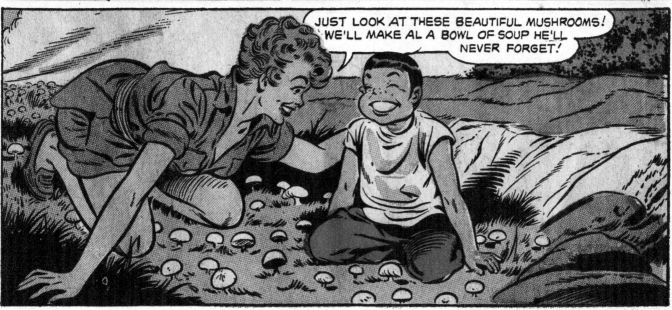

JUST LOOK AT THESE BEAUTIFUL MUSHROOMS! WE'LL MAKE AL A BOWL OF SOUP HE'LL NEVER FORGET!

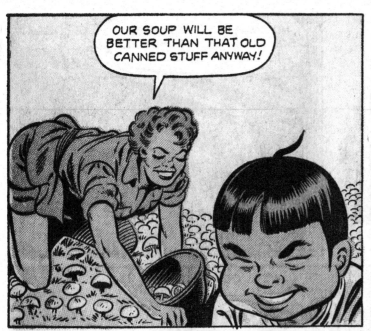

OUR SOUP WILL BE BETTER THAN THAT OLD CANNED STUFF ANYWAY!

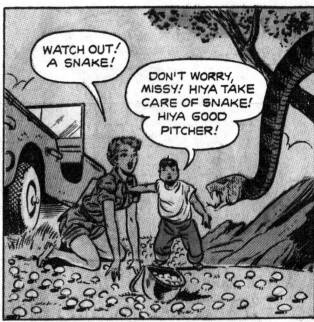

WATCH OUT! A SNAKE!

DON'T WORRY, MISSY! HIYA TAKE CARE OF SNAKE! HIYA GOOD PITCHER!

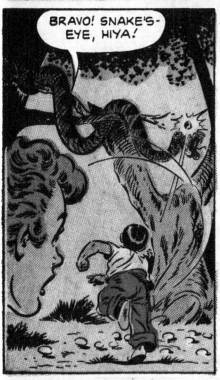

BRAVO! SNAKE'S-EYE, HIYA!

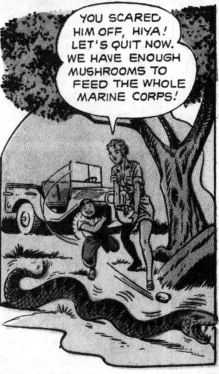

YOU SCARED HIM OFF, HIYA! LET'S QUIT NOW. WE HAVE ENOUGH MUSHROOMS TO FEED THE WHOLE MARINE CORPS!

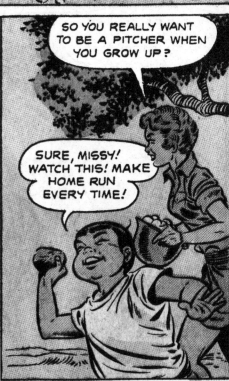

SO YOU REALLY WANT TO BE A PITCHER WHEN YOU GROW UP?

SURE, MISSY! WATCH THIS! MAKE HOME RUN EVERY TIME!

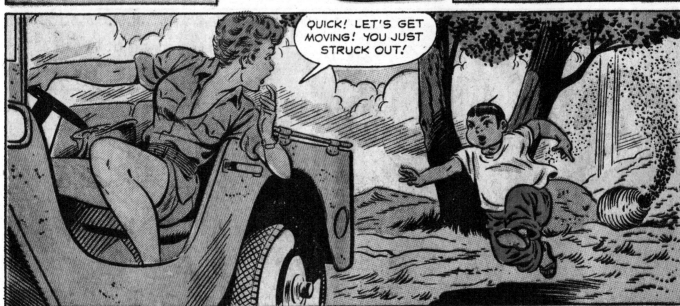

QUICK! LET'S GET MOVING! YOU JUST STRUCK OUT!

EARLY THAT EVENING...

HIYA DEEPLY SORRY ABOUT HORNETS, MISSY KATE!

FORGET IT, HIYA! IT WAS WORTH IT TO GET THIS SOUP FOR AL!

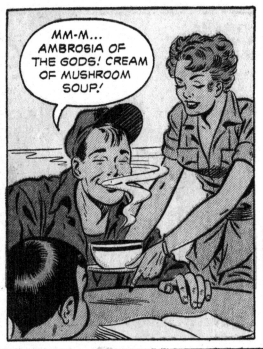

MM-M... AMBROSIA OF THE GODS! CREAM OF MUSHROOM SOUP!

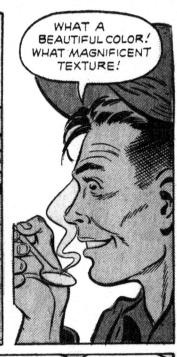

WHAT A BEAUTIFUL COLOR! WHAT MAGNIFICENT TEXTURE!

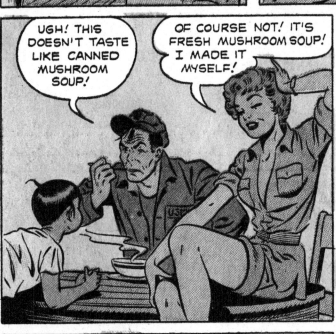

UGH! THIS DOESN'T TASTE LIKE CANNED MUSHROOM SOUP!

OF COURSE NOT! IT'S FRESH MUSHROOM SOUP! I MADE IT MYSELF!

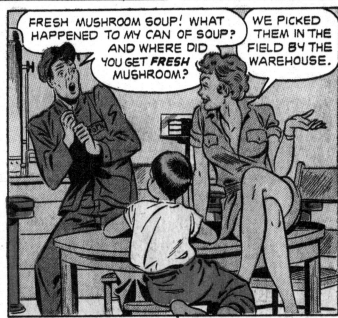

FRESH MUSHROOM SOUP! WHAT HAPPENED TO MY CAN OF SOUP? AND WHERE DID YOU GET FRESH MUSHROOM?

WE PICKED THEM IN THE FIELD BY THE WAREHOUSE.

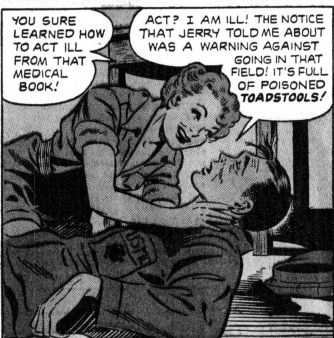

YOU SURE LEARNED HOW TO ACT ILL FROM THAT MEDICAL BOOK!

ACT? I AM ILL! THE NOTICE THAT JERRY TOLD ME ABOUT WAS A WARNING AGAINST GOING IN THAT FIELD! IT'S FULL OF POISONED TOADSTOOLS!

THE DOC SAYS YOU'LL BE HERE FOR A WEEK. WELL, YOU WANTED TO GO ON SICK CALL, DIDN'T YOU?

YEAH, BUT I DIDN'T WANT TO BE SICK WHEN I WENT!

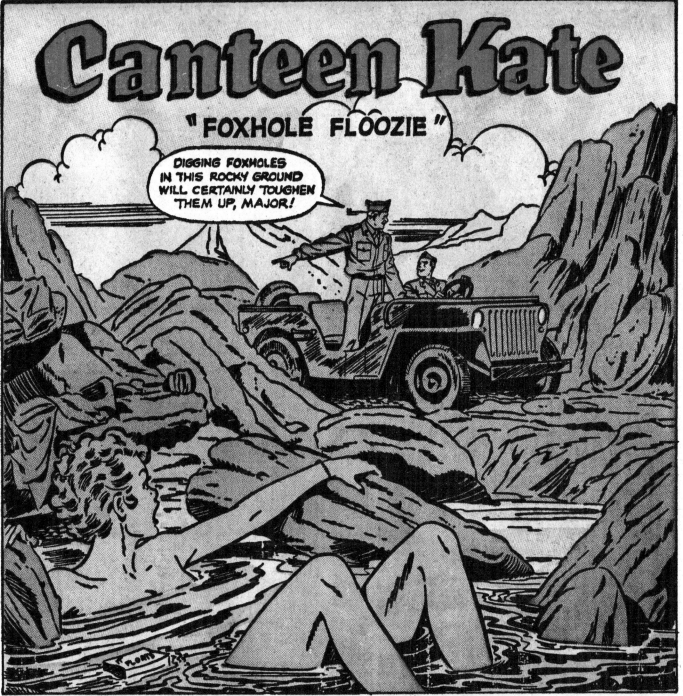

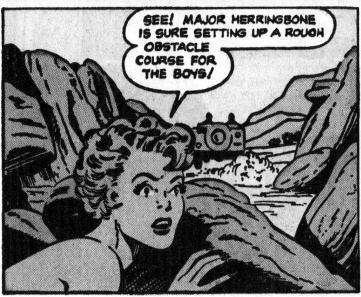

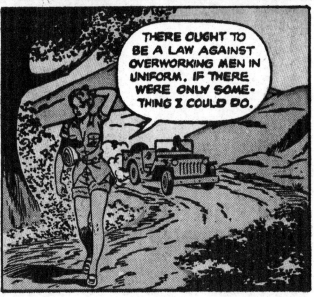

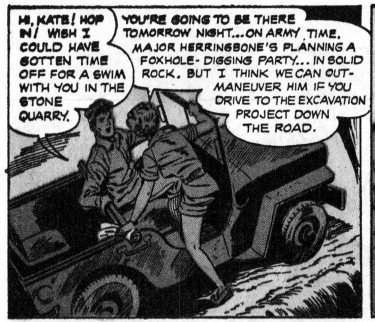

HI, KATE! HOP IN! WISH I COULD HAVE GOTTEN TIME OFF FOR A SWIM WITH YOU IN THE STONE QUARRY.

YOU'RE GOING TO BE THERE TOMORROW NIGHT...ON ARMY TIME. MAJOR HERRINGBONE'S PLANNING A FOXHOLE-DIGGING PARTY... IN SOLID ROCK. BUT I THINK WE CAN OUT-MANEUVER HIM IF YOU DRIVE TO THE EXCAVATION PROJECT DOWN THE ROAD.

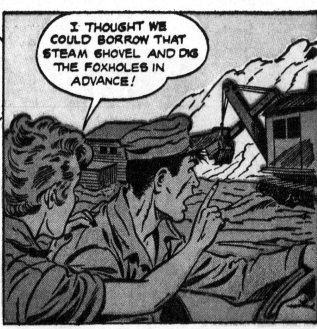

I THOUGHT WE COULD BORROW THAT STEAM SHOVEL AND DIG THE FOXHOLES IN ADVANCE!

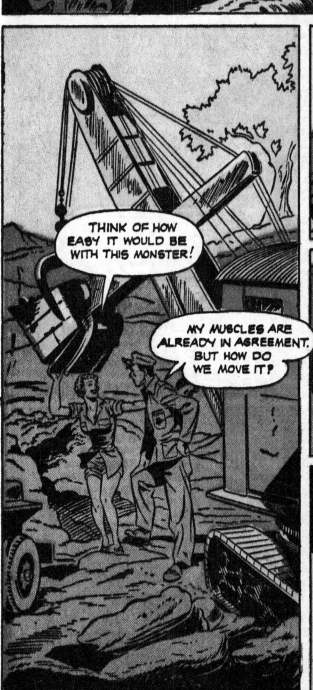

THINK OF HOW EASY IT WOULD BE WITH THIS MONSTER!

MY MUSCLES ARE ALREADY IN AGREEMENT. BUT HOW DO WE MOVE IT?

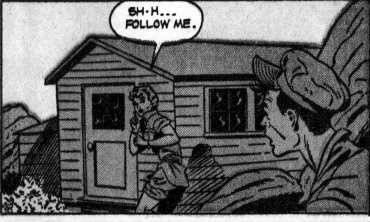

SH-H... FOLLOW ME.

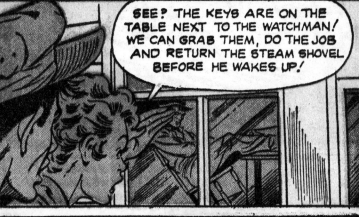

SEE? THE KEYS ARE ON THE TABLE NEXT TO THE WATCHMAN! WE CAN GRAB THEM, DO THE JOB AND RETURN THE STEAM SHOVEL BEFORE HE WAKES UP!

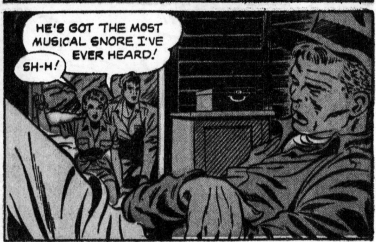

HE'S GOT THE MOST MUSICAL SNORE I'VE EVER HEARD!

SH-H!

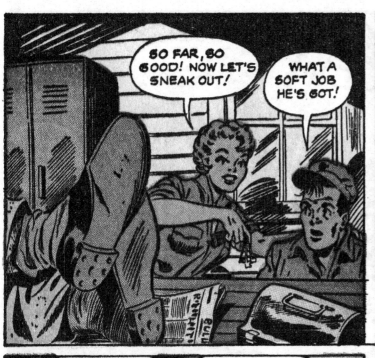

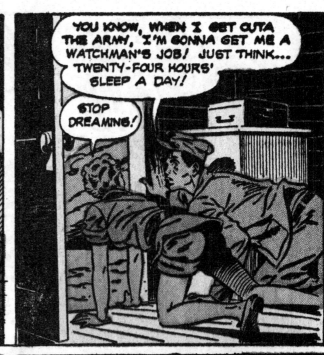

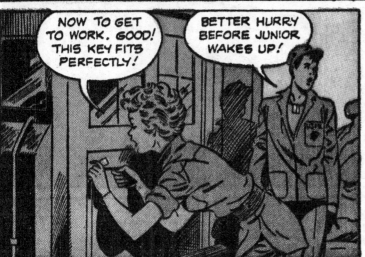

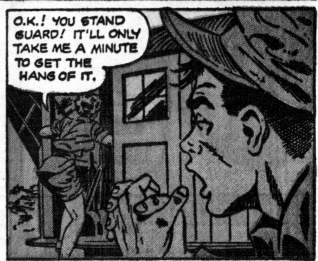

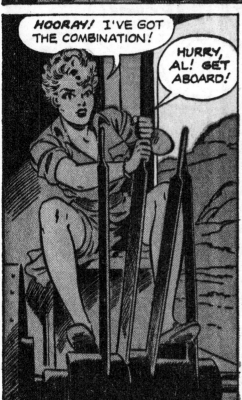

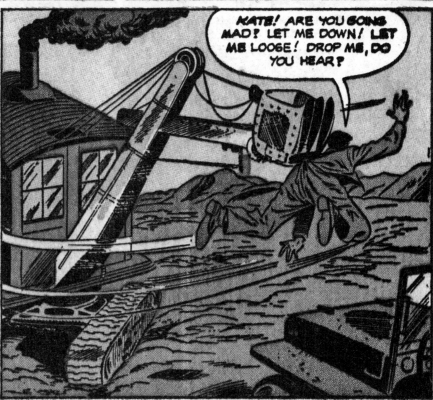

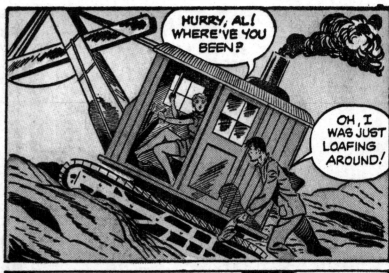

HURRY, AL! WHERE'VE YOU BEEN?

OH, I WAS JUST LOAFING AROUND!

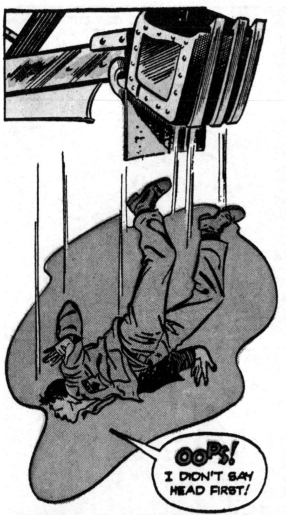

OOPS! I DIDN'T SAY HEAD FIRST!

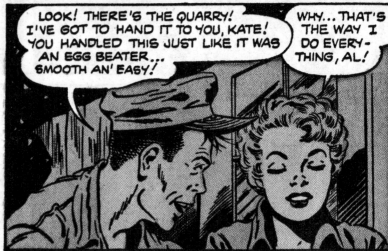

LOOK! THERE'S THE QUARRY! I'VE GOT TO HAND IT TO YOU, KATE! YOU HANDLED THIS JUST LIKE IT WAS AN EGG BEATER... SMOOTH AN' EASY!

WHY... THAT'S THE WAY I DO EVERY-THING, AL!

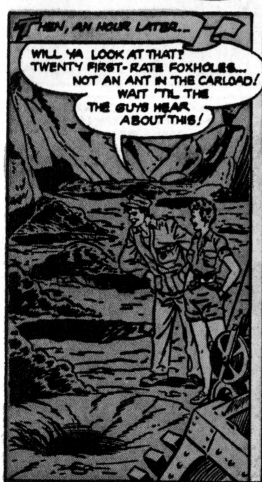

THEN, AN HOUR LATER...

WILL YA LOOK AT THAT? TWENTY FIRST-RATE FOXHOLES... NOT AN ANT IN THE CARLOAD! WAIT 'TIL THE THE GUYS HEAR ABOUT THIS!

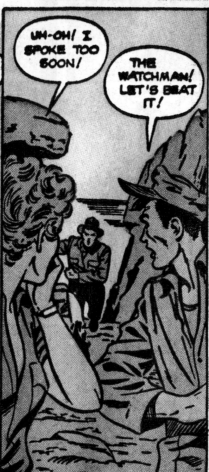

UM-OH! I SPOKE TOO SOON!

THE WATCHMAN! LET'S BEAT IT!

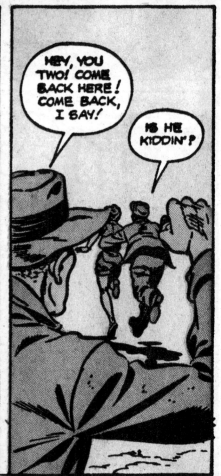

HEY, YOU TWO! COME BACK HERE! COME BACK, I SAY!

IS HE KIDDIN'?

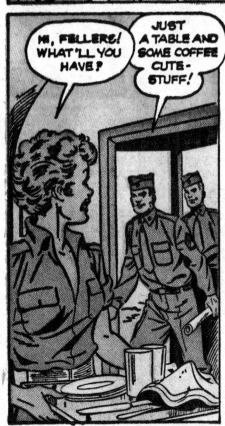

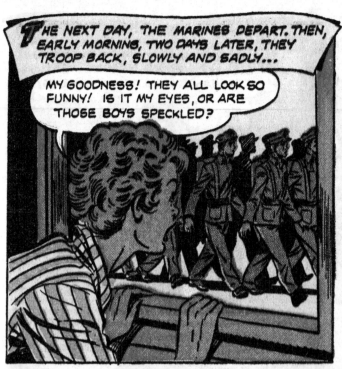

THE NEXT DAY, THE MARINES DEPART. THEN, EARLY MORNING, TWO DAYS LATER, THEY TROOP BACK, SLOWLY AND SADLY...

MY GOODNESS! THEY ALL LOOK SO FUNNY! IS IT MY EYES, OR ARE THOSE BOYS SPECKLED?

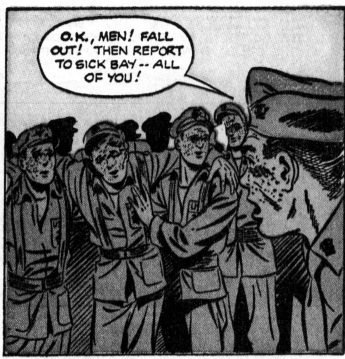

O.K., MEN! FALL OUT! THEN REPORT TO SICK BAY -- ALL OF YOU!

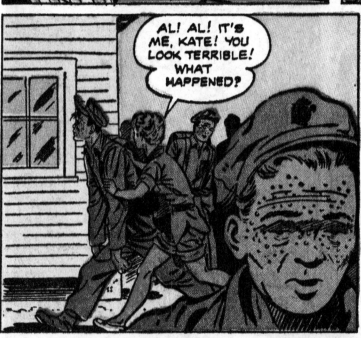

AL! AL! IT'S ME, KATE! YOU LOOK TERRIBLE! WHAT HAPPENED?

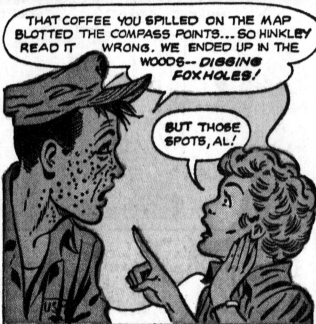

THAT COFFEE YOU SPILLED ON THE MAP BLOTTED THE COMPASS POINTS... SO HINKLEY READ IT WRONG. WE ENDED UP IN THE WOODS-- DIGGING FOXHOLES!

BUT THOSE SPOTS, AL!

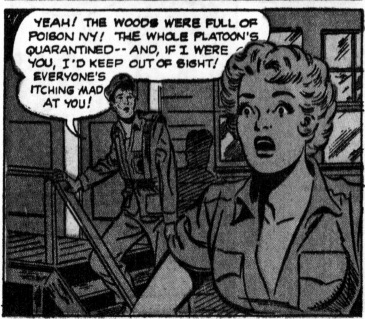

YEAH! THE WOODS WERE FULL OF POISON IVY! THE WHOLE PLATOON'S QUARANTINED-- AND, IF I WERE YOU, I'D KEEP OUT OF SIGHT! EVERYONE'S ITCHING MAD AT YOU!

WELL, THESE FOXHOLES WEREN'T WASTED AFTER ALL. I'LL HIDE HERE UNTIL IT'S SAFE TO GO BACK TO THE BASE!

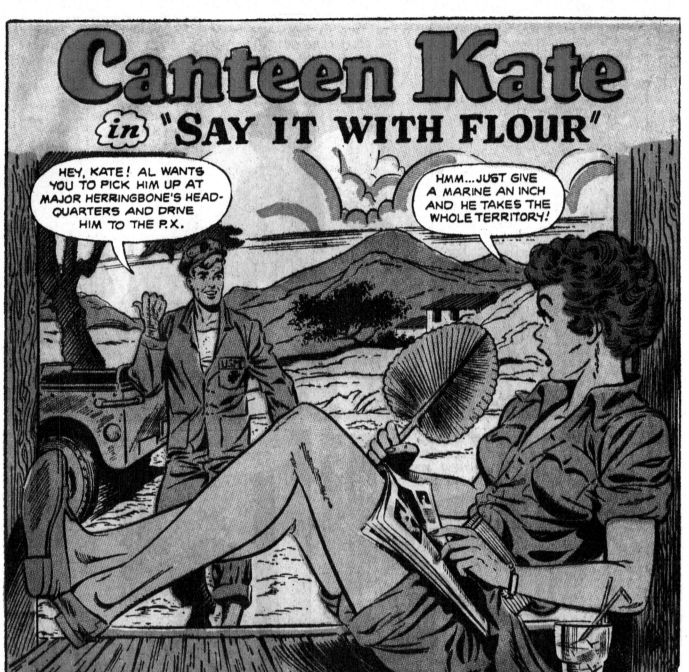

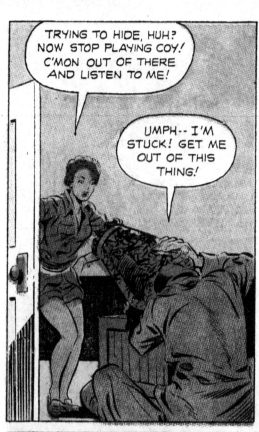

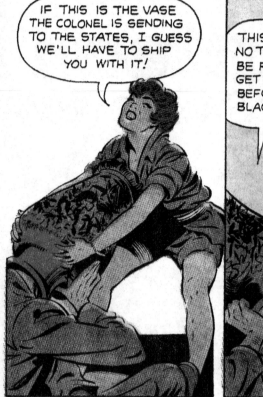

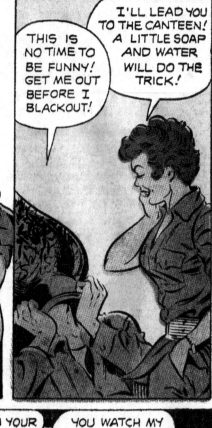

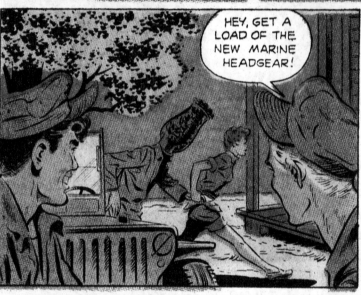

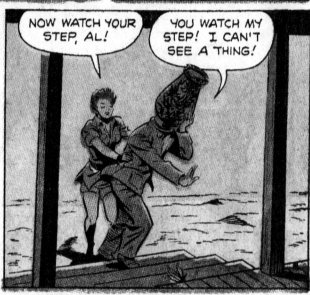

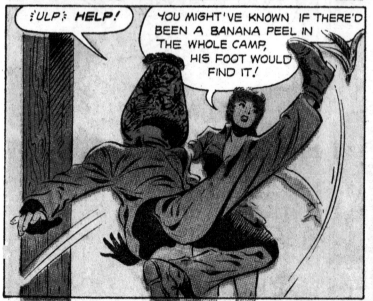

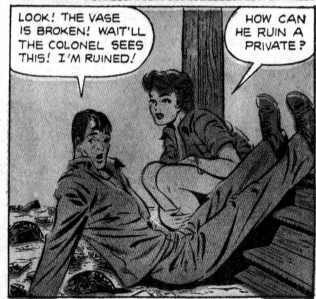

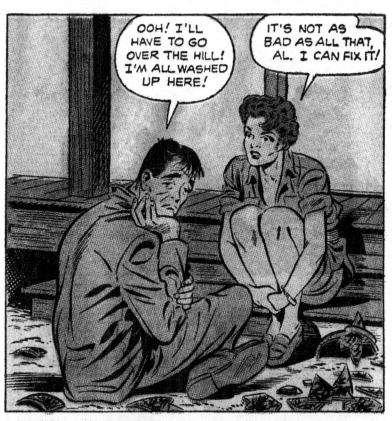

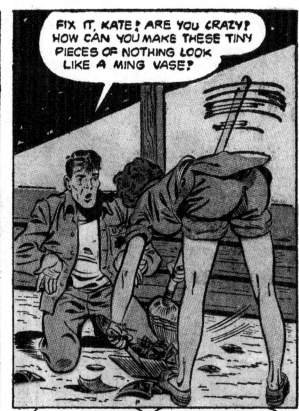

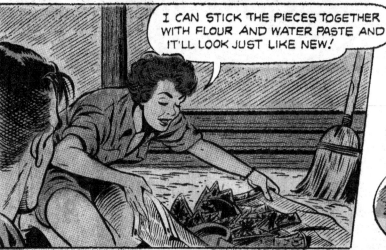

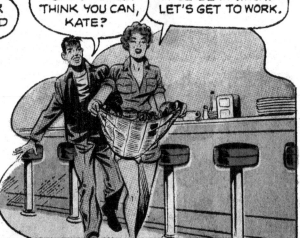

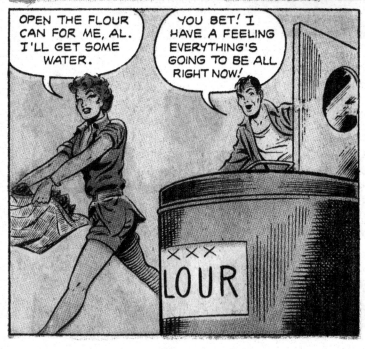

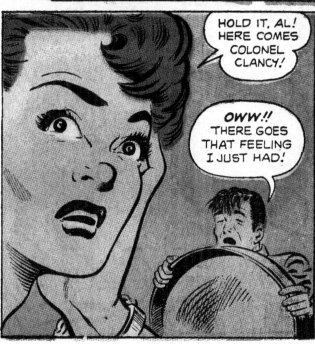

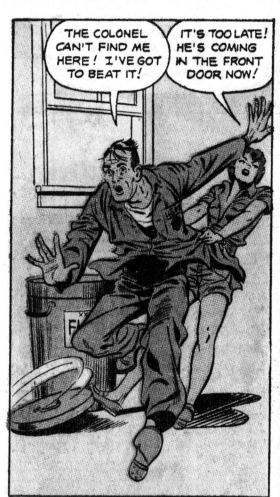

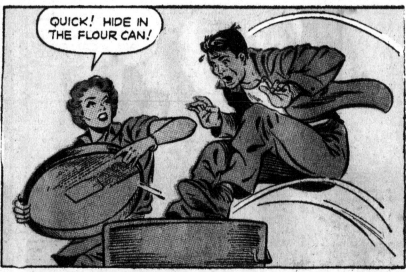

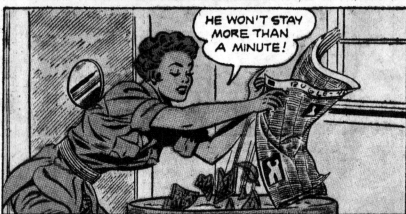

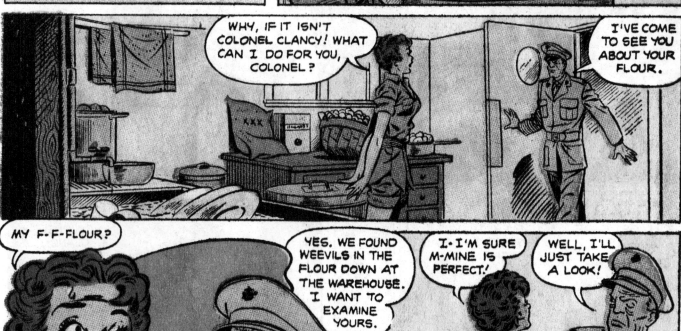

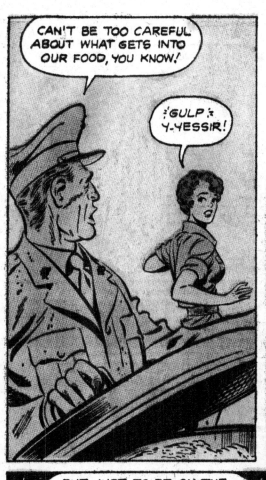

CAN'T BE TOO CAREFUL ABOUT WHAT GETS INTO OUR FOOD, YOU KNOW!

:GULP: Y-YESSIR!

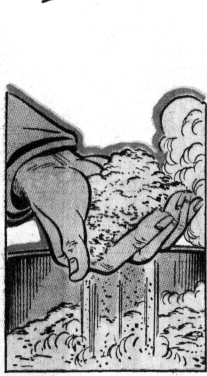

HMMM...

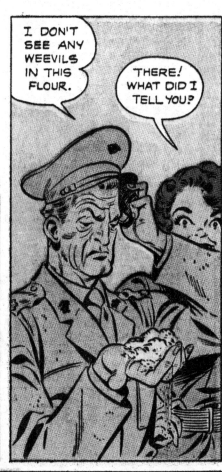

I DON'T SEE ANY WEEVILS IN THIS FLOUR.

THERE! WHAT DID I TELL YOU?

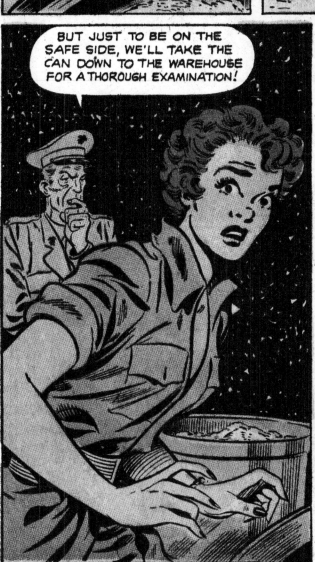

BUT JUST TO BE ON THE SAFE SIDE, WE'LL TAKE THE CAN DOWN TO THE WAREHOUSE FOR A THOROUGH EXAMINATION!

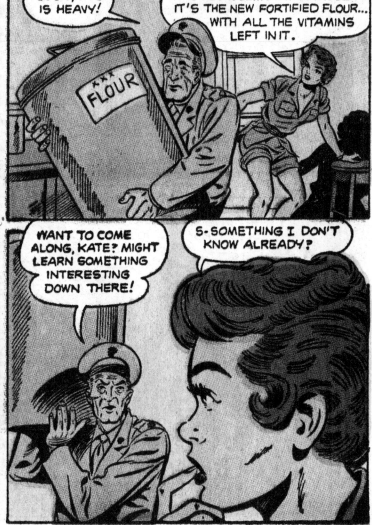

GOSH, THIS IS HEAVY!

IT'S BECAUSE... ER... BECAUSE IT'S THE NEW FORTIFIED FLOUR... WITH ALL THE VITAMINS LEFT IN IT.

FLOUR

WANT TO COME ALONG, KATE? MIGHT LEARN SOMETHING INTERESTING DOWN THERE!

S-SOMETHING I DON'T KNOW ALREADY?

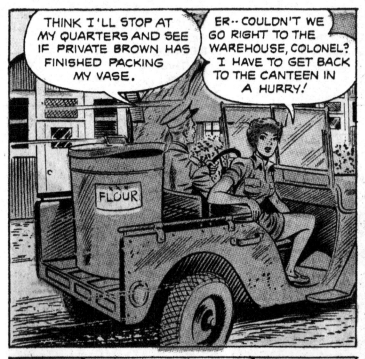

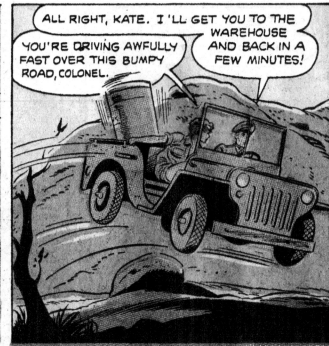

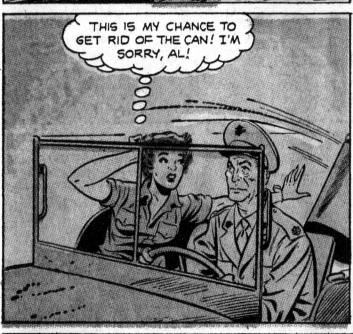

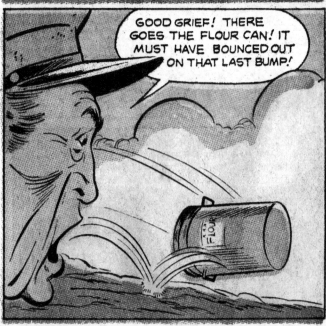

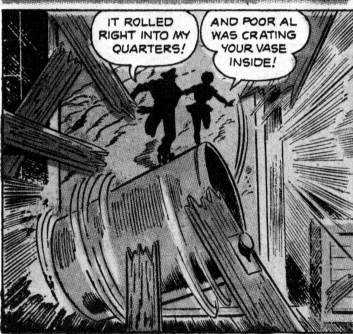

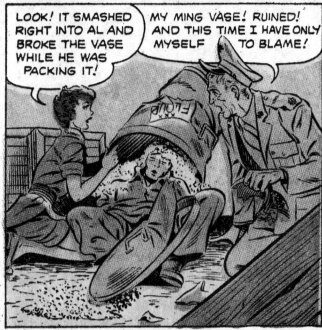

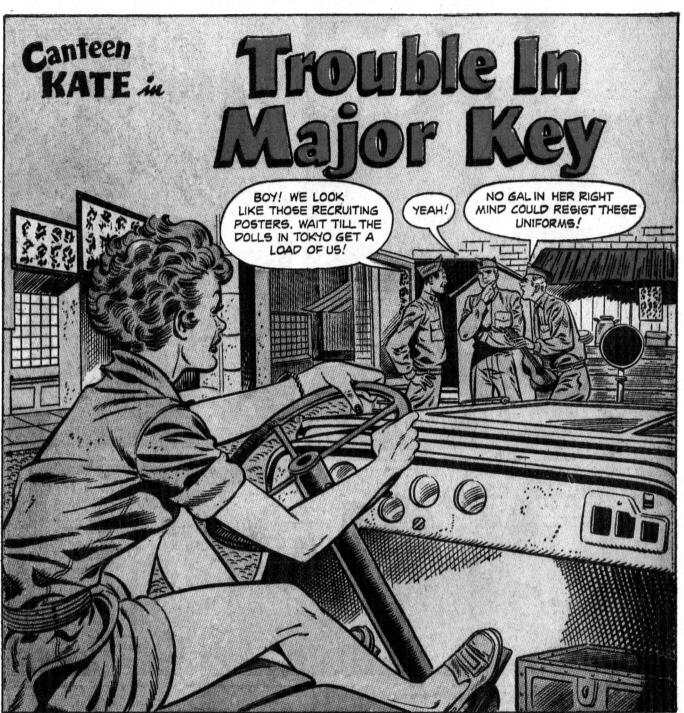

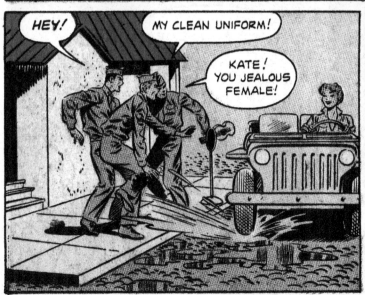

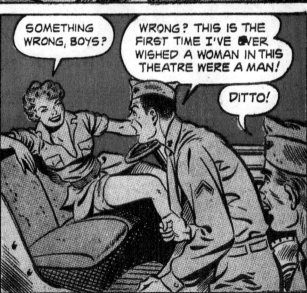

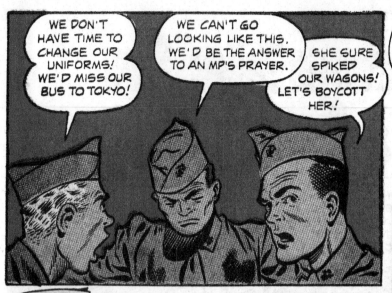

WE DON'T HAVE TIME TO CHANGE OUR UNIFORMS! WE'D MISS OUR BUS TO TOKYO!

WE CAN'T GO LOOKING LIKE THIS. WE'D BE THE ANSWER TO AN MP'S PRAYER.

SHE SURE SPIKED OUR WAGONS! LET'S BOYCOTT HER!

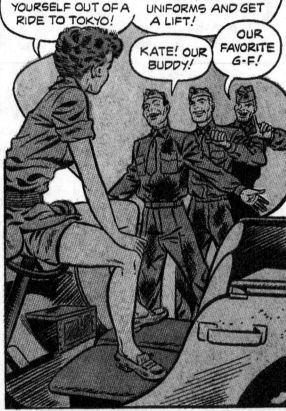

BOYCOTT ME AND YOU BOYCOTT YOURSELF OUT OF A RIDE TO TOKYO!

YOU BOYS COULD STILL CHANGE INTO CLEAN UNIFORMS AND GET A LIFT!

KATE! OUR BUDDY!

OUR FAVORITE G-F!

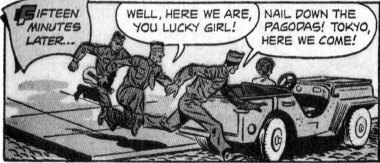

FIFTEEN MINUTES LATER...

WELL, HERE WE ARE, YOU LUCKY GIRL!

NAIL DOWN THE PAGODAS! TOKYO, HERE WE COME!

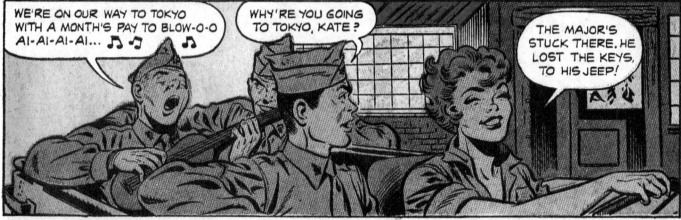

WE'RE ON OUR WAY TO TOKYO WITH A MONTH'S PAY TO BLOW-O-O AI-AI-AI-AI... ♪ ♫ ♪

WHY'RE YOU GOING TO TOKYO, KATE?

THE MAJOR'S STUCK THERE. HE LOST THE KEYS, TO HIS JEEP!

AND YOU'RE RESCUING HIM, HUH?

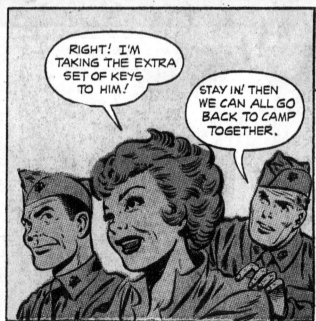

RIGHT! I'M TAKING THE EXTRA SET OF KEYS TO HIM!

STAY IN! THEN WE CAN ALL GO BACK TO CAMP TOGETHER.

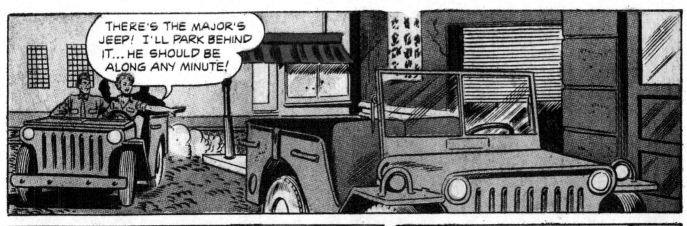

THERE'S THE MAJOR'S JEEP! I'LL PARK BEHIND IT... HE SHOULD BE ALONG ANY MINUTE!

THANKS FOR THE LIFT, KATE!

WE'LL MEET YOU HERE TONIGHT.

HEY! POP YOUR PUPILS AT THOSE EAGER-BEAVER MP'S EXAMINING PASSES.

I HOPE YOU HAVE YOURS.

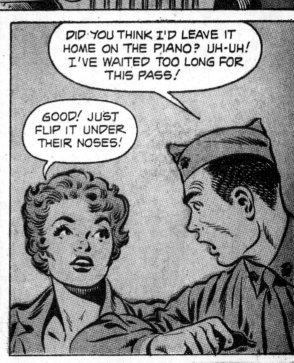

DID YOU THINK I'D LEAVE IT HOME ON THE PIANO? UH-UH! I'VE WAITED TOO LONG FOR THIS PASS!

GOOD! JUST FLIP IT UNDER THEIR NOSES!

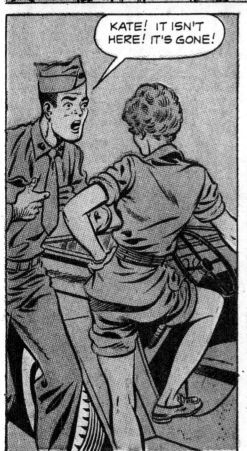

KATE! IT ISN'T HERE! IT'S GONE!

I *KNOW* I HAD IT! I... JIMINY! COULD I HAVE LEFT IT IN MY OTHER UNIFORM?

NO-O. I PUT IT IN A SAFE PLACE SO I WOULDN'T LOSE IT! BUT WHERE?

THIS IS NO TIME FOR A MEMORY COURSE! HERE COME THE MP'S!

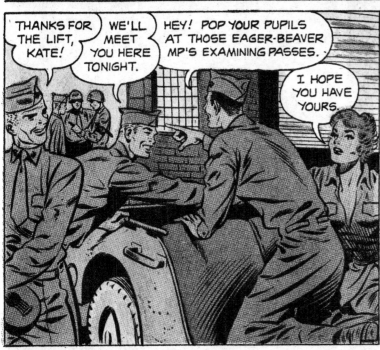

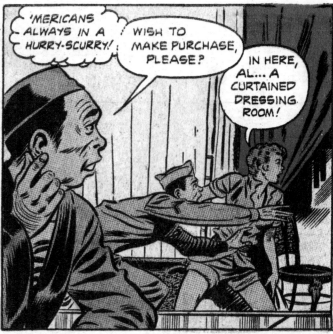

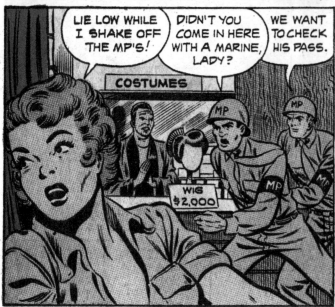

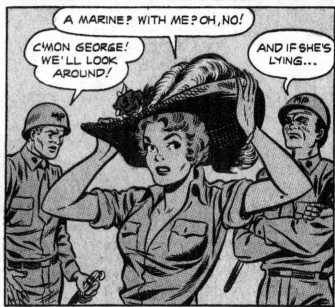

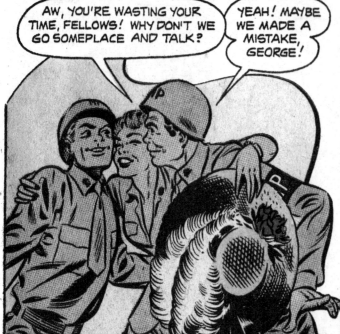

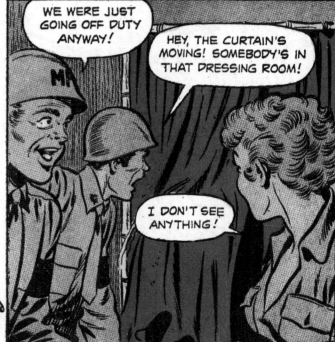

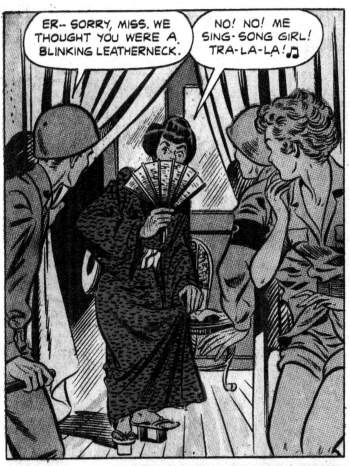

ER-- SORRY, MISS. WE THOUGHT YOU WERE A BLINKING LEATHERNECK.

NO! NO! ME SING-SONG GIRL! TRA-LA-LA! ♫

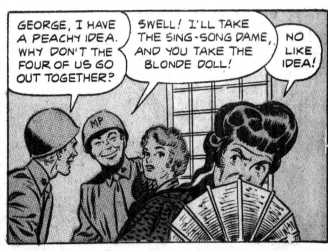

GEORGE, I HAVE A PEACHY IDEA. WHY DON'T THE FOUR OF US GO OUT TOGETHER?

SWELL! I'LL TAKE THE SING-SONG DAME, AND YOU TAKE THE BLONDE DOLL!

NO LIKE IDEA!

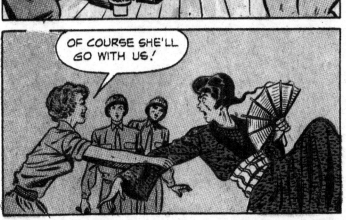

OF COURSE SHE'LL GO WITH US!

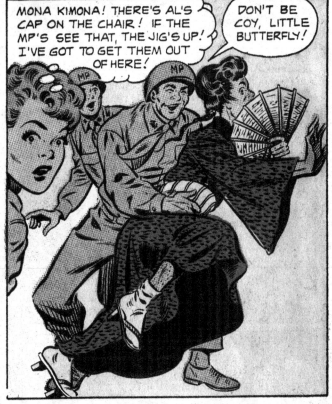

MONA KIMONA! THERE'S AL'S CAP ON THE CHAIR! IF THE MP'S SEE THAT, THE JIG'S UP! I'VE GOT TO GET THEM OUT OF HERE!

DON'T BE COY, LITTLE BUTTERFLY!

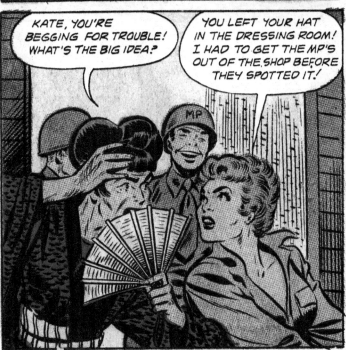

KATE, YOU'RE BEGGING FOR TROUBLE! WHAT'S THE BIG IDEA?

YOU LEFT YOUR HAT IN THE DRESSING ROOM! I HAD TO GET THE MP'S OUT OF THE SHOP BEFORE THEY SPOTTED IT!

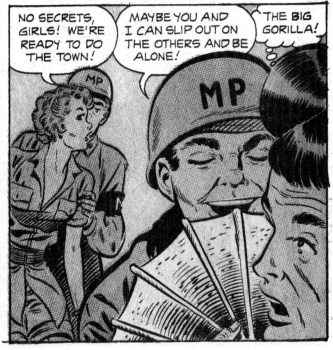

NO SECRETS, GIRLS! WE'RE READY TO DO THE TOWN!

MAYBE YOU AND I CAN SLIP OUT ON THE OTHERS AND BE ALONE!

THE BIG GORILLA!

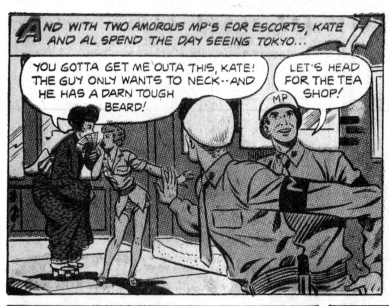

YOU GOTTA GET ME OUTA THIS, KATE! THE GUY ONLY WANTS TO NECK--AND HE HAS A DARN TOUGH BEARD!

LET'S HEAD FOR THE TEA SHOP!

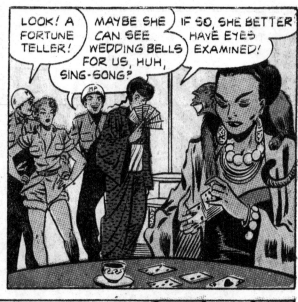

LOOK! A FORTUNE TELLER!

MAYBE SHE CAN SEE WEDDING BELLS FOR US, HUH, SING-SONG?

IF SO, SHE BETTER HAVE EYES EXAMINED!

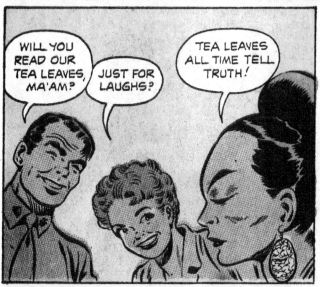

WILL YOU READ OUR TEA LEAVES, MA'AM?

JUST FOR LAUGHS?

TEA LEAVES ALL TIME TELL TRUTH!

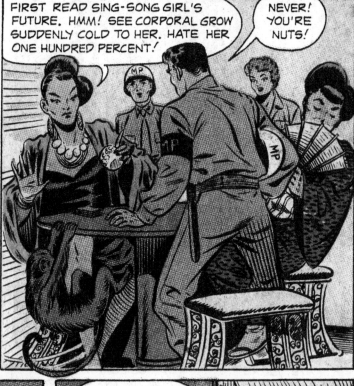

FIRST READ SING-SONG GIRL'S FUTURE. HMM! SEE CORPORAL GROW SUDDENLY COLD TO HER. HATE HER ONE HUNDRED PERCENT!

NEVER! YOU'RE NUTS!

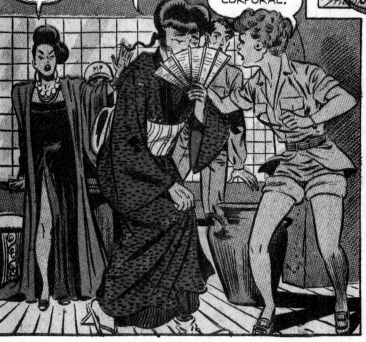

WAIT! THERE'S MORE!

SING-SONG GIRL MUST LEAVE! NO WISH TO STAY AND BE HATED!

YEAH! WE HAVE TO GO! YOU'RE JUST NOT HER DISH OF TEA, CORPORAL!

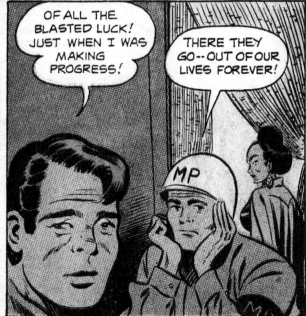

OF ALL THE BLASTED LUCK! JUST WHEN I WAS MAKING PROGRESS!

THERE THEY GO-- OUT OF OUR LIVES FOREVER!

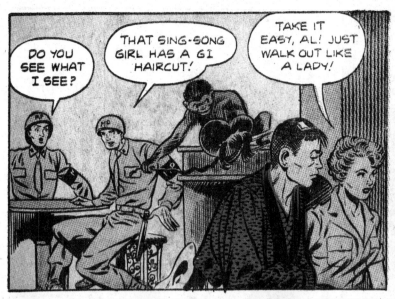

DO YOU SEE WHAT I SEE?

THAT SING-SONG GIRL HAS A GI HAIRCUT!

TAKE IT EASY, AL! JUST WALK OUT LIKE A LADY!

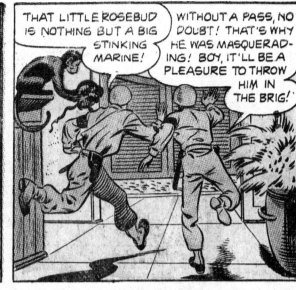

THAT LITTLE ROSEBUD IS NOTHING BUT A BIG STINKING MARINE!

WITHOUT A PASS, NO DOUBT! THAT'S WHY HE WAS MASQUERADING! BOY, IT'LL BE A PLEASURE TO THROW HIM IN THE BRIG!

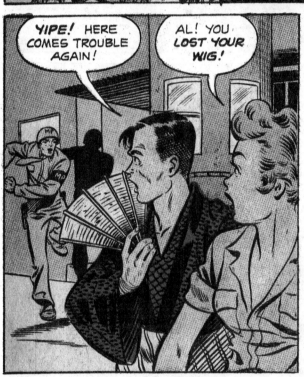

YIPE! HERE COMES TROUBLE AGAIN!

AL! YOU LOST YOUR WIG!

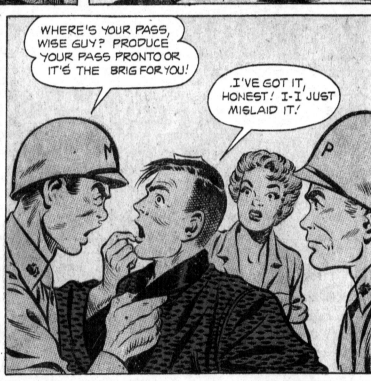

WHERE'S YOUR PASS, WISE GUY? PRODUCE YOUR PASS PRONTO OR IT'S THE BRIG FOR YOU!

.I'VE GOT IT, HONEST! I-I JUST MISLAID IT!

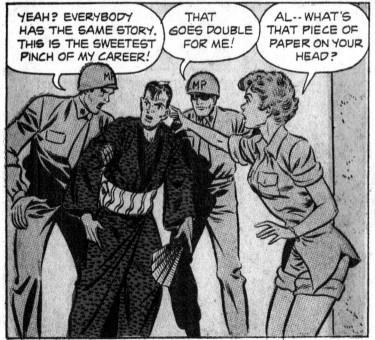

YEAH? EVERYBODY HAS THE SAME STORY. THIS IS THE SWEETEST PINCH OF MY CAREER!

THAT GOES DOUBLE FOR ME!

AL--WHAT'S THAT PIECE OF PAPER ON YOUR HEAD?

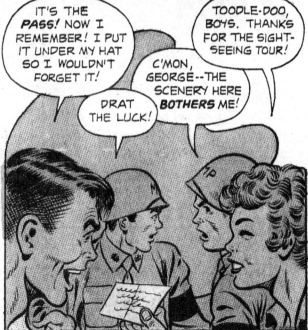

IT'S THE PASS! NOW I REMEMBER! I PUT IT UNDER MY HAT SO I WOULDN'T FORGET IT!

DRAT THE LUCK!

TOODLE-DOO, BOYS. THANKS FOR THE SIGHT-SEEING TOUR!

C'MON, GEORGE--THE SCENERY HERE BOTHERS ME!

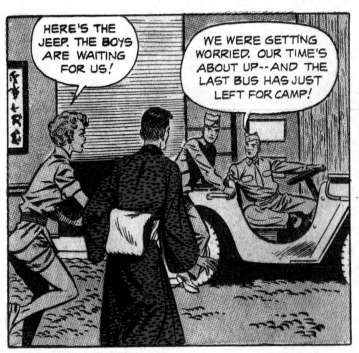

HERE'S THE JEEP. THE BOYS ARE WAITING FOR US!

WE WERE GETTING WORRIED. OUR TIME'S ABOUT UP--AND THE LAST BUS HAS JUST LEFT FOR CAMP!

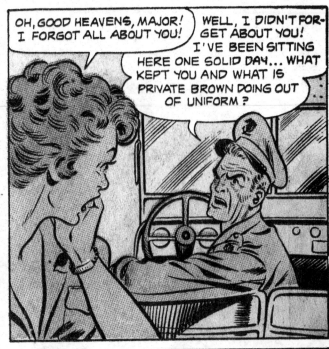

OH, GOOD HEAVENS, MAJOR! I FORGOT ALL ABOUT YOU!

WELL, I DIDN'T FORGET ABOUT YOU! I'VE BEEN SITTING HERE ONE SOLID DAY... WHAT KEPT YOU AND WHAT IS PRIVATE BROWN DOING OUT OF UNIFORM?

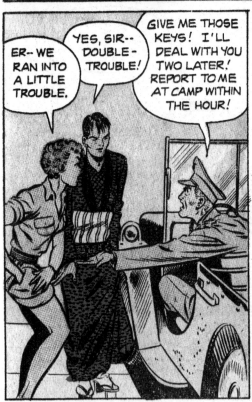

ER-- WE RAN INTO A LITTLE TROUBLE.

YES, SIR-- DOUBLE-TROUBLE!

GIVE ME THOSE KEYS! I'LL DEAL WITH YOU TWO LATER! REPORT TO ME AT CAMP WITHIN THE HOUR!

HEY--LOOK! OUR MP FRIENDS! HA-HA! I BET THEY'D LIKE TO SEE US OVER-STAY OUR LEAVE!

BOY! WAS HE SORE!

LET'S NOT GIVE 'EM THE THRILL! PILE IN!

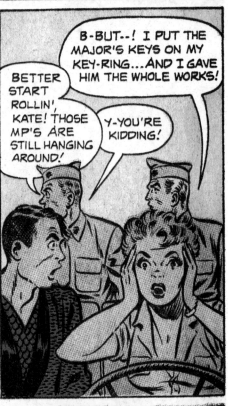

B-BUT--! I PUT THE MAJOR'S KEYS ON MY KEY-RING...AND I GAVE HIM THE WHOLE WORKS!

BETTER START ROLLIN', KATE! THOSE MP'S ARE STILL HANGING AROUND!

Y-YOU'RE KIDDING!

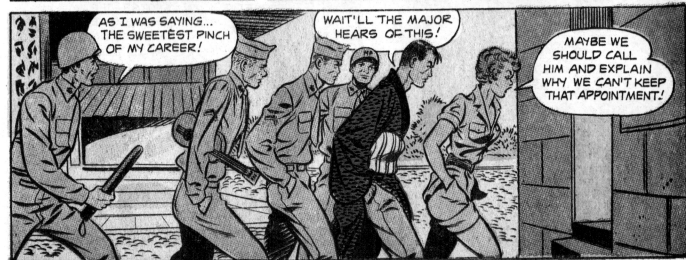

AS I WAS SAYING... THE SWEETEST PINCH OF MY CAREER!

WAIT'LL THE MAJOR HEARS OF THIS!

MAYBE WE SHOULD CALL HIM AND EXPLAIN WHY WE CAN'T KEEP THAT APPOINTMENT!

# Canteen KATE in Party Line

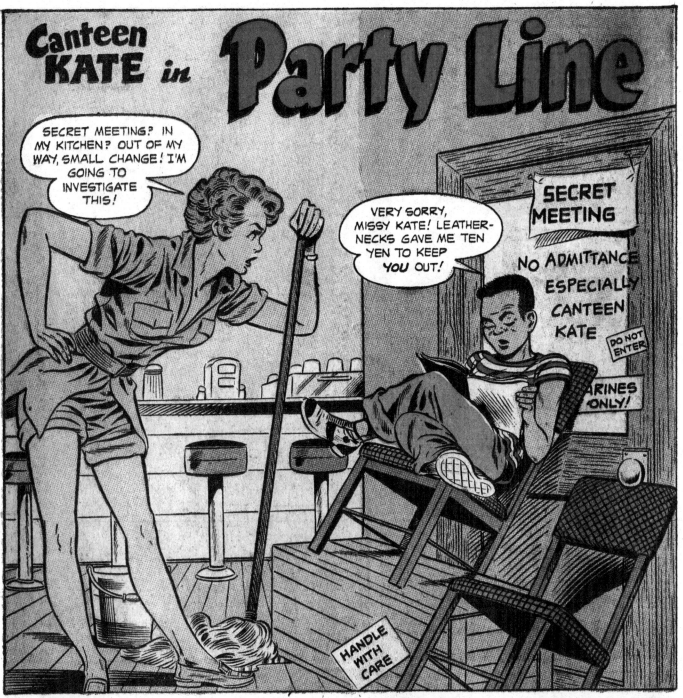

SECRET MEETING? IN MY KITCHEN? OUT OF MY WAY, SMALL CHANGE! I'M GOING TO INVESTIGATE THIS!

VERY SORRY, MISSY KATE! LEATHER-NECKS GAVE ME TEN YEN TO KEEP *YOU* OUT!

SECRET MEETING

NO ADMITTANCE ESPECIALLY CANTEEN KATE

DO NOT ENTER

ARINES ONLY!

HANDLE WITH CARE

OF ALL THE NERVE! NO MARINE IS GOING TO KEEP ANY SECRETS FROM *ME!* I'LL GO AROUND TO THE BACK!

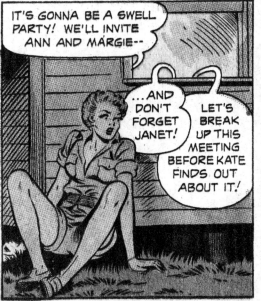

IT'S GONNA BE A SWELL PARTY! WE'LL INVITE ANN AND MARGIE--

...AND DON'T FORGET JANET!

LET'S BREAK UP THIS MEETING BEFORE KATE FINDS OUT ABOUT IT!

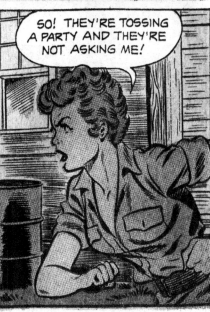

SO! THEY'RE TOSSING A PARTY AND THEY'RE NOT ASKING ME!

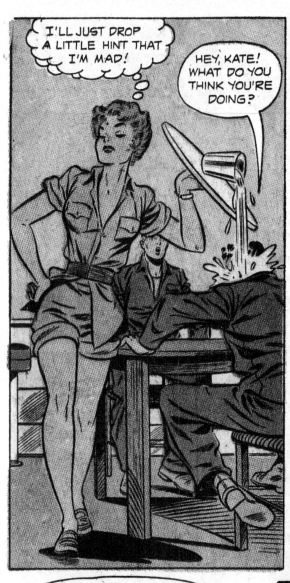

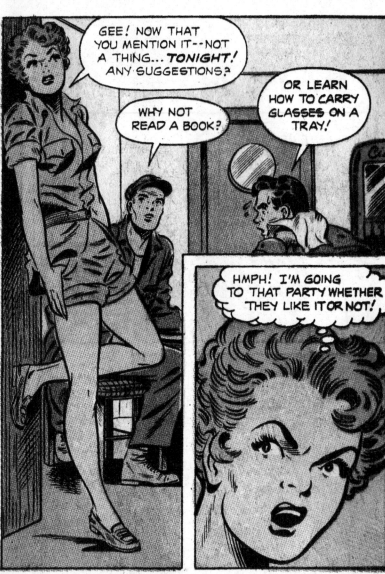

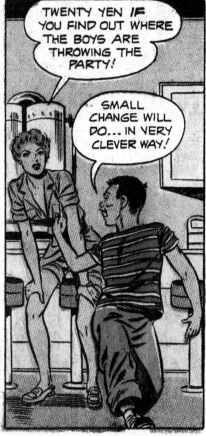

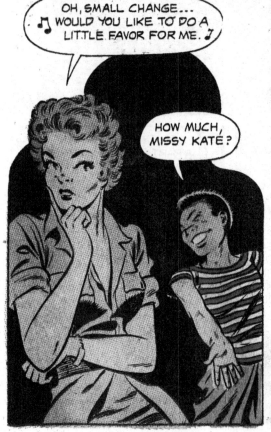

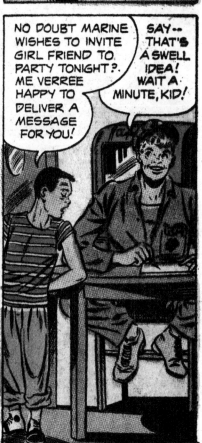

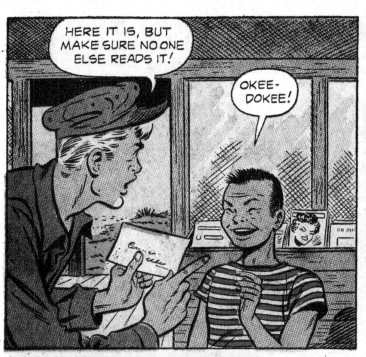

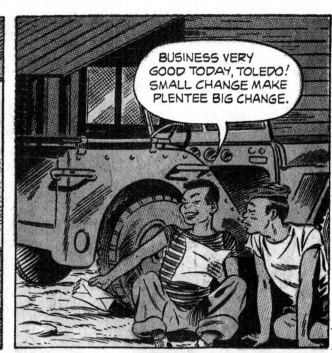

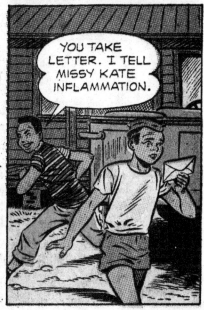

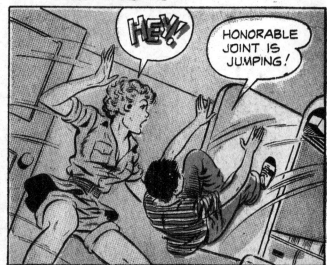

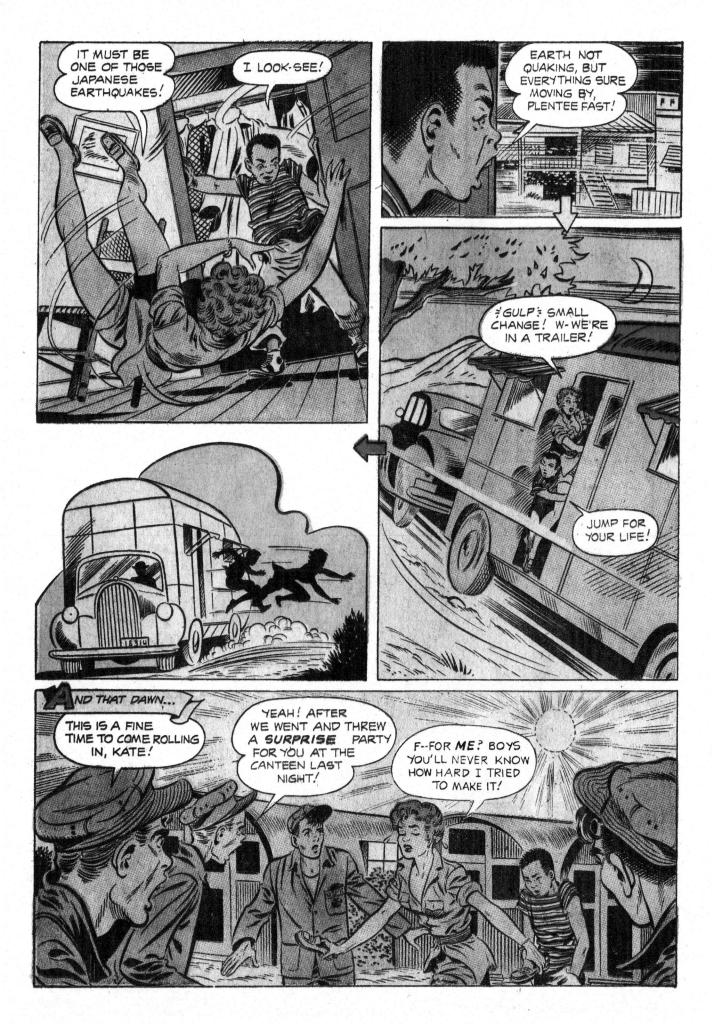

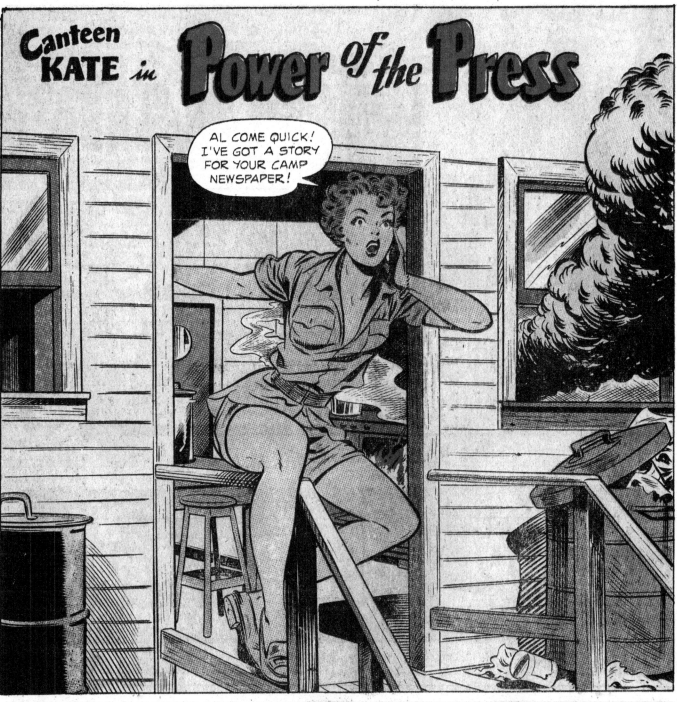

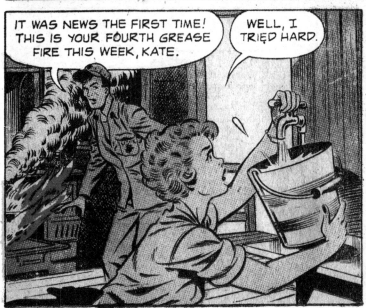

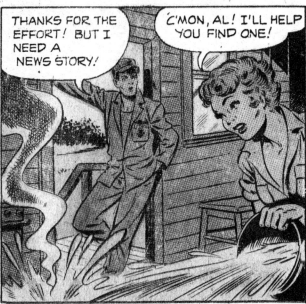

I'VE ALREADY TURNED THIS CAMP INSIDE OUT, BUT ANYTHING WORTH WRITING ABOUT IS LABELED CONFIDENTIAL!

THEN WE'LL LOOK OUTSIDE THE CAMP.

BUT I DON'T HAVE A PASS, KATE!

NEVER MIND. THERE'S AN OLD TARPULIN IN THE BACK. CRAWL UNDER IT AND HIDE.

I'D HATE TO LAND IN THE BRIG FOR WHAT LITTLE I'M GONNA GET OUT OF THIS!

DON'T WORRY, AL. I KNOW THE MP AT THE GATE. LEAVE EVERY-THING TO ME!

STOP!

THIS TARPULIN!

IT WAS HANGING OVER THE SIDE. I'LL TUCK IT IN SO YOU WON'T LOSE IT!

OH, I'M SURE IT WOULD FIND ITS WAY BACK!

WELL, NOW THAT WE'RE OUT OF CAMP, WHERE ARE WE GOING?

LET'S TRY THAT OLD SHACK! A PROSPECTOR MIGHT LIVE THERE!

YOU'VE BEEN SEEING TOO MANY MOVIES. THERE AREN'T ANY PROSPECTORS HERE IN JAPAN.

C'MON BACK, KATE. THERE'S NO NEWS IN THERE.

AL--LOOK! A SKELETON!

YIPE! LET'S GET OUT OF HERE!

H- HE'S CLUTCHING AN OLD MAP IN HIS HAND!

I CAN GET ALL THE MAPS I WANT FROM THE AAA. LET'S GET GOING.

IT'S A TREASURE MAP, AL! IT SHOWS THE LOCATION OF BURIED GOLD.

YOU SURE IT ISN'T A MAP OF FORT KNOX?

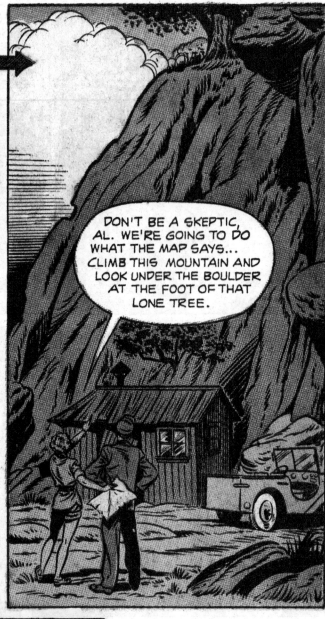

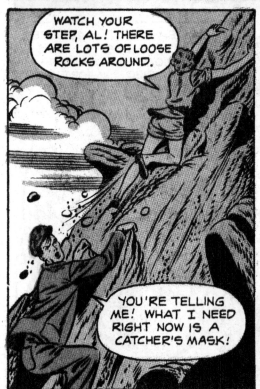

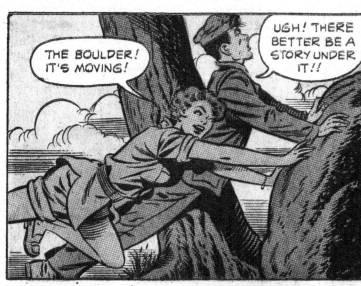

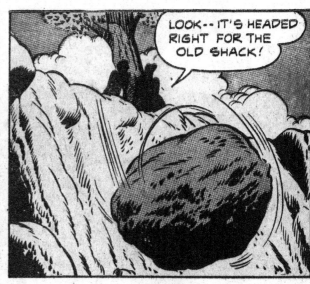

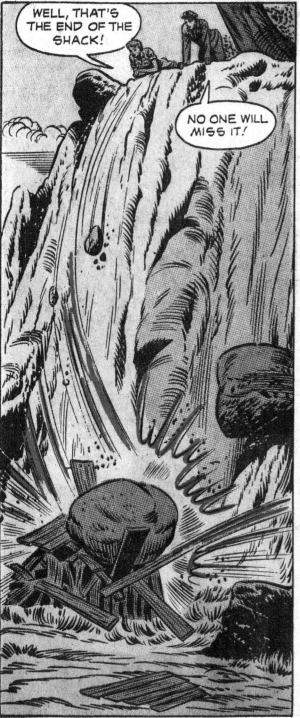

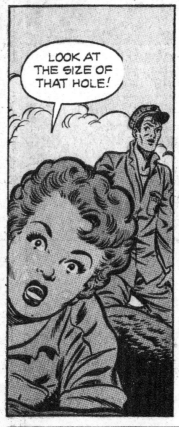

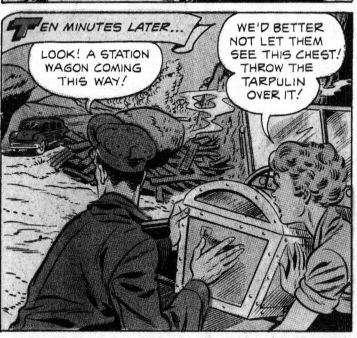

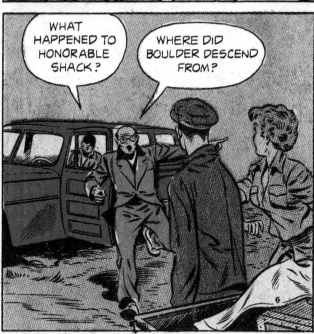

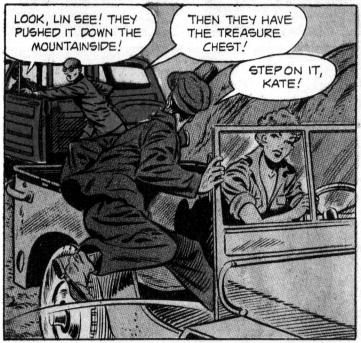

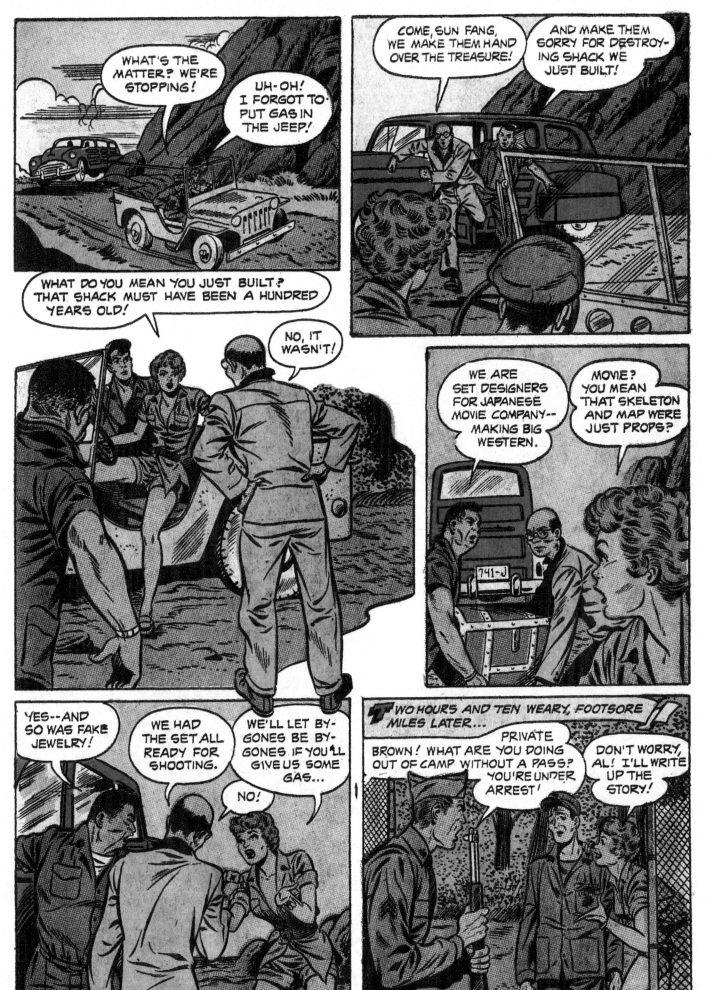

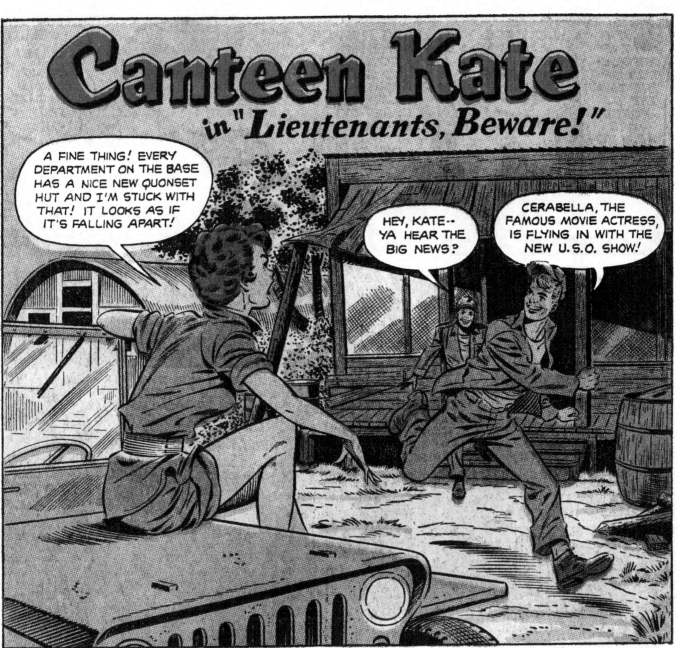

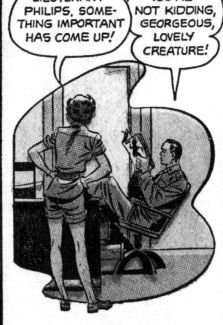

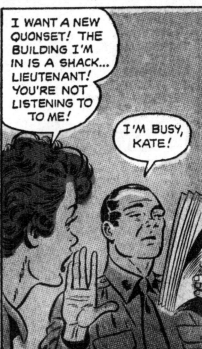

HMM... THIS CALLS FOR STRATEGY!

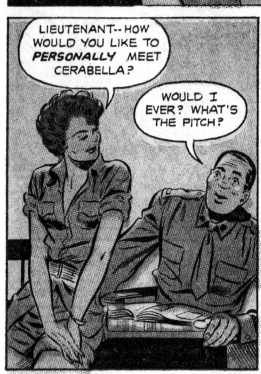

LIEUTENANT-- HOW WOULD YOU LIKE TO **PERSONALLY** MEET CERABELLA?

WOULD I EVER? WHAT'S THE PITCH?

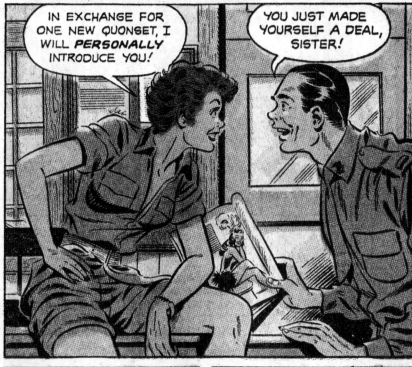

IN EXCHANGE FOR ONE NEW QUONSET, I WILL **PERSONALLY** INTRODUCE YOU!

YOU JUST MADE YOURSELF A DEAL, SISTER!

LY DEPT.

SO FAR-- SO GOOD!

THIS IS WHERE THE U.S.O. TROUPES ALWAYS STAY! I'LL JUST MARCH RIGHT IN AND ASK CERA-BELLA POINT BLANK!

VISITORS' QUARTERS

SHE'S OUT, BUT-- GEE! WHAT A BEAUTIFUL GOWN! I HAVEN'T SEEN ANYTHING LIKE IT SINCE I LEFT THE STATES!

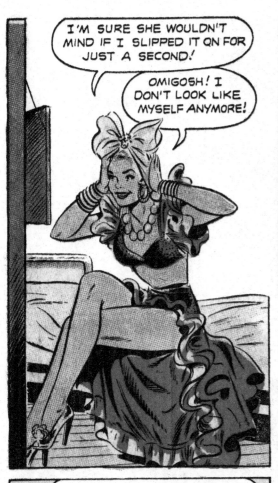

I'M SURE SHE WOULDN'T MIND IF I SLIPPED IT ON FOR JUST A SECOND!

OMIGOSH! I DON'T LOOK LIKE MYSELF ANYMORE!

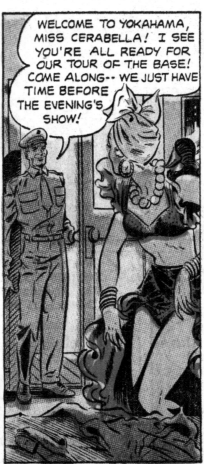

WELCOME TO YOKAHAMA, MISS CERABELLA! I SEE YOU'RE ALL READY FOR OUR TOUR OF THE BASE! COME ALONG-- WE JUST HAVE TIME BEFORE THE EVENING'S SHOW!

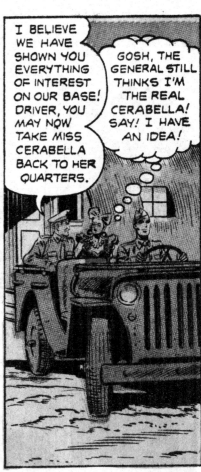

I BELIEVE WE HAVE SHOWN YOU EVERYTHING OF INTEREST ON OUR BASE! DRIVER, YOU MAY NOW TAKE MISS CERABELLA BACK TO HER QUARTERS.

GOSH, THE GENERAL STILL THINKS I'M THE REAL CERABELLA! SAY! I HAVE AN IDEA!

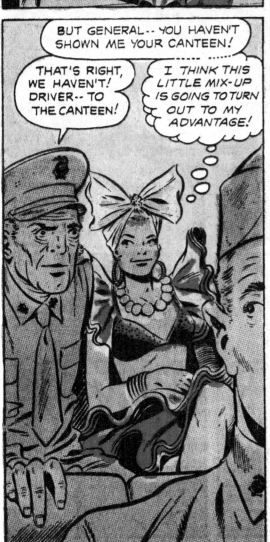

BUT GENERAL-- YOU HAVEN'T SHOWN ME YOUR CANTEEN!

THAT'S RIGHT, WE HAVEN'T! DRIVER-- TO THE CANTEEN!

I THINK THIS LITTLE MIX-UP IS GOING TO TURN OUT TO MY ADVANTAGE!

GOOD HEAVENS, GENERAL! THAT BUILDING IS A DISGRACE TO YOUR BASE! YOU SHOULD HAVE A NEW QUONSET RIGHT AWAY!

BY JOVE, MISS CERABELLA, YOU'RE RIGHT! I'LL--

SO THERE YOU ARE, MISS CANTEEN KATE! IF YOU'RE THROUGH MASQUERADING, I'D LIKE TO GET INTO MY COSTUME FOR TONIGHT'S SHOW!

I'VE BEEN DUPED! YOUNG LADY, REPORT TO MY OFFICE AT 0800 IN THE MORNING!

WELL, GET GOING!... FIND A JEEP TO TAKE ME TO THE CAMP THEATRE!

GOSH, I'LL NEVER GET A NEW QUONSET NOW! EVERYBODY'S MAD AT ME... EXCEPT...

...LIEUTENANT PHILIPS!

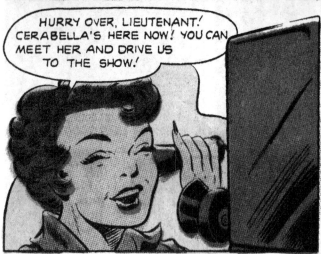

HURRY OVER, LIEUTENANT! CERABELLA'S HERE NOW! YOU CAN MEET HER AND DRIVE US TO THE SHOW!

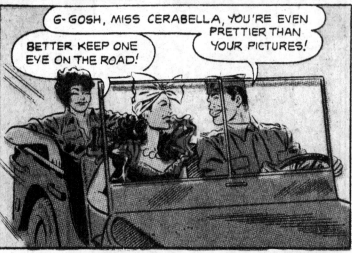

G-GOSH, MISS CERABELLA, YOU'RE EVEN PRETTIER THAN YOUR PICTURES!

BETTER KEEP ONE EYE ON THE ROAD!

PHOOEY, I CAN LOOK AT THE ROAD ANY TIME! BESIDES, I KNOW THIS ROAD AS WELL AS THE MARINE HANDBOOK!

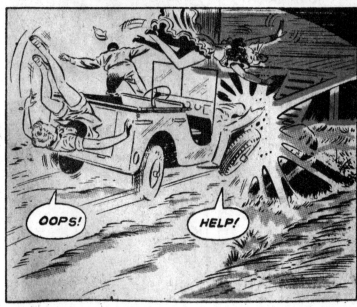

OOPS!

HELP!

HA-HA!

BRAVO!

THE BOYS SEEM TO THINK THIS IS PART OF YOUR ACT, CEREBELLA!

*0800 THE FOLLOWING MORNING AT THE GENERAL'S OFFICES...*

GOSH, AL-- I WONDER IF HE'LL GIVE ME A GENERAL COURT MARSHALL, A DISHONORABLE DISCHARGE OR WORSE?

COURAGE, KATE.

THE GENERAL WILL SEE YOU NOW.

GOOD LUCK!

IT'S BEEN NICE KNOWING YOU, AL!

*20 MINUTES LATER...*

GEE, AL, THE GENERAL WASN'T MAD AT ALL! HE'S EVEN GETTING ME A NEW HUT! I JUST TOOK THE BULL BY THE HORNS AND I EXPLAINED THE WHOLE THING IN A BUSINESS-LIKE FASHION.

THANKS AGAIN, GENERAL!

DON'T MENTION IT!

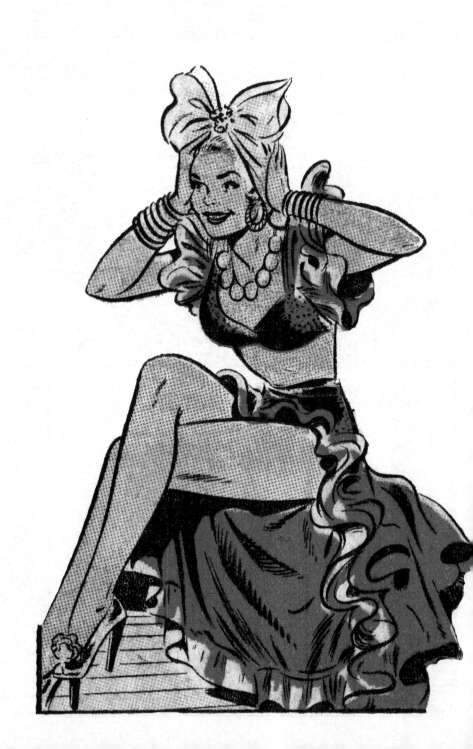

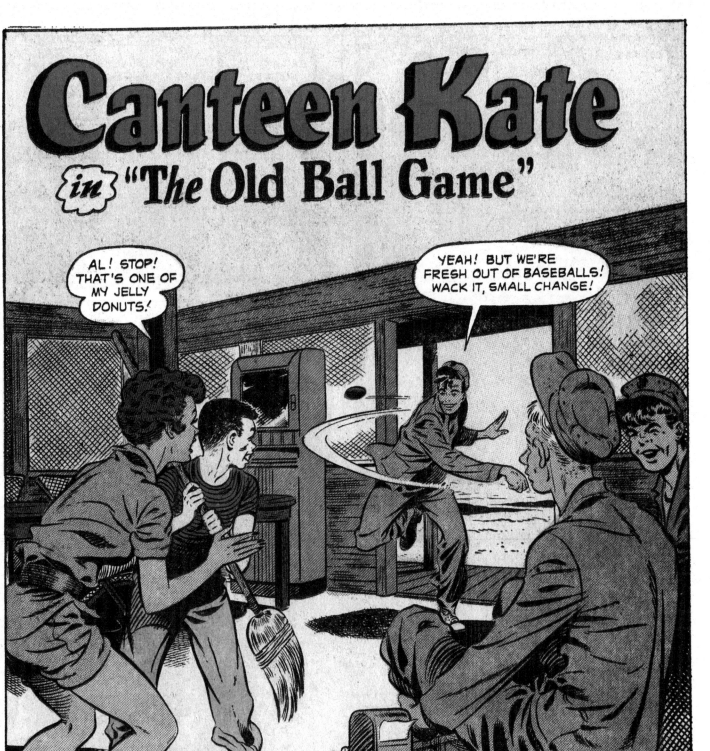

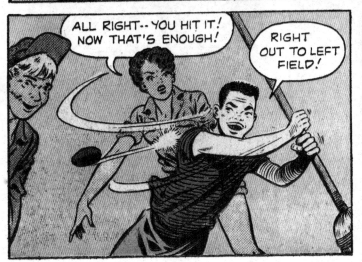

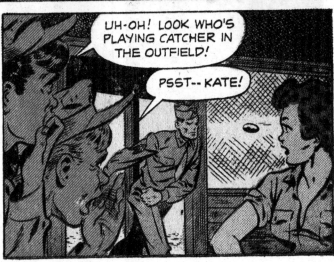

133

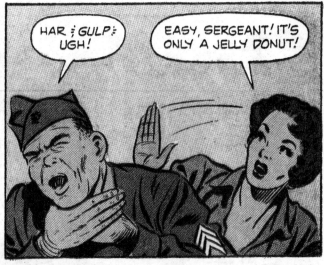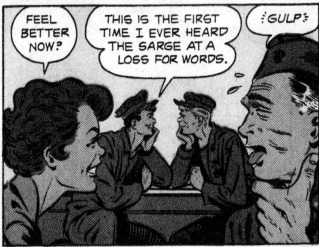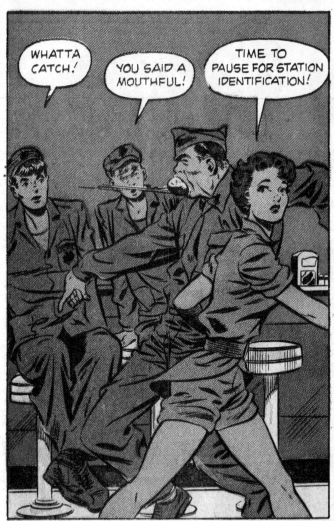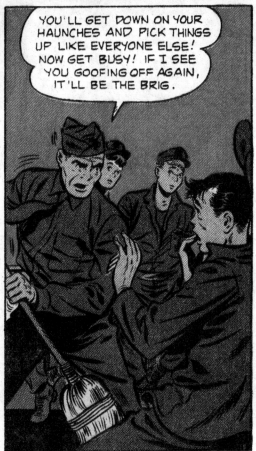

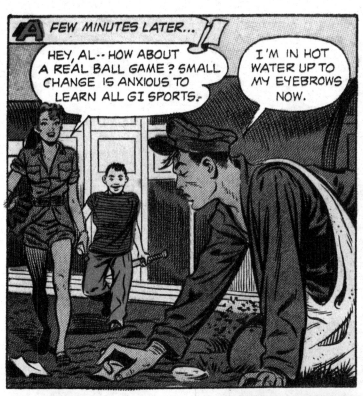

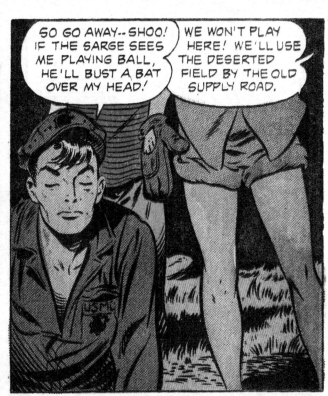

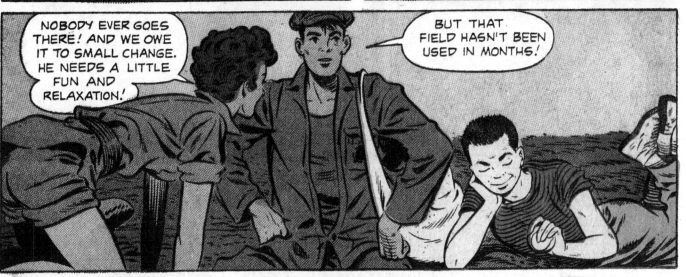

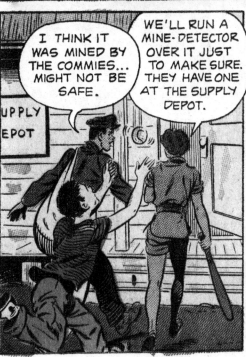

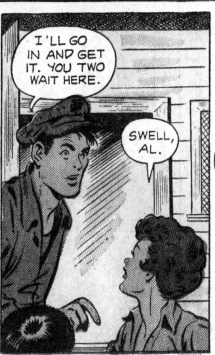

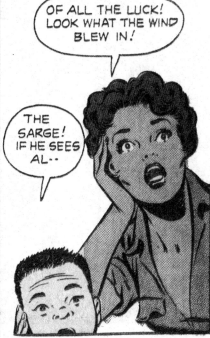

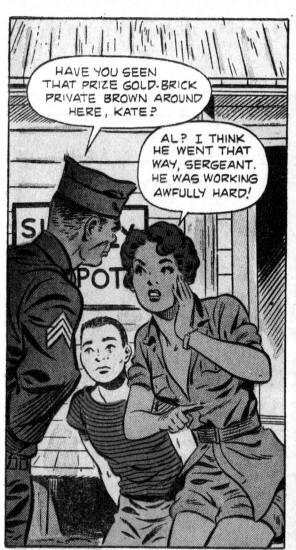

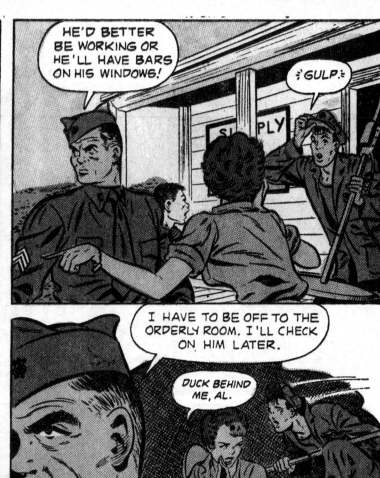

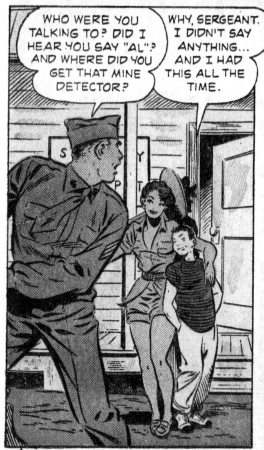

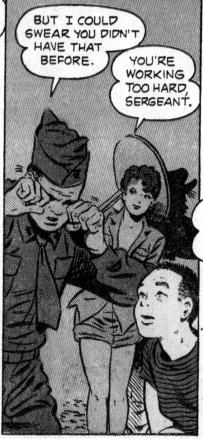

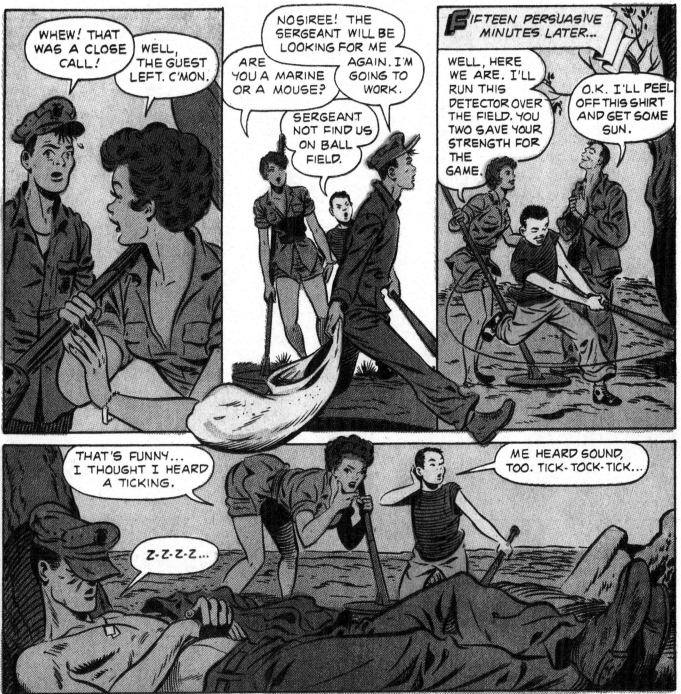

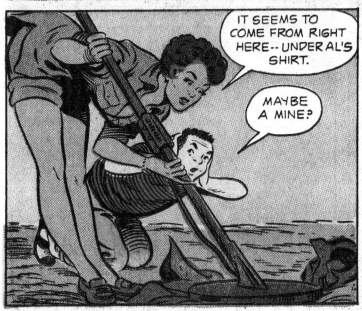

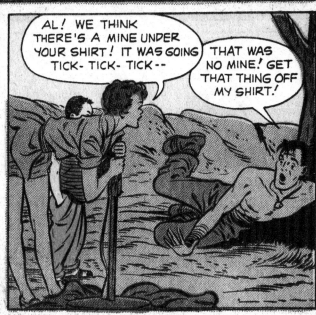

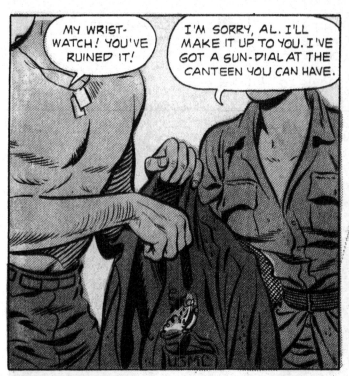

MY WRIST-WATCH! YOU'VE RUINED IT!

I'M SORRY, AL. I'LL MAKE IT UP TO YOU. I'VE GOT A SUN-DIAL AT THE CANTEEN YOU CAN HAVE.

I CAN'T WEAR A SUN-DIAL ON MY WRIST.

OH, AL, STOP FUMING!

SMALL CHANGE MOST ANXIOUS FOR BALL GAME.

I'VE BEEN OVER THE WHOLE FIELD AND THERE'S NOT A SIGN OF A MINE!

ALL RIGHT. I'LL PITCH. YOU CAN HAVE FIRST LICKS AND SMALL CHANGE CAN CATCH.

THE FASTER YOU THROW THEM IN, THE HARDER I'LL HIT THEM OUT, BUSH-LEAGUER!

IS THAT SO? BET YOU DON'T GET THIS ONE!

OH, NO?

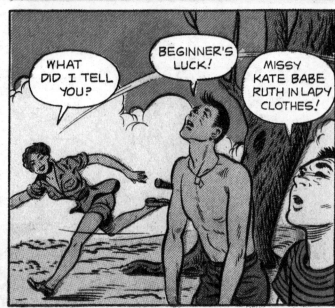

WHAT DID I TELL YOU?

BEGINNER'S LUCK!

MISSY KATE BABE RUTH IN LADY CLOTHES!

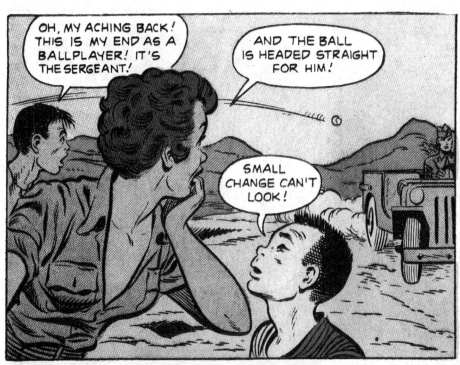

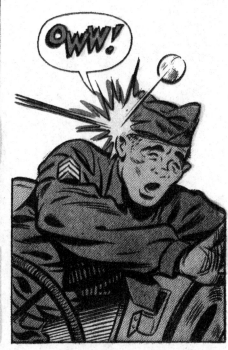

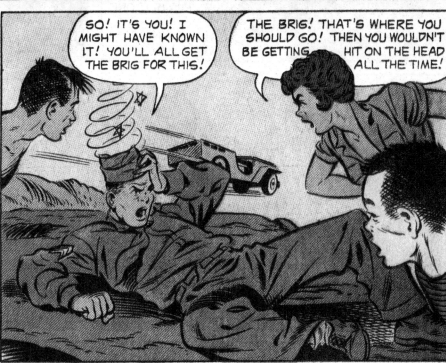

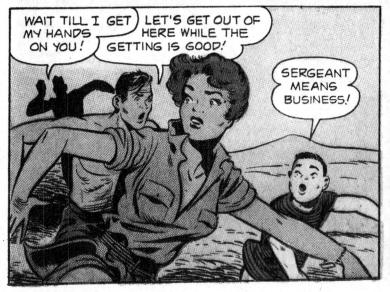

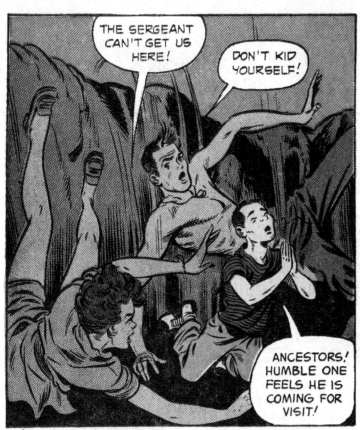

THE SERGEANT CAN'T GET US HERE!

DON'T KID YOURSELF!

ANCESTORS! HUMBLE ONE FEELS HE IS COMING FOR VISIT!

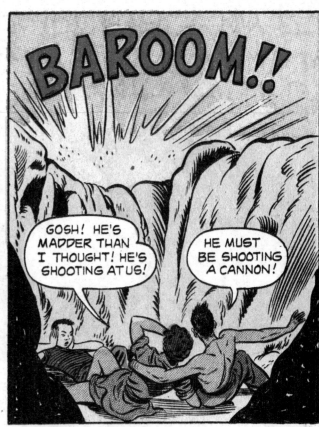

BAROOM!!

GOSH! HE'S MADDER THAN I THOUGHT! HE'S SHOOTING AT US!

HE MUST BE SHOOTING A CANNON!

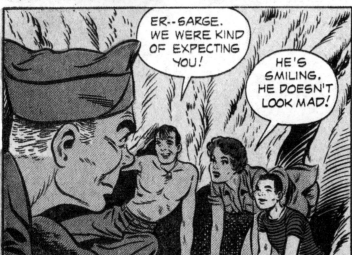

ER--SARGE. WE WERE KIND OF EXPECTING YOU!

HE'S SMILING, HE DOESN'T LOOK MAD!

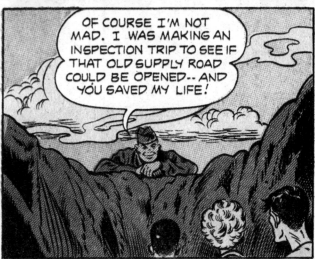

OF COURSE I'M NOT MAD. I WAS MAKING AN INSPECTION TRIP TO SEE IF THAT OLD SUPPLY ROAD COULD BE OPENED-- AND YOU SAVED MY LIFE!

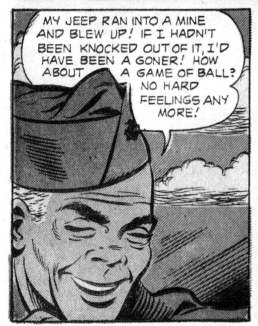

MY JEEP RAN INTO A MINE AND BLEW UP! IF I HADN'T BEEN KNOCKED OUT OF IT, I'D HAVE BEEN A GONER! HOW ABOUT A GAME OF BALL? NO HARD FEELINGS ANY MORE!

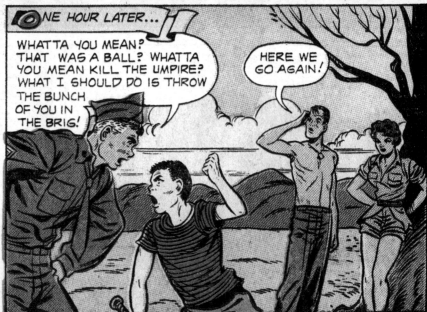

ONE HOUR LATER...

WHATTA YOU MEAN? THAT WAS A BALL? WHATTA YOU MEAN KILL THE UMPIRE? WHAT I SHOULD DO IS THROW THE BUNCH OF YOU IN THE BRIG!

HERE WE GO AGAIN!

# FIFTY MILLION FRENCHMEN

KATE HAD A HUNCH THAT SOMETHING WAS UP WHEN MAJOR HERRINGBONE STEPPED INTO THE CANTEEN WITH A VERY SMUG SMILE.

"KATIE," THE MAJOR SAID AS HE FLOPPED DOWN ON A STOOL BY THE COUNTER, "I THINK YOUR PROMOTION IS LONG OVERDUE."

"PROMOTION?" CHIRPED KATE IN BEWILDERMENT. "I DON'T CATCH. PUT IT IN SIMPLER LANGUAGE, SIR. LIKE, DO YOU MEAN I'M TO BE TRANSFERRED?"

"NOT FROM THIS BASE. NO MA'AM!" THE MAJOR WAS VERY EMPHATIC. "YOU MIGHT CALL IT UPGRADED IF THE WORD PROMOTION DOESN'T APPEAL TO YOU," HE ADDED WITH A COY WINK.

KATE SWUNG BEHIND THE COUNTER AND WALKED UP BEHIND THE SODA TAPS UNTIL SHE WAS FACING HIM. KATE DIDN'T LIKE TO BE KEPT IN SUSPENSE.

"OKAY. LET'S HEAR THE NEWS," SHE BLURTED OUT. KATE BRACED HERSELF AGAINST THE EDGE OF THE STAINLESS STEEL SINK FOR THE SHUDDERING ANNOUNCEMENT.

"WOULDN'T YOU LIKE TO LEAVE THIS ENLISTED MEN'S CANTEEN AND WORK IN THE OFFICERS' CLUB?" THE MAJOR ASKED IN A PERSUASIVE TONE THAT ALMOST FOOLED KATE FOR AN INSTANT.

"NO, SIR. I WOULD NOT," KATE SAID FLATLY. "OF COURSE, IF THAT'S AN ORDER," SHE ADDED GLUMLY, "I'LL OBEY."

"COME, COME, KATIE!" THE MAJOR WHEEDLED. "SHOW SOME *ESPRIT DE CORPS!*"

"WHAT MIGHT THAT BE?" KATE SAID, SQUINTING AT HIM SHARPLY.

"IT'S A FRENCH EXPRESSION," MAJOR HERRINGBONE TOLD HER. "GIVING A LITERAL TRANSLATION IT MEANS SPIRIT OF THE CORPS. IN MILITARY USAGE IT IS APPLIED THE SAME AS YOU WOULD USE THE WORD ENTHUSIASM WHEN SPEAKING OF MEMBERS OF A GROUP."

"IT SOUNDS TERRIBLE TO ME," KATE TOSSED BACK AT HIM. "BUT I SUPPOSE FIFTY MILLION FRENCHMEN CAN'T BE WRONG. WHEN DO I START?"

"THIS NOON," THE MAJOR SAID, GETTING OFF THE STOOL. "REPORT TO LIEUTENANT MARTIN. HE WILL INFORM YOU OF YOUR DUTIES." BEFORE KATE COULD QUESTION HIM ABOUT THE LATTER DETAIL, MAJOR HERRINGBONE LEFT.

"I'VE GOT TROUBLES," KATE MOANED AS SHE SLIPPED OFF HER APRON. HER REMARK WAS OVERHEARD BY THE MARINES WHO WERE CROWDING IN ON THE WAKE OF HERRINGBONE'S DEPARTURE. THEY ASKED HER WHAT WAS THE TROUBLE, AND SHE GAVE IT TO THEM STRAIGHT.

"THE BRASS WANTS ME OVER AT WONDERLAND."

"BUT YOU CAN'T DO THIS TO US, KATIE!" A BIG PFC WHINED. "WE NEED YOU HERE! WHO'S GONNA TAKE YOUR PLACE? A MESS MAN IN A WHITE COAT?"

"WE HAD ONE OF THOSE ONCE BEFORE," A HARDFACED PRIVATE GROANED.

AND AS THE NUMBER ONE CONTROVERSY FLAMED ANEW, KATE SLIPPED QUIETLY AROUND THE EDGE OF THE CROWD AND MADE HER WAY OUTSIDE UNNOTICED. IT DIDN'T TAKE HER FIFTEEN MINUTES TO DISCOVER WHY THE BOYS CALLED THE OFFICERS' CLUB "WONDERLAND." THE BUILDING WAS CRAWLING WITH NINETY DAY WONDERS.

THEY CALLED HER "SWEETHEART" AND "MISS" AND ALL THE OTHER NAMES SHE DIDN'T LIKE SUCH AS HOSTESS, SISTER, AND KID. ALL THE BOYS BACK AT THE CANTEEN HAD ALWAYS ADDRESSED HER AS KATE, AND BEFORE THE DAY WAS OVER, SHE HAD BEGUN PLOTTING TO GET BACK WITH THE ENLISTED MEN.

SHE BROKE A FEW PLATES, SPILLED A FEW GLASSES, BUT NONE OF THE OFFICERS SEEMED TO MIND. THEY PUSHED EACH OTHER ASIDE TO TAKE TURNS HELPING HER PICK UP THE PIECES. AT CHOW TIME WHEN THE PLACE WAS EMPTIED, LIEUTENANT MARTIN, A SMUG, EFFICIENT MAN, SENT HER ON AN ERRAND TO THE COMMISSARY. EN ROUTE SHE RAN INTO MARINE PRIVATE ROCKY SAMPSON, A BATTLE-

141

FRONT VETERAN SERVING HIS SECOND ENLISTMENT. ROCKY'S FACE WAS AS HARD AS THE BOULDERS ON HEARTBREAK RIDGE. AT THE TOP OF HIS ENDLESS GRIPE LIST WERE SECOND LIEUTENANTS OF THE PRE-COMBAT VARIETY.

"YOU DON'T LOOK HAPPY, KATE," HE RASPED IN A TONELESS WHISPER. "WANT ME TO BLOW UP THAT JOINT TONIGHT SO YOU CAN COME BACK TO OUR CANTEEN?"

KATE STOPPED AND TOOK HIS BIG, CALLOUSED HAND. HER NIMBLE MIND SPRANG INTO ACTION. HERE WAS THE MAN TO HELP HER. IF SHE GAVE THE WORD, HE WOULDN'T HESITATE TO DRIVE AN M-26 TANK THROUGH THE CLUB BUILDING AT THE HEIGHT OF THE EVENING RUSH SPELL. BUT DESTRUCTION OF A LESS DRASTIC NATURE COULD SERVE HER PURPOSES.

"JUGGLE A FEW NICE, FULL GARBAGE CANS OVER HERE TONIGHT AFTER CLOSING TIME," SHE TOLD HIM, "AND EMPTY THEM UNDER THE SCREENED VERANDAH. MOTHER NATURE WILL DO THE REST."

"LEAVE IT TO ME, KATE!" ROCKY SAID WITH A GRIN. "I'LL REALLY LOAD THE PIG FEED UNDER THAT PORCH!"

WHEN KATE CAME BACK TO THE CLUB AFTER CHOW SHE WAS CARRYING A SHARP-NOSED PAIR OF SCISSORS IN THE POCKET OF HER SKIRT. THEY WERE SMALL ENOUGH TO BE COVERED BY HER PALM. AT EVERY OPPORTUNITY THAT NIGHT SHE WOULD BACK UP TO THE SCREENED PANELS ALONG THE VERANDAH, JAB THE POINT OF THE SCISSORS INTO THE SCREEN AND THEN SPREAD THE BLADES TO STRETCH THE SCREEN WIRE. IN EACH SPOT THIS WOULD LEAVE A HOLE LARGE ENOUGH FOR A FLY TO ENTER WITHOUT RETRACTING HIS LANDING GEAR.

MAJOR HERRINGBONE SHOWED UP JUST BEFORE CLOSING TIME. HE TAPPED KATE'S SHOULDER AND SAID, "YOUR PRESENCE HAS LIVENED UP THE PLACE, MY DEAR. I KNEW I COULD DEPEND ON YOU TO SHOW REAL *ESPRIT DE CORPS*."

KATE ROLLED INTO HER BUNK THAT NIGHT AND PRAYED THAT ROCKY'S SPECIAL GARBAGE DETAIL WOULD HIT NO SNAG. IN THE MORNING HE WAS THE FIRST PERSON TO GREET HER WHEN SHE LEFT HER BILLET. "EVERYTHING WENT OKAY, KATE!" HE SAID WITH A DEEP CHUCKLE.

"SOON AS THE SUN GETS HOT, YOU'LL NEED TO WEAR A GAS MASK IN THAT JOINT."

KATE WINKED AT HIM, AND WENT OFF TO BREAKFAST. A COUPLE OF YARDBIRDS WERE MOPPING UP THE CLUB WHEN KATE SHOWED UP TO HELP LIEUTENANT MARTIN WITH THE ACCOUNTS AND REQUISITIONS. THE FAINT AROMA OF GARBAGE WAS ALREADY AFLOAT ON THE BREEZE. MARTIN WENT OUT IN THE FORENOON, AND KATE SAT BACK TO LET MOTHER NATURE TAKE HER COURSE.

BEFORE NOON A NOXIOUS ODOR ENVELOPED THE IMMEDIATE SURROUNDINGS. HOUSE FLIES, HORSE FLIES, FRUIT FLIES AND MANY OTHER VARIETIES

CAME IN SQUADRONS! THE VERANDAH SCREEN WAS BLACK WITH THEM, AND THE MORE ADVENTUROUS ONES FOUND THEIR WAY THROUGH THE HOLES KATE HAD PUNCHED THROUGH THE SCREEN.

LIEUTENANT MARTIN RETURNED, HOLDING HIS NOSE WITH HIS LEFT HAND AND FANNING AWAY FLIES WITH HIS RIGHT. KATE WAS SITTING BETWEEN TWO ELECTRIC FANS FOR PROTECTION.

"I HATE THIS AWFUL PLACE!" SHE GROANED. "ANOTHER DAY HERE AND YOU'LL HAVE TO SEND ME TO THE INFIRMARY!"

NERVOUS PERSPIRATION BROKE OUT ON LIEUTENANT MARTIN'S FACE. "I'LL SPEAK TO MAJOR HERRINGBONE, KATE. HE SHOULD BE ALONG ANY MOMENT NOW. OH, HERE HE COMES!"

HERRINGBONE FOUGHT HIS WAY THROUGH ATTACK FORMATIONS OF WINGED INSECTS, THINKING HE WOULD FIND SAFETY INSIDE THE SCREEN DOOR. HE YIPPED, CLAWED AT HIS NECK, AND IN GENERAL BEHAVED IN NO WAY BECOMING TO AN OFFICER. KATE SWALLOWED HARD TO KEEP FROM LAUGHING. THEN WITH A STRAIGHT FACE SHE STOOD UP AND CAME BEFORE HIM. "SORRY, MAJOR, BUT I'VE LOST MY *ESPRIT DE CORPS*. I CAN'T STAND THIS PLACE ANY LONGER. YOU'LL HAVE TO BREAK ME ONE GRADE. I'M GOING BACK TO THE ENLISTED MEN'S CANTEEN WHERE THE AIR IS SWEETER AND THE FLIES ARE FEWER."

SHE WAS GONE BEFORE HERRINGBONE COULD UNTANGLE HIS TONGUE. HE BRUSHED THE FLIES AWAY FROM THE SCREEN TO OBTAIN VISIBILITY, AND WATCHED KATE TRAIPSING AWAY. "SHE CAN'T DO THIS TO US, LIEUTENANT! OF COURSE, SHE'LL BE BACK. SHE'S ONLY TAKING FRENCH LEAVE UNTIL WE'VE ELIMINATED THE SOURCE OF HER COMPLAINT. ER, HAVE YOU DETERMINED YET WHAT IT MAY BE?"

"GARBAGE," SAID LIEUTENANT MARTIN. "I'M AFRAID YOUR IDEA WAS NOT POPULAR WITH THE ENLISTED MEN. I SHALL MAKE A THOROUGH INVESTIGATION."

BUT LIEUTENANT MARTIN'S PROBE WENT NO FURTHER THAN A BRIEF SESSION WITH KATE AT THE CANTEEN A SHORT WHILE LATER.

"DID YOU SEE OR HAVE YOU HEARD ANY REPORT OF A MARINE DUMPING GARBAGE CANS UNDER THE PORCH OF THE OFFICERS' CLUB?" HE ASKED HER.

"A MARINE?" KATE ASKED INNOCENTLY. "WHY, NO. BUT YOU CAN TELL MAJOR HERRINGBONE I DID SEE A FRENCHMAN. I BELIEVE HIS NAME WAS ALPHONSE. HE WAS SELLING PERFUME, AND WHEN I REFUSED TO BUY FROM HIM HE SAID, 'JUST YOU WAIT, M'AMSELLE!' WELL, I WAITED, AND YOU SEE WHAT HAPPENED. THE FRENCHMAN GOT HIS REVENGE!"

LIEUTENANT MARTIN GAVE KATE A FRIGHTENED LOOK AS HE HURRIEDLY BACKED OUT THE CANTEEN DOOR, AND SHE HASN'T SEEN HIM SINCE!

*THE END*

# Cover Gallery

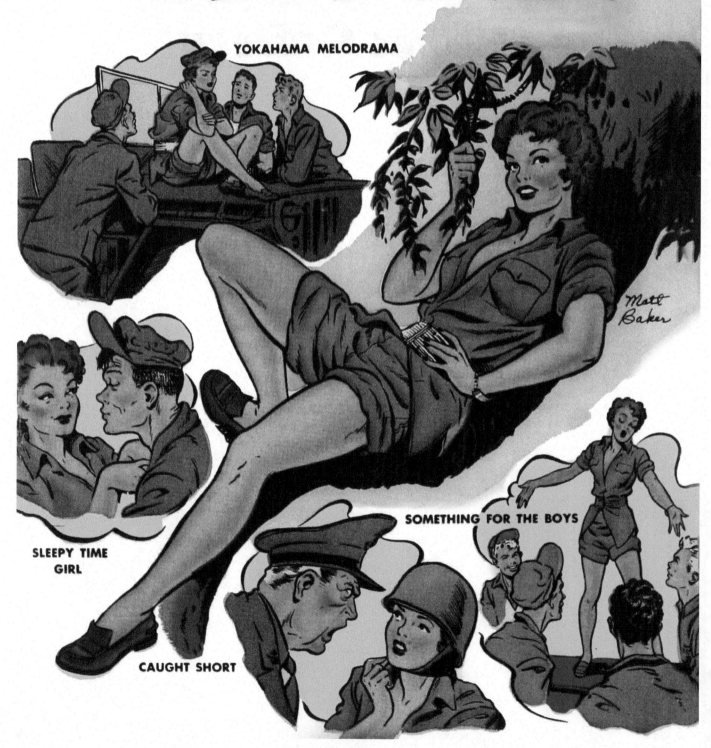

# Canteen KATE

YOKAHAMA MELODRAMA

SLEEPY TIME
GIRL

CAUGHT SHORT

SOMETHING FOR THE BOYS

Matt Baker

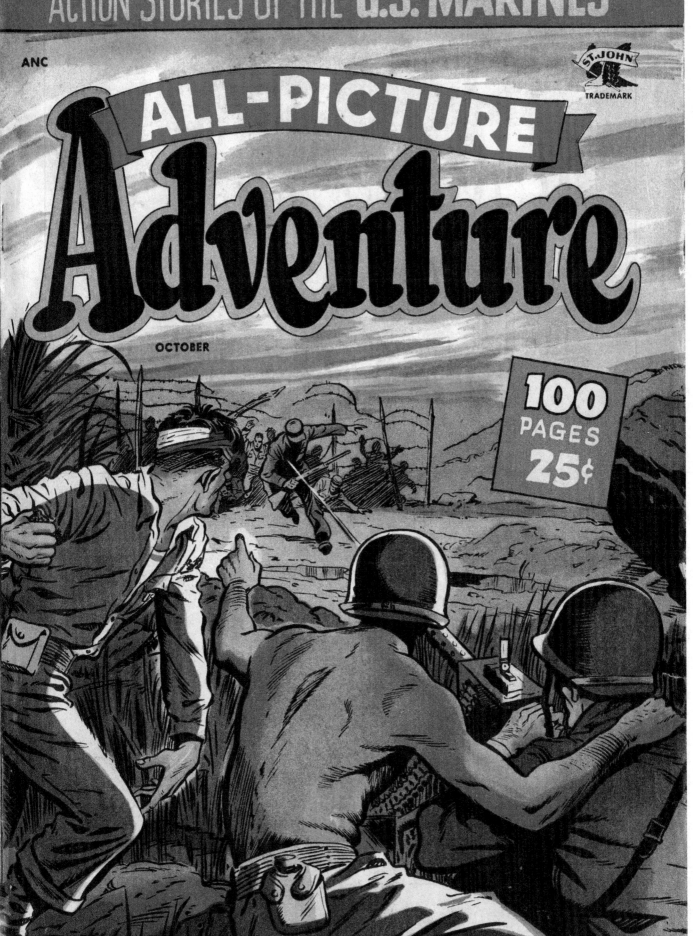

# ACTION STORIES OF THE DEVIL DOGS IN KOREA!

# Fightin' MARINES

ANC
10¢

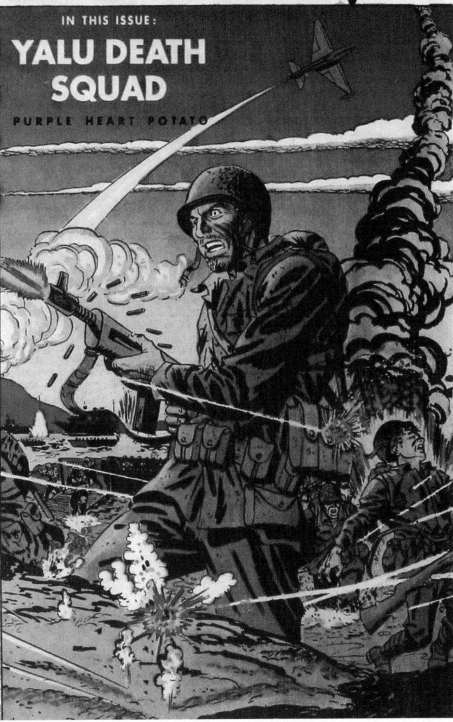

IN THIS ISSUE:

## YALU DEATH SQUAD

PURPLE HEART POTATO

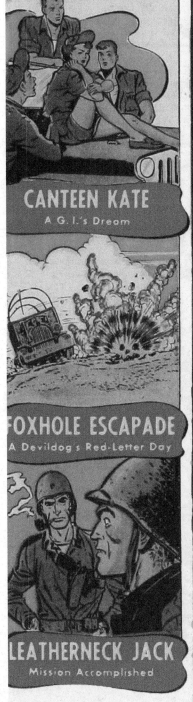

## CANTEEN KATE
A G.I.'s Dream

## FOXHOLE ESCAPADE
A Devildog's Red-Letter Day

## LEATHERNECK JACK
Mission Accomplished

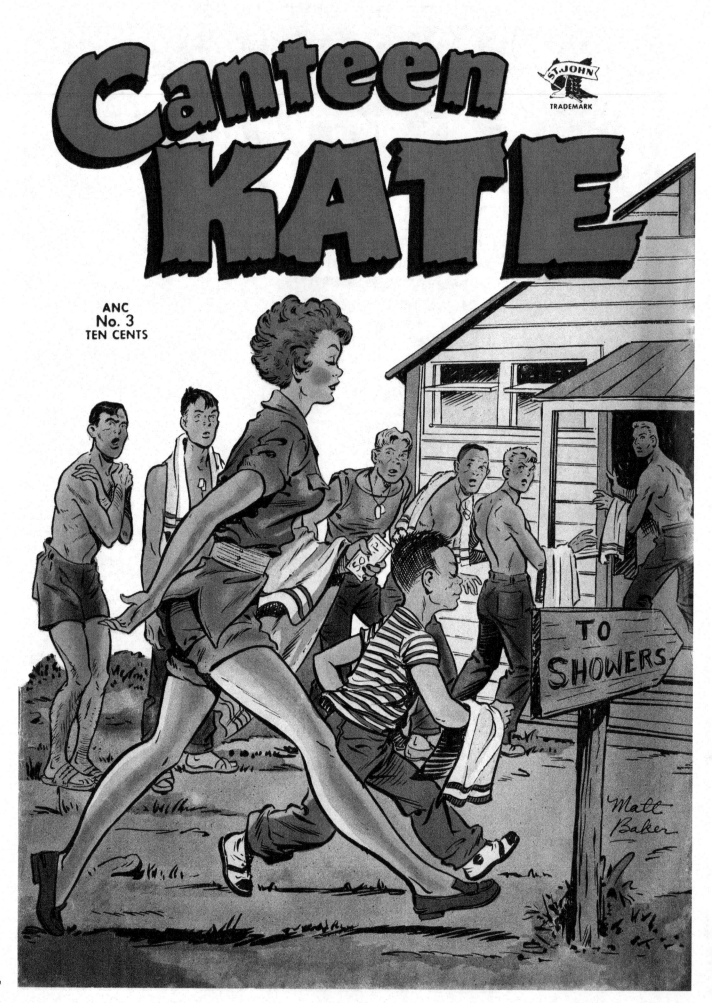

# Fightin' MARINES

No. 3

ANC
10¢
St.J

**CANTEEN KATE**
Call to Arms

**FRONTLINE SNAFU**
Two G. I.'s Strike Back

**LEATHERNECK JACK**
Blitz at Junkyard Junction

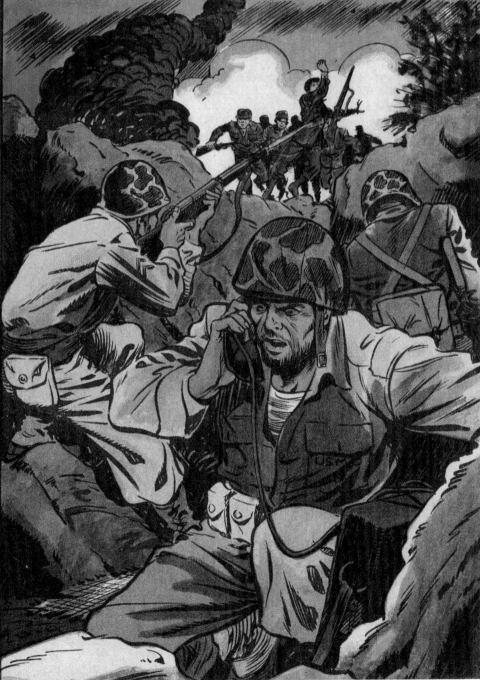

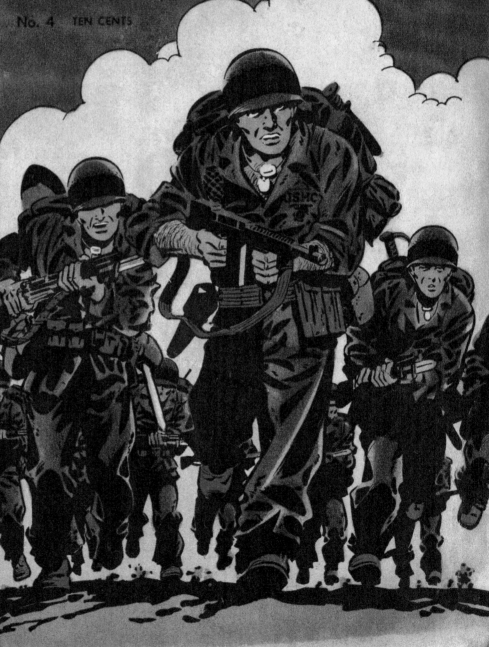

ACTION STORIES OF THE DEVIL DOGS IN KOREA!

# Fightin' MARINES

No. 4    TEN CENTS

CANTEEN KATE
Tailor Maid

LEATHERNECK JACK
War of Nerves

TRIPOLI SHORES
Detour to Destruction

# Fightin' MARINES

No. 6    TEN CENTS

CANTEEN KATE

LEATHERNECK JACK

TRIPOLI SHORES

# ACTION STORIES OF THE DEVIL DOGS IN KOREA!

## Fightin' MARINES

St. JOHN

No. 7    TEN CENTS

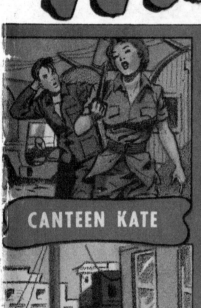

CANTEEN KATE

LEATHERNECK JACK

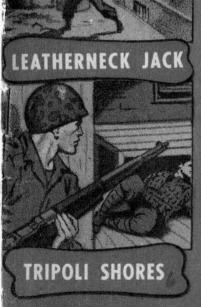

TRIPOLI SHORES

# ACTION STORIES OF THE DEVIL DOGS IN KOREA!

# Fightin' MARINES

ANC

ST. JOHN
TRADEMARK

CANTEEN KATE

LEATHERNECK JACK

TRIPOLI SHORES

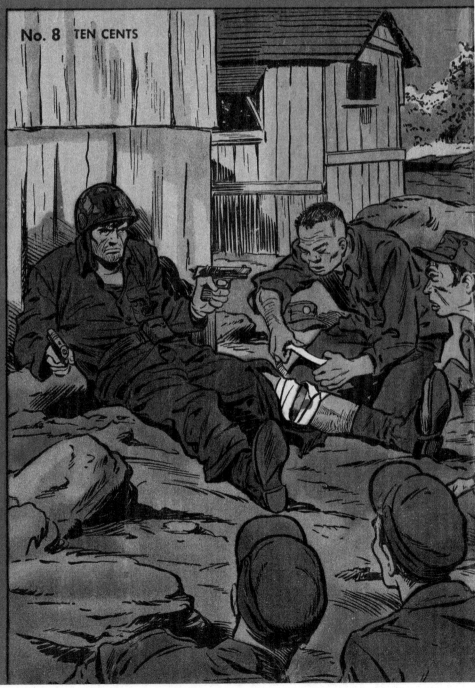

No. 8   TEN CENTS

ANC

# Fightin' MARINES

No. 9 TEN CENTS

CANTEEN KATE,

LEATHERNECK JACK

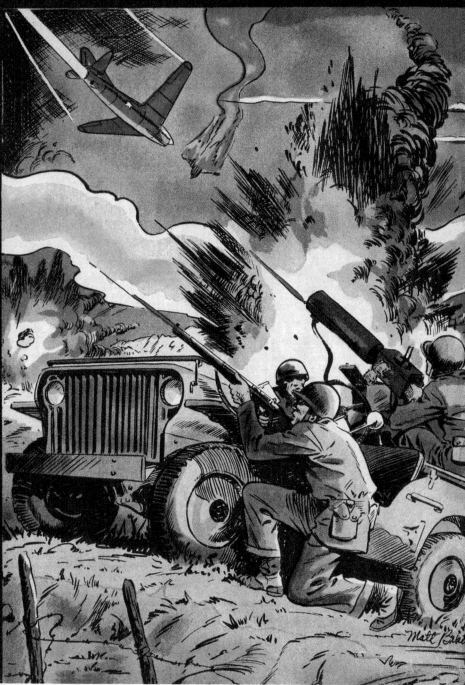